WE'MOON 2020 GAIA RHYTHMS FOR WOMYN

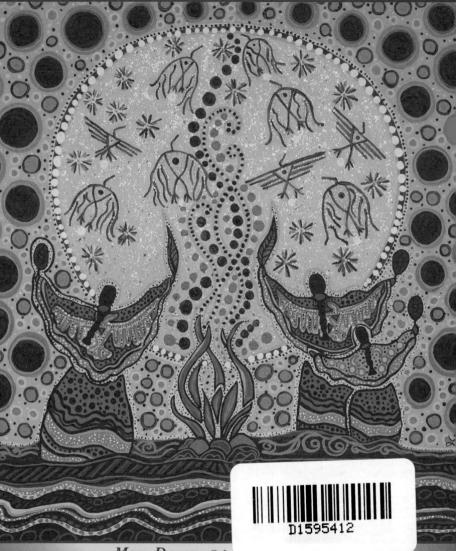

Moon Dancers @ Lea.

WAKE UP CALL

39TH EDITION OF WE'MOON published by

Mother Tongue Ink

We'Moon 2020: Gaia Rhythms for Womyn Spiral, Sturdy Paperback Binding, Unbound & Spanish Editions © Mother Tongue Ink 2019

Mother Tongue Ink

Estacada, OR 97023 All Correspondence: P.O. Box 187, Wolf Creek, OR 97497 www.wemoon.ws

We'Moon Founder/Crone Editor: Musawa, Special Editor: Bethroot Gwynn We'Moonagers: Sue Burns, Barb Dickinson, Graphic Design: Sequoia Watterson We'Moon Creatrix/Editorial Team: Bethroot Gwynn, Sequoia Watterson, Sue Burns, Leah Markman, Barb Dickinson, Production Coordinator: Barb Dickinson Production Assistant & Retail Sales: Leah Markman Proofing: EagleHawk, Sandra Pastorius, Kathryn Henderson, Becky Bee, Amber Torrey Promotion: Leah Markman, Sue Burns, Susie Schmidt, Barb Dickinson Accounts Manager: Sue Burns Order Fulfillment: Susie Schmidt, Shipping Assistant: Dana Page

© Copyrights of individual works belong to each We'Moon contributor except where copyrighted to Mother Tongue Ink, or other publishers as specified. Permission to reproduce any part of this book must be obtained from the contributors and/or Mother Tongue Ink. See page 192 for particulars.

<u>Disclaimer:</u> Mother Tongue Ink does not take responsibility for views expressed by artists or writers in their work in We'Moon, or for readers' use of astrological, herbal or any other information contained herein.

Astrological Data graciously provided by Rique Pottenger.

This eco-audit applies to all We'Moon 2020 products:

Hansol Environmental Benefits Statement:

WeMoon 2020 is printed on Hansol Paper using 60% recycled content: 50% pre-consumer waste, 50% post-consumer waste, with solvent-free soy and vegetable based inks with VOC levels below 1%.
By using recycled fibers instead of virgin fibers, we saved:

114 fully grown trees
45,717 gallons of water
31 million BTUs of energy
2,695 pounds of solid waste
8,066 pounds of greenhouse gasses

As a moon calendar, this book is reusable: every 19 years the moon completes a metonic cycle, returning to the same phase, sign and degree of the zodiac.

We'Moon is printed in South Korea by Sung In Printing America on recycled paper using low VOC soy-based inks.

Order directly from Mother Tongue Ink To Order see p. 230. Email: weorder@wemoon.ws

Retail: 877-693-6666 or 541-956-6052 Wholesale: 503-288-3588

We'Moon 2020 Datebooks: • \$21.95 Spiral ISBN: 978-1-942775-19-5 Sturdy Paperback ISBN: 978-1-942775-20-1 Unbound ISBN: 978-1-942775-21-8 Spanish Edition ISBN: 978-1-942775-22-5 In the Spirit of We'Moon • \$26.95 Paperback ISBN: 978-1-890931-75-9 Preacher Woman for the Goddess • \$16 Paperback ISBN: 978-1-942775-12-6

The Last Wild Witch • \$9.95 Paperback ISBN: 978-1-890931-94-0 Other We'Moon 2020 Products: We'Moon on the Wall • \$16.95 ISBN: 978-1-942775-23-2 Greeting Cards (6-Pack) • \$11.95 ISBN: 978-1-942775-24-9

Organic Cotton Tote • \$13 We'Moon Cover Poster • \$10

2020

JANUARY										
S	M	T	W	T	F	S				
			1	2	3	4				
5	6	7	8	9	(10)	11				
12	13	14	15	16	17	18				
19	20	21	22	23	24)	25				
26	27	28	29	30	31					

MARCH										
S	M	T	W	T	F	S				
		3								
8	9	10	11	12	13	14				
15	16	17	18	19	20	21				
22	23	(24)	25	26	27	28				
29	30	31								

MAY										
S	M	T	W	T	F	S				
					1	2				
3	4	5	6	7	8	9				
10	11	12	13	14	15	16				
17	18	19	20	21	22)	23				
24	25	26	27	28	29	30				
31										
		STATE OF THE PARTY OF	THE PARTY OF							

JULI										
S	M	T	W	T	F	S				
			1	2	3	4				
5	6	7	8	9	10	11				
12	13	14	15	16	17	18				
19	(20)	21	22	23	24	25				
26	27	28	29	30	31					

SEPTEMBER									
S	M	T	W	T	F	S			
		1	2	3	4	5			
6	7	8	9	10	11	12			
13	14	15	16	(17)	18	19			
20	21	22	23	24	25	26			
27	28	29	30						

NOVEMBER										
S	M	T	W	T	F	S				
1	2	3	4	5	6	7				
8	9	10	11	12	13	14				
15	16	17	18	19	20	21				
22	23	24	25	26	27	28				
29	30									

4 Seasons © Serena Supplee 2010

FEBRUARY										
S	M	T	W	T	F	S				
						1				
	3									
9	10	11	12	13	14	15				
16	17	18	19	20	21	22				
23	24	25	26	27	28	29				
		Δ	PRI	П						

APRIL										
S	M	T	W	T	F	S				
			1	2	3	4				
5	6	7	8	9	10	11				
		14								
19	20	21	(22)	23	24	25				
26	27	28	29	30						

JUNE									
S	M	T	W	T	F	S			
	1	2	3	4	5	6			
7	8	9	10	11	12	13			
14	15	16	17	18	19	20			
21	22	23	24	25	26	27			
28	29	30							

		AL	Jul	21		
S	M	T	W	T	F	S
				6		
				13		
16	17	(18)	19	20	21	22
23	24	25	26	27	28	29
30	31					

S	M	T	W	T	F	S
				1	2	3
	5					
11	12	13	14	15	(16)	17
18	19	20	21	22	23	24
25	26	27	28	29	30	31

OCTOBER

DECEMBER									
S	M	T	W	T	F	S			
		1	2	3	4	5			
	7			THE PERSON NAMED IN		Control of the last of the las			
13	(14)	15	16	17	18	19			
20	21	22	23	24	25	26			
27	28	29	30	31					

COVER NOTES

Lioness © Saba Taj 2014

Lioness is part of a series of portraits of Muslim American women, titled An-Noor, or The Light. These works challenge the dehumanizing, hegemonic representations of Muslim women as oppressed and Other, and in need of liberation. Truly, Muslims are a combination of many parts, ever changing, complicated by diaspora. Lioness references the famous Norman Rockwell painting Rosie the Riveter. The holy book in the subject's lap is adorned with a pattern inspired by the reproductive system, but the most impactful component of this piece is the subject herself. Her confidence radiates through her posture and her gaze.

Crescendo © Cheryl Braganza 2010

This piece was inspired by a demonstration of women in Mumbai, Braganza's birthplace. "Women were demonstrating in a long procession, shouting slogans, carrying sticks, and demanding that the government offer better sanitary conditions for these women—clean water and toilets. I wanted to record the vitality of these women, let people hear the thunder in their voices and feel the earth tremble under their feet. After all, what they were screaming for was the basic human right that all women be given the respect and consideration they so rightly deserve."

DEDICATION

Every year, we donate a portion of our proceeds to an organization doing good work that resonates with our theme—bringing positive change to the world and to the lives of women. Wake Up Call, this year's theme, is a call to action to rebalance and remediate. With 2020 as a presidential election year in the US, we could think of no better way to energize our

intentions than by naming VoteRunLead this year's dedicatee.

"VoteRunLead trains women to run for office. And win. With more than 33,000 women trained to run for office, VoteRunLead is the largest and most diverse campaign and leadership program in the country. We work to equip women with the right know-how, trainings and how-to's to help them enter politics with a purpose. We believe that by empowering women to run as they are, they will build a campaign based on their own passion, their own ideas and their own values. This is a historic time, when women are stepping up in droves to run for office and make impactful change."

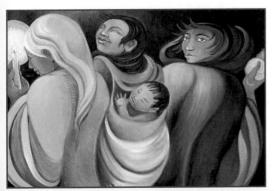

We at We'Moon are thrilled by the massive movement among women to run for public office, and it delights us to put some money where our passions are. Learn more at voterunlead.org

© Mother Tongue Ink 2019

Muses II © Toni Truesdale 2002

TABLE OF CONTENTS

INTRODUCTION

Title Page1	Alchemy in 202020		
Copyright Info2	Eclipses/Mercury Retrograde22		
Year at a Glance 2020 3			
Cover Notes/Dedication4	Wake Up Herbs24		
What is We'Moon? 6 Tarot Card #20: Judgment			
	Star Council26		
Constellations of the Zodiac 10	Who Will Inherit the Earth?28		
Signs and Symbols at a Glance 11	Introduction to the Holy Days30		
Astro Overview 2020 12			
2020 Astro Assignments15	Introduction to We'Moon 2020 32		
Sky Map 202018	Invocation33		
Astro Year at a Glance Intro 19			
MOON CALENDAR: WAKE UP CALL			
I Wake-Up	VIII True Home 117		
II Spirit Sight 47	IX 20/20 Vision 129		
III Sprouting 59	X The Witches are Back139		
IV Awakened Woman 71			
V Love Calls81	XII Liberation 165		
VI Earth Answers95	XIII Holding It Together 175		
VII Facing the Music 107			
APPENDIX			
We'Moon Evolution184	Ephemeris 101206		
We'Moon Tarot186	Planetary Ephemeris207		
We'Moon on the Web186	Asteroid Ephemeris213		
Staff Appreciation187	Month at a Glance Calendars214		
We'Moon Ancestors188	2020 Lunar Phase Card226		
Contributor Bylines/Index190	Year at a Glance 2021228		
Errors/Corrections201	Available from We'Moon229		
We'Moon Sky Talk202	World Time Zones232		
Know Yourself204	Conventional Holidays233		
Goddess Planets205	Become a We'Moon Contributor 234		
WEDDON 2020 TENTINE WOITEDS			

WEMOON 2020 FEATURE WRITERS:

We'Moon Wisdom: Musawa; Astrologers: naimonu james, Heather Roan Robbins, Sandra Pastorius, Gretchen Lawlor, Susan Levitt, Mooncat!, Beate Metz; Introduction to We'Moon 2020: Bethroot Gwynn; Holy Days: Oak Chezar; Lunar Phase Card: Susan Baylies; Herbs: Sue Burns; Tarot: Leah Markman

WHAT IS WE'MOON? A HANDBOOK IN NATURAL CYCLES

We'Moon: Gaia Rhythms for Womyn is more than an appointment book: it's a way of life! We'Moon is a lunar calendar, a handbook in natural rhythms, and a collaboration of international womyn's cultures. Art and writing by wemoon from many lands give a glimpse of the great diversity and uniqueness of a world we create in our own images. We'Moon is about womyn's spirituality (spirit-reality). We share how we live our truths, what inspires us, and our connection with the whole Earth and all our relations.

Wemoon means "we of the moon." The Moon, whose cycles run in our blood, is the original womyn's calendar. We use the word "wemoon" to define ourselves by our primary relation to the cosmic flow, instead of defining ourselves in relation to men (as in woman or female). We'Moon is sacred space in which to explore and celebrate the diversity of she-ness on Earth. We come from many different ways of life. As wemoon, we share a common mother root. We'Moon is created by, for and about womyn: in our image.

We'Moon celebrates the practice of honoring the Earth/Moon/Sun as our inner circle of kin in the Universe. The Moon's phases reflect her dance with Sun and Earth, her closest relatives in the sky. Together these three heavenly bodies weave the web of light and dark into our lives. Astrology measures the cycle by relating the Sun, Moon and all other planets in our universe through the backdrop of star signs (the zodiac), helping us to tell time in the larger cycles of the universe. The holy days draw us into the larger solar cycle as the moon phases wash over our daily lives.

We'Moon is dedicated to amplifying the images and voices of wemoon from many perspectives and cultures. We invite all women to share their work with respect for both cultural integrity and creative inspiration. We are fully aware that we live in a racist patriarchal society. Its influences have permeated every aspect of society, including the very liberation movements committed to ending oppression. Feminism is no exception—historically and presently dominated by white women's priorities and experiences. We seek to counter these influences in our work. We'Moon does not support or condone cultural appropriation (taking what belongs to others) or cultural fascism (controlling artistic expression). We do not knowingly publish oppressive content of any kind. Most of us in our staff group are lesbian or queer—we live outside the norm. At the same time, we are mostly womyn who benefit from white privilege. We seek to make We'Moon a safe and welcoming place for all wimmin, especially for women of color (WOC) and others marginalized by the mainstream. We are eager to publish more words and images depicting people of color created by WOC. We encourage more WOC to submit their creative work to We'Moon for greater inclusion and visibility (see p. 234).

Musawa © Mother Tongue Ink 2008

How TO USE THIS BOOK Useful Information about We'Moon

Refer to the **Table of Contents** to find more detailed resources, including: World Time Zones, Planetary and Asteroid Ephemeris, Signs and Symbols, Year at a Glance, and Month at a Glance Calendars.

Time Zones are in Pacific Standard/Daylight Time with the adjustment for GMT and EDT given at the bottom of each datebook page.

The names and day of the week and months are in English with four additional language translations: Bengali, Spanish, Irish and Mandarin.

Moon Theme Pages mark the beginning of each moon cycle with a twopage spread near the new moon. Each page includes the dates of that Moon's new and full moon and solar ingress.

Susan Baylies' Lunar Phase Card features the moon phases for the entire year on pp. 226–227	₩	p. 45 p. 57
There is a two-page Holy Day spread for all equinoxes, solstices and cross quarter days, from a Northern Hemisphere	HQ	p. 69 p. 79 p. 93
perspective. These include writings by a different feature writer each year. Actro Overview gives a synopsis of actrol accurrences	(6) (6)	p. 105 p. 119
Astro Overview gives a synopsis of astral occurrences throughout the year from one of our featured astrologers, Heather Roan Robins, on pp. 12–14.		p. 131 p. 145
Read the Astrological Horoscopes for your particular sign on the pages shown on the right —>	19	p. 155p. 167p. 181
4 1 D :		1

Astrology Basics

Planets: Like chakras in our solar system, planets allow for different frequencies or types of energies to be expressed. See Mooncat's article (pp.204–205) for more detailed planetary attributes.

Signs: The twelve signs of the zodiac are a mandala in the sky, marking off 30° segments of a circle around the earth. Signs show major shifts in planetary energy through the cycles.

Glyphs: Glyphs are the symbols used to represent planets and signs.

Sun Sign: The Sun enters a new sign once a month (on or around the 21st), completing the whole cycle of the zodiac in one year. The sun sign reflects qualities of your outward shining self.

Moon Sign: The Moon changes signs approximately every 2 to $2^{1}/_{2}$ days, going through all twelve signs of the zodiac every $27^{1}/_{3}$ days (the sidereal month). The Moon sign reflects qualities of your core inner self.

Moon Phase: Each calendar day is marked with a graphic representing the phase of the Moon.

Lunar Quarter Phase: At the four quarter-points of the lunar cycle (new, waxing half, full and waning half moons), we indicate the phase, sign and exact time for each. These points mark off the "lunar week."

Day of the Week: Each day is associated with a planet whose symbol appears in the line above it (e.g., DDD for Moon: Moonday)

Eclipse: The time of greatest eclipse is given, which is near to, but not at the exact time of the conjunction $(\mathfrak{O} \sigma \mathfrak{D})$ or opposition $(\mathfrak{O} \mathcal{S} \mathfrak{D})$. See "Eclipses" (p. 22).

Aspects $(\Box \triangle \& \sigma + \pi)$ are listed in fine print under the Moon sign each day, and show the angle of relationship between different planets as they move. Daily aspects provide something like an astrological weather forecast, indicating which energies are working together easily and which combinations are more challenging.

Transits are the motion of the planets and the moon as they move among the zodiacal constellations and in relationship to one another

Ingresses (\rightarrow) : When the Sun, Moon and planets move into new signs.

Moon "Void of Course" (\mathbb{D} v/c): The Moon is said to be "void of course" from the last significant lunar aspect in each sign until the Moon enters a new sign. This is a good time to ground and center yourself.

Super Moon: A Super Moon is a New or Full Moon that occurs when the Moon is at or within 90% of perigee, its closest approach to Earth. On average, there are four to six Super Moons each year. Full Super Moons could appear visually closer and brighter, and promote stronger tides. Personally, we may use the greater proximity of Super Moons to illuminate our inner horizons and deepen our self-reflections and meditations.

Apogee (ApG): The point in the Moon's orbit that is **farthest** from Earth. At this time, the effects of transits may be less noticeable immediately, but may appear later. Also, **Black Moon Lilith**, a hypothetical center point of the Moon's elliptical orbit around the

Perigee (PrG): The point in the Moon's orbit that is **nearest** to Earth. Transits with the Moon, when at perigee, will be more intense.

Earth, will be conjunct the Moon.

8

Equilibrium © Gaid Orion 2014

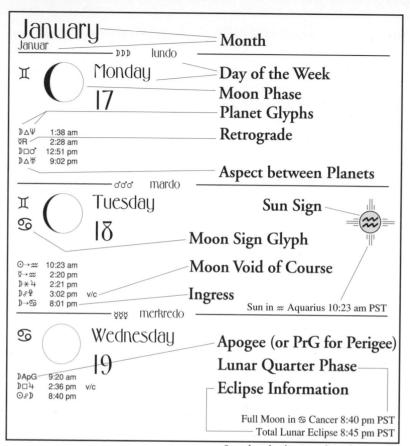

Sample calendar page for reference only

Lunar Nodes: The most Northern and Southern points in the Moon's monthly cycle when it crosses the Sun's ecliptic or annual path, offering to integrate the past (South) and future (North) directions in life.

Aphelion (ApH): The point in a planet's orbit that is **farthest** from the Sun. At this time, the effects of transits (when planets pass across the path of another planet) may be less noticeable immediately, but may appear later.

Perihelion (**PrH**): The point in a planet's orbit that is **nearest** to the Sun. Transits with planets, when they are at perihelion, will be more intense.

Direct or Retrograde (D or R): These are times when a planet moves forward (D) or backward (R) through the signs of the zodiac (an optical illusion, as when a moving train passes a slower train that appears to be going backward). When a planet is in direct motion, planetary energies are more straightforward; in retrograde, planetary energies turn back in on themselves and are more involuted. See "Mercury Retrograde" (p. 22).

© Mother Tongue Ink 2000

CONSTELLATIONS OF THE ZODIAC

These stations of the zodiac were named thousands of years ago for the constellations that were behind them at the time. The signs of the zodiac act like a light filter, coloring the qualities of life force. As the Sun, Moon and other planets move through the zodiac, the following influences are energized:

Aquarius (Air): Community, ingenuity, collaboration, idealism. It's time to honor the philosophy of love and the power of community.

H Pisces (Water): Introspection, imagination, sensitivity and intuition. We process and gestate our dreams

T Aries (Fire): Brave, direct, rebellious, energized. Our inner teenager comes alive; our adult self needs to direct the energy wisely.

8 Taurus (Earth): Sensual, rooted, nurturing, material manifestation. We slow down, get earthy, awaken our senses, begin to build form, roots, and stubborn strength.

I Gemini (Air): Communication, networking, curiosity, quick witted. We connect with like minds and build a network of understanding.

- **Solution** Cancer (Water): Family, home, emotional awareness, nourishment. We need time in our shell and with our familiars.
- **A** Leo (Fire): Creativity, charisma, warmth, and enthusiasm. Gather with others to celebrate and share bounty.
- **W** Virgo (Earth): Mercurial, curious, critical, and engaged. The mood sharpens our minds and nerves, and sends us back to work.
- △ Libra (Air): Beauty, equality, egalitarianism, cooperation. We grow more friendly, relationship oriented, and incensed by injustice.
- **11.** Scorpio (Water): Sharp focus, perceptive, empowered, mysterious. The mood is smoky, primal, occult, and curious; still waters run deep.
- ✓ Sagittarius (Fire): Curiosity, honesty, exploration, playfulness.

 We grow more curious about what's unfamiliar.
- **18** Capricorn (Earth): Family, history, dreams, traditions. We need mountains to climb and problems to solve.

adapted from Heather Roan Robbins' Sun Signs and Sun Transits © Mother Tongue Ink 2016

SIGNS AND SYMBOLS AT A GLANCE

PLANETS

Personal Planets are closest to Earth.

⊙Sun: self radiating outward, character, ego

D Moon: inward sense of self, emotions, psyche

♥ Mercury: communication, travel, thought

Q Venus: relationship, love, sense of beauty, empathy

Mars: will to act, initiative, ambition

<u>Asteroids</u> are between Mars and Jupiter and reflect the awakening of feminine-defined energy centers in human consciousness.

Social Planets are between personal and outer planets.

4 Jupiter: expansion, opportunities, leadership

ት Saturn: limits, structure, discipline

Note: The days of the week are named in various languages after the above seven heavenly bodies.

E Chiron: is a small planetary body between Saturn and Uranus representing the wounded healer.

Transpersonal Planets are the outer planets.

以 Uranus: cosmic consciousness, revolutionary change

Ψ **Neptune**: spiritual awakening, cosmic love, all one

E Pluto: death and rebirth, deep, total change

ZODIAC SIGNS

T Aries

8 Taurus

I Gemini

S Cancer

A Leo

11 Virgo

M Scorpio

Sagittarius

18 Capricorn

★ Aquarius

> Pisces

ASPECTS

Aspects show the angle between planets; this informs how the planets influence each other and us. We'Moon lists only significant aspects:

of CONJUNCTION (planets are 0-5° apart)

linked together, energy of aspected planets is mutually enhancing

8 OPPOSITION (planets are 180° apart)

polarizing or complementing, energies are diametrically opposite

Δ TRINĔ (planets are 120° apart)

harmonizing, energies of this aspect are in the same element

☐ SQUARE (planets are 90° apart)

challenging, energies of this aspect are different from each other

★ SEXTILE (planets are 60° apart)

cooperative, energies of this aspect blend well

↑ QUINCUNX (planets are 150° apart)

variable, energies of this aspect combine contrary elements

OTHER SYMBOLS

D v/c-Moon is "void of course" from last lunar aspect until it enters new sign. ApG-Apogee: Point in the orbit of the Moon that's farthest from Earth. PrG-Perigee: Point in the orbit of the Moon that's nearest to Earth. ApH-Aphelion: Point in the orbit of a planet that's farthest from the Sun. PrH-Perihelion: Point in the orbit of a planet that's nearest to the Sun. D or R-Direct or Retrograde: Describes when a planet moves forward (D) through the zodiac or appears to move backward (R).

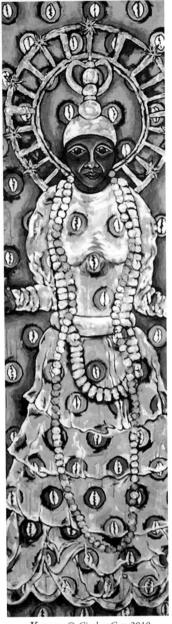

Yemaye © Cinders Gott 2010

ASTROLOGICAL OVERVIEW: 2020

The personal is political. In 2020 the stars ask us to pay attention to our spiritual life and relationships, but always remember they are embedded in the body politic, and the body politic needs our help. Our spirituality must feed into community and community organizing to help us build a healthier world. Jupiter and Saturn both conjunct Pluto in structural Capricorn, one after the other, and then finish up the year conjunct with one another in collaborative Aquarius on the Winter Solstice. We have a chance to turn things around, but we need to stay awake, aware and involved.

As Jupiter, Saturn and Pluto run together, they bring an opportunity for death and rebirth of power systems and political structures throughout the world; but it may get messy before it gets better. Pluto brings revolution to the nature of the sign it occupies by exposing its shadow side; 2008–2024 Pluto in Capricorn asks us to look at the abuse and use of political power, nuclear and fossil fuel power, gender-based authority, tradition, honor and responsibility. Pluto now approaches its first return to its position during the American Revolution, perfecting in 2022.

Jupiter—connected to liberal politics is expansive and speaks of generosity,

abundance and codependence. Saturn—connected to conservative politics—contracts and speaks of structure, tradition, discipline, restriction, control. A balanced tension between the two influences holds us upright. Every 20 years we have a great conjunction

between these two; since the American Revolution, every great conjunction brought to the USA a presidential term where the presidency underwent attack or stress—often precipitated a healthy bipartisan response. This year, in Aquarius, that conjunction calls for a philosophical rebirth.

Mercury usually retrogrades for three weeks, three times a year; this year's dates are 2/16–3/9, 6/17–7/12, and 10/13–11/3. On voting day in the USA, it appears stationary direct, which can precipitate problematic confusion, close votes and recounts. During this year, in which we need to overhaul systems that serve the community, let's advocate for transparent, efficient voting systems around the globe, and vote early in the USA.

On January 10, Uranus turns direct under a full moon and lunar eclipse in Cancer, which can pivot change both at home and in work. Saturn conjuncts Pluto on 1/12, and begins a breakdown of old structures. It also asks us to investigate what makes us secure, the health of our bones and teeth, the foundations of our house and our work. Watch out for power trips on every level.

Jupiter sextiles Neptune repeatedly this year—2/20, 7/27 and 10/12—renewing our sense of hope, helping us imagine a better future. This soft, intuitive, potentially escapist aspect can make us lazy or can make is visionary; it's up to us to use it well. Seek visions.

Saturn encourages us to step into a more collaborative, less authoritarian approach, as it steps out of Capricorn and into Aquarius 3/21, retrogrades back into Capricorn 7/1, and reenters Aquarius 12/16. We need to keep our philosophies alive and compassionate, not just impose a new system that still doesn't listen to the people.

Jupiter calls for introspection on the political left as well as the right, as it conjuncts Pluto at 24° Capricorn 4/4, 6/29 and 11/12. Jupiter maximizes whatever it touches; and here it increases the Hecate-Kali work of revolution, transformation, death and rebirth. We can use this to create a liberating time, or experience control issues. Some incident could call us to face our fears of mortality and move past them into a bigger acceptance.

Truth will out; the search for honesty becomes a spiritual practice. We may be surprised and transformed by a new perspective which precipitates change, triggered by a full Sagittarius lunar eclipse. The moon squares Mars in Pisces on 6/5. All of this is echoed and magnified by a total solar eclipse 12/14, with Sun and Moon at 23° Sagittarius, and Mercury 20° Sagittarius. These eclipses ask us to examine our personal illusions, check our truths, and speak them aloud; we can demand truth, but can't rush to a new conclusion or simplify reality. World events or personal issues call us to move out of victimhood and into a deeper understanding, deeper compassion, and compassionate action.

As the year closes, the stars bring it home to us that our personal lives are intricately woven into our community, our community into our country, our country into the global present. As we face the realities of environmental troubles and seek collaboration to solve them, as we face health and economic issues which stem from our interwoven connection around the globe, we become acutely aware of this interconnected global community and our place in it. Saturn enters collective, cooperative Aquarius 12/16; Jupiter enters Aquarius 12/19; and at winter solstice on December 21, they join for the great conjunction for the first time since 2000. Aquarius turns our vision outwards and asks us to hold hands, to look at how we structure our families, circles, teams, society and global community. We are encouraged to form and expand spiritual and political circles, and find collaborative answers in cohousing and community investment.

This Capricorn/Aquarius nexus works in systems. Like the roots of trees within a forest, our psyches and our daily living conditions touch one another throughout the globe. We become deeply aware of our human role in the ecosystem, and can begin a great effort to transform that role. This conjunction encourages us to work together to investigate, address and heal systemic racism and gender assumption, systemic inequality, systematic abuse of our mother Earth.

As our eyes turn outward, we may neglect our more intimate relationships unless we remember to truly hold hands and feel one another's hearts. As the stars call us outwards, it's up to us to choose and treasure interpersonal sensitivity and emotional connection.

2020 ASTROLOGICAL ASSIGNMENTS

2020 eclipses in Sagittarius trigger new honesty, and this honesty encourages us to restructure the systems of power while Saturn and Jupiter conjunct Pluto in Capricorn. By the end of 2020, Jupiter and Saturn enter Aquarius and empower us to integrate an authentically

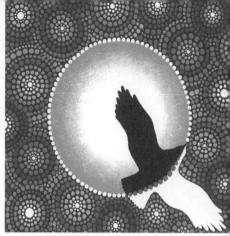

Spirit Wings © Elspeth McLean 2011

collaborative philosophy. We can hear a clue to our assignment in this great work through the signs of our Sun and ascendant. Each month, as the Sun changes signs, we all may feel the call of that sign.

Aries: Your assignment is to embrace responsibility and model healthy and positive authority. Speak from a place of strength and confidence, rather than defiance, when wrestling with other powers. Look for a new understanding about how you learn and communicate, as you may need to publish and network to get the word out. Build the infrastructure and networks needed so you can relax into the new organization by 2021.

Taurus: You may get a unique perspective about how shared resources are being utilized, how money is handled behind-the-scenes, or how sexual politics affects fair distribution. Speak up. Don't be discouraged, but steadily push to evolve the system, whether it's your circle, community, or international organization. Find connections in the larger global community with common interests. Your integrity and effort can help your work grow more meaningful in the future.

Gemini: You're multifaceted, and can use your versatile communications to weave together unusual allies into a healthy network. But be honestly who you are rather than bend to fit others' desires, whether in work, love, or community partnerships. If this honesty exposes unconscious power struggles around money and resources, keep the conversation flowing—just dig deeper to make sure you have the whole truth. Do the homework and your world will expand in the years ahead.

15

Cancer: Take inventory of your helpfulness; notice where you enable. Bring fresh air to any dysfunctional places which drain you and test your health. Encourage beloveds, believe in them, but let them do their own work, and then bring this energy out to a larger scope. When your boundaries feel clean and strong, you can let people closer in. By year's end you won't have to hold the line so intensely; new relationships grow more collaborative and supportive.

Leo: Inspire! You may have hidden your creative flow recently, feeling upstaged by hard work or potentially learning new skills or because of responsibilities to health. Be honest about your talents, let go of what does not grow corn, and pursue those hidden sparks within. Look at your natural creativity and charisma, and offer that in service. Your life force improves when you feel needed and effective. In return, your community expands and steadies.

Virgo: You have a rich and thoughtful philosophy; reassess it, and bring it home. Critique, but stay focused on the healing goals, both in your personal life and the world at large. Walk your talk in daily life, and find your relationships to animals and beloveds become more clear, clean, and energizing. Your creativity is strong, but needs you to choose discipline; give it time to manifest, and do it for the sake of all.

Libra: Take the pressure off family tensions this year. You have a natural inner gauge around social justice, so bring your eyes and tactful approach to the problem. Help educate. You know that inspiring information delivered without a strong personal torque, facts rather than opinion, open more minds. Lovingly help those around you become more aware of the vestiges of racism, internalized gender issues, and encourage sisterhood. Your creativity flows in response.

Scorpio: Ask what community resources need to be mobilized and what needs to be conserved. You aren't ruthless, but may see more clearly what surgery is necessary to create sustainability. Others may engage in personality struggles to control the situation, but you don't have to take the bait. Keep the focus on effectiveness, not ego, and hold clean boundaries for those less able. You feel more at home on the other side of this reorganization.

Sagittarius: Sometimes it can be hard for you to forgive yourself, so you don't look under all the rocks. Go for it! Let go of some preconceptions about yourself and about what you do or don't have to offer the world—find a new, empowering authenticity. Deal squarely with tough practicalities. From this integral place, heed the call to help your community get honest about, and improve on, their relationships to financial and ecological resources.

Capricorn: Be honest about how much you have actually healed and about what still needs work in your psyche; you've been in deep evolution and may need to reassess how far you've come. Be who you are now. Adjust to a more congruent sense of personal responsibility. This frees you up to offer healthy leadership while empowering others. Put your special gifts to service cultural responsibility, and find fresh reliable camaraderie.

Aquarius: If you've been holding on to an old image of community or sense of belonging, new realizations help you let go of what *was* so you're more open to *what is.* You learn much vicariously this year, walking friends and community through their challenges, and working through some personal inner demons in the process. Out of this work arises the potential for a stronger sense of self, woven into a refreshed

and dynamic community.

Pisces: You see that the emperor has no clothes on, where people in authority, both close to home and nationally, are not in their integrity. Your assignment is to say what you see in an effective way, and to grow that integrity within people and systems. Sometimes your fellow collaborators may disagree on the goal; their job may be to fight, yours is to hold the vision for a positive future and to guide those steps forward. Inner peace grows in response.

Heather Roan Robbins © Mother Tongue Ink 2019

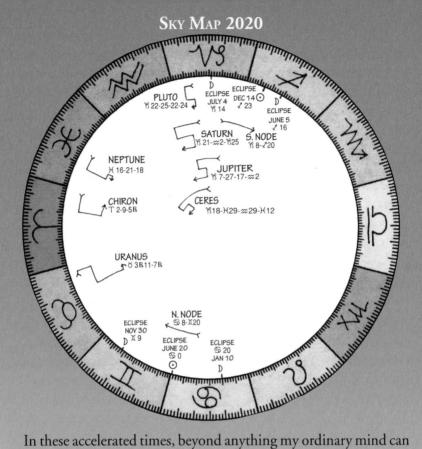

In these accelerated times, beyond anything my ordinary mind can comprehend, I look to the skies for navigational advice. Hoping to engage every sense, every source of understanding, with my finger I trace the path of each planet in this 2020 Sky Map. I am comforted—perhaps this simple ritual, repeated every so often this year, will connect me with the grander, wiser perspectives of these starry overseers.

My fingertip encounters hope and opportunity as I trace the path of **Jupiter**. **Saturn's** steady pressure holds me to ethical responsibility even if others aren't/can't/won't. **Pluto** pushes me to empower rather than overpower, as our worlds reorganize. My finger buzzes with brilliant resourcefulness as I follow **Uranus** in early Taurus. **Neptune** leads my finger to a quiet corner, whispering compassion and dreams of better times ahead

You hold in your hands We'Moon 2020, offering day by day, a steady stream of inspirational guidance from wise women all over the world. Take it in, through all of your senses. And in those wobbly moments, return to this map and let your finger remember the way forward.

ASTROLOGICAL YEAR AT A GLANCE INTRODUCTION

smash yourself open. search for the seeds of liberation within you. do not give up, search. there! pluck these tiny warriors from the tender fat of yourself and plant

them in the earth for safekeeping. go find the other smashed ones.

Hathor Pours Cosmology
© Lindy Kehoe 2017

pluto and jupiter meet in capricorn three times in 2020; three times you may experience the miracle of remembering. get your presence practices on point—you need them now. you must learn to listen to what has come before you, so you can weave a coherent present and co-create a radiant future. capricorn is about putting in the work, your own brilliant, unique work. expect resistance from within yourself; learn to swallow it whole and continue on.

2020 offers us wisdom to see that we are crucial co-creators of past/present/future. in this year of recall and recognition, we must transmute oppression as it lives within us, within our lineage, and within our homes. move with integrity!

within and within and within. and again.

the pressure is high, the dials are turned up. stay present as best you can and remember: this will not last forever. by year's end saturn and jupiter will move from capricorn into aquarius like a sigh. the intense, visceral work of pluto, saturn, and jupiter in capricorn will lead us into a time of revolution, expansion, and reformation in aquarius. rebuild yourself from the inside out so you have the strength needed to nourish the future you desire.

blessings!

naimonu james © mother tongue ink 2019

p. 45

ay p. 57

p. 69

p. 79

al p. 105

p. 119

p. 131

p. 135

p. 145

p. 155

p. 167

i use all lowercase because i prefer it.

to learn more about astrological influences for your sign, find your sun and rising signs in the pages noted to the right.

ALCHEMY IN 2020: THE SATURN / PLUTO CONJUNCTION

The Planetary Elements

† **Saturn's** archetype wields the sickle of time, a binding force for setting limits.

With a commitment to purpose, and the cultivation of wisdom, Saturn maintains the precedents for abiding in the finite world. It tests our moral compass, and reforms our social responsibilities.

Pluto, known in myth as the overlord of the underworld, symbolizes the dilemmas of dualism and life's reversals.

As a catalyst for turning points of change, Pluto evolves us, into the soul of the collective and the infinite.

The Alchemical Brew

2020 begins with a jolt from pressures of the times when Saturn and Pluto conjoin at 22° Capricorn on January 12th. It will be a wake up call that echoes throughout the year and beyond. Listen up. Three times each century these planets align with symbolic synergy as we reset our collective agenda. The previous 1982–83 Saturn/Pluto cycle in Libra brought some sobering realities: a retreat into nostalgia and narcissism; catalyzing global terrorism; the unencumbered rise of the uber rich; economic instability; the Internet of Things; and a resurgence of nationalism in a post-truth world. These are some of the nested dilemmas setting the stage for this next transformative cycle, lasting until 2045.

In Capricorn, Saturn and Pluto represent the karmic forces that will expose ethical abuses by authoritarians in power, precipitating economic insecurities and moral outrage. The entrenched interests of the moneyed class, the plutocrats, hold many hostage in a predatory capitalism resulting in mass indebtedness. The industrial age has run aground, breeching the limits of our climate's capacities and our own conscience. We have altered the nature of Nature by the indiscriminate overconsumption of Earth's resources, and with the wastelands of our leavings. Time throws no lifelines to generations now emerging in peril of traumatic ill health. Undermined by the effects of electromagnetic radiation, chemical toxicants, living in cyber-centric cultures and alienated from nature, how many are sabotaged at birth?

20

March into April, Mars activates our survival drive when it joins with Jupiter, Saturn and Pluto, and our voices grow louder with urgency for government accountability and human rights. On April 4th, June 29th and November 12th, Jupiter, planet of social justice, conjoins Pluto while dire climate changes and global weaponization displace millions of people into migration, and we face the snares of scapegoating. Rulings from the high courts tip the scales of our tolerances. The US presidential election may fuel paranoia and polarization with the fervor of an un-civil political war. On Winter Solstice, December 21st, Jupiter and Saturn conjoin at 0° Aquarius. This 20 year cycle offers shifts in dynamics for social participation and group identity. Realign reactivity.

The Cauldron of Our Better Angels

During transit periods
adapt this ceremonial offering
for personal or community use.
Call forth the image of a wondrous bowl
that transmutes the alchemical brew
of our dysfunctions with grace.

Bring love. Invite callings from all the directions. Visualize a Cauldron of Our Better Angels, and circle round with the courage to confront our despair. Evoke our release from the trances and shadows keeping us in fear and separation. Allow space for grief to flow. Tap into gratitude. Imagine that our interconnected intent can support healthy social cohesion with goodwill as the glue and integrity as a strategy. May we realign our collective energies and let the gritty bits of patriarchal overload that threaten to diminish our species, loosen their grip. Through this redemptive power we may liberate ourselves from otherness to oneness. Lying in wait within our human hearts, fresh seeds of possibility emerge, as we come to inhabit a new mind, a new body, a new story. Let us become the critical mass of caring awareness that lives on to re-symbolize our dance of survival and renew the face of the Earth.

Be the momentum.

ECLIPSES: 2020

Solar and Lunar Eclipses occur when the Earth, Sun and Moon align at the Moon's nodal axis, usually four times a year, during New and Full Moons, respectively. The South (past) and North (future) Nodes symbolize our evolutionary path. Eclipses catalyze destiny's calling. Use eclipse degrees in your birth chart to identify potential release points.

January 10: Penumbral Lunar Eclipse at 19° Cancer opens us to watery, dreamy realms where healing can happen. Expose your heart

to the wonders of wholeness. Be well.

June 5: Penumbral Lunar Eclipse at 15° Sagittarius fires up our questioning mind, asks us to aim for moral high ground. As the light returns find mutual learning opportunities to spread shared wisdom.

June 20: Annular Solar Eclipse at 0° Cancer releases memories of who we used to be. Let the returning light feed the emergence of your

wings. Let fresh parts of yourself flutter into being.

July 4: Penumbral Lunar Eclipse at 13° Capricorn commits us to retracing our steps. As the light returns make your path holy ground.

November 30: Penumbral Lunar Eclipse at 8° Gemini reminds us:

by our example, we will be known—honesty speaks volumes.

December 14: Total Solar Eclipse at 23° Sagittarius highlights our desire for influence and meaning. Let the returning light spread your cultivated wisdom. Exchange views and enlighten hearts.

MERCURY RETROGRADE: 2020

Mercury, planetary muse and mentor of our mental and communicative lives, appears to reverse its course three or four times a year. We may experience less stress during these periods by taking the time to pause and go back over familiar territory and give second thoughts to dropped projects or miscommunications. Breakdowns can help us attend to the safety of mechanics and mobility. It's time to "recall the now" of the past and deal with underlying issues. Leave matters that lock in future commitments until Mercury goes direct.

Mercury has three retrograde periods this year in water signs:

February 16-March 9: Mercury's retrograde in Pisces reminds us to revisit dreams and release our tears, regrets and best laid plans. When it goes direct again, renew with what feeds your soul.

June 17–July 12: When Mercury retraces steps in Cancer, look for cracks in the hard shell of protective attachments that keep you stuck. When direct

again, emerge in greater awareness into your circle of kinship.

October 13-November 3: Take time when Mercury retrogrades in Scorpio to investigate your underlying motivations. When Mercury goes direct again, allow space to have the real conversations.

THE YEAR OF THE RAT 2020

The Year of the Rat begins on the new Moon of January 24th. (Chinese New Year begins the second new Moon after Winter Solstice.) Rat year is a time of abundance, plenty and good fortune, because Rat is considered a very lucky astrology sign. Rat year is also the time for a new beginning in life, because Rat is the first sign of the Chinese zodiac.

Now is an ideal time to start planning to achieve your goals. Ventures begun in a Rat year are fortunate, but only if well planned. This is not the year for spontaneous adventure or high risk.

Social Rat loves the pack, making Rat year the best time to work collectively. Rat is a doer who cares about performance, progress and reward. Anticipate scientific discoveries, medical breakthroughs and technological inventions. Creativity flourishes, with advancement in everything from artificial intelligence to soil analysis on Mars.

Rat year is always about money, like the last Rat year, 2008—the Great Recession. This year has an even stronger focus on financial markets, wealth and real estate, because it's a Metal year. There are five Taoist elements: Fire, Earth, Metal, Water and Wood; 2020 is the year of the Metal Rat. Metal represents money, so anticipate fluctuations in world economies. There can be a financial reset of rich and poor, with more people raised out of poverty. Metal also represents weaponry, and Rat year can bring collective militarization.

Wemoon born in Rat years (1912, 1924, 1936, 1948, 1960, 1972, 1984, 1996, 2008, 2020) are smart, sharp, funny gals who are highly perceptive. They are excellent at analyzing data to arrive at the correct conclusion, and can quickly figure out how to solve problems. Their quick wit and style makes them popular, and they can be very delightful when they turn on the charm. But a Rat wemoon won't reveal her true feelings if they block her success. Even the shyest Rat can be competitive, ambitious and calculating because Rat wants to win.

Rat correlates to the Western, sign Sagittarius. Rat is most compatible with another Rat, Ox, Dragon and Monkey. The element Metal is associated with the lungs in Chinese medicine, so take care of your lungs this year, especially in autumn.

WAKE UP HERBS

In these turbulent times, my instinct was to focus on herbs that stimulate and enliven us for this Wake Up Call edition of We'Moon. These herbs (like caffeine) say, "Do better faster! Adjust your body to an ever changing and often stressful environment." Even better: Let's go

for deep nourishment, gentle restoration, and sustainable energy, while building the capacity to nourish others. We can use plants to bolster us as we combat the toxic forces of Patriarchy, Late Stage Capitalism, and White Supremacy. My hope is that you not only use herbal powers to support your activism, but that each of us, using whatever privilege and accessibility we have, will share these herbs and insights with others within and outside of our own communities. Equity in herbal medicine!

For sustainable support and grounded stability, let's nourish ourselves gently and deeply. Nutrition and movement are always first, right? Then, supplement with an adaptogen that sustains your life energy. Ashwagandha is a traditional plant native to India and common in Ayurveda medicine. Taken tonically, it can improve memory and regulate blood sugar; it is anti-inflammatory and lowers cortisol-a hormone of chronic stress that is not your friend. Or look below your feet, get grounded, and relish the effects of medicinal mushrooms. Chaga, Cordyceps, and Reishi powerfully boost your immune system, keeping you strong and healthy in the fight against racism and sexism gone viral. Nourish with nettle, have dinner with dandelion, attend to yourself with alfalfa, cleanse with clover, chill out with oat straw. Grow your own and share with your neighbor.

If you do need just a quick pick-me-up, pinch an orange or lemon peel under your nose. The scent boosts your serotonin (the happy hormone) and lowers norepinephrine (another stress hormone).

Our responsibility to redistribute resources includes herbs and health, both personally and communally—for our children, for the planet—and is paramount in the fight for justice: I am only truly well when all women are well.

TAROT CARD #20: JUDGMENT

Look down at your feet, flat on the earth. We each have come so far in our journeys, and Judgment calls on us to truly "meet ourselves," to confront our decisions, our imperfections, and decide where to walk next. This is a card of both inaction and decisive intentional forward movement.

Judgment is a door half ajar—opening into darkness. Judgment is a fork in the road, a crossroads where we are faced with a choice. Do we walk the path we've walked before, circling back to the Fool's beginning, carving our footsteps into the Earth? Or do we take a path we cannot yet see? This dark and beautifully mysterious path leads us to the last archetype in the major Arcana—The World—there is no exit here; to enter through this door we must be ready. The Judgment card invites us to step back and truly ask ourselves the hard questions. These are the breaths you take before you jump off the high dive, or quickly scamper back down the ladder to solid ground.

What have we learned? What do we need to improve on? Has our perception of reality clouded the truth, or are we clearly seeing through static? When Judgment steps out before us, She challenges us to think deeply about our situation. Is there any other answer or viewpoint we missed? Reach out into the world; step into the footsteps of your neighbor, lover or enemy—see through their eyes. Do they think differently than we do, and is it wrong if so? Can we accept and honor the choices of others while still honoring our roots and our truth? Plant your feet firmly to dig into these answers.

We stand and stare at the door we can only see through if we open it. This is our choice—to walk the familiar old path of patterns and history or step though into a beautiful unknown. We can only walk forward if we are ready and open to difficulty, to doing what is right and not always what is easy. It is time to look at ourselves objectively and peel away the veils of false perception—discern what is real. We are

calling our Truth to step forward. Are you ready to open the door and walk through?

Leah Markman © Mother Tongue Ink 2019

Cannabis Goddess Blessing © Katalin Pazmandi 2017

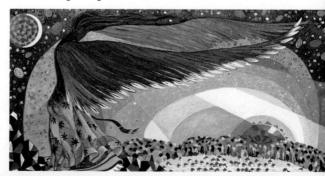

STAR COUNCIL

What if you had a council of personal advisors available 24/7 to guide you through these intense, uncertain times? You do! Your astrological chart is a geometric portrait of the living forces of your own Star Council—the Sun, Moon and planets.

Who are these planetary advisors, and what wisdom do they offer? Sun lights up your path and fuels you with purpose. Moon helps you feel, brings comfort when stressed. Venus opens you to love and to be loved. Mercury assists you in giving and receiving information. Mars is your courageous warrior who pursues what you desire. Jupiter points to greater horizons and gifts you with hope. Saturn advises how accomplishment and authority are best cultivated. Chiron shape-shifts your challenges into healing tools. Uranus is your wild genius. Neptune is your portal to spirit and your imagination. Pluto's x-ray eyes reveal what is essential, and what must change or die.

How do you contact your Star Council? It can be as simple as standing in a circle of post-its representing the 12 signs of the zodiac, surrounded by cards/objects/stones representing the planetary characters, in the positions where they are found in your birth chart.

Place your Rising sign card on the floor to the East, your left, then lay out the rest of the 12 zodiac signs to complete a counterclockwise circle. East will be on your left, West on your right, South in front of you, North behind you. Now place the planets you see above the horizon in your chart to the South—in front of you—and those below the horizon to your North—at your back.

The energetic field created by this circle is a very potent space—treat it with respect by entering and leaving the circle with intention (best via your Rising sign). Ask permission and offer gratitude. Stay alert, use all your senses to connect with your council. Bring in meditation or movement, journaling, art or drumming. Note clusters of planets and patterns they create with each other—everything has meaning, all offer some pieces of wisdom.

Native peoples and spiritual seekers around the world have used circles forever as portals to go beyond the limits of what our everyday minds can understand or perceive. Astrologers use astrodrama,

astroshamanism, experiential and embodied astrology to understand the human experience via its synchronicity with celestial patterns and cycles.

When I'm working with people new to astrology, I organize the signs into the four basic elements: Fire, Earth, Air and Water. I use red paper, pen or paint for the three Fire signs, Aries/Leo/Sagittarius; green to designate Earth signs, Taurus/Virgo/Capricorn; yellow for Air signs, Gemini/Libra/Aquarius, and blue for Water signs, Cancer/Scorpio/Pisces. Beginners will connect with their Venus in Leo more readily when they experience her as Fire: hotheaded and active, attracted to passion and daring.

When I taught high school astrology, we had fabulous times playing with ordinary objects as planetary representatives. A potato peeler became Pluto, a spark plug was Uranus, Venus a mirror, Mercury a phone. Saturn had a ruler, Jupiter binoculars

I've created cards with symbols, colors and keywords for each planet, and collected stones, marbles and crystals to represent the planets. I've collaged cards with gathered images. Several classes created masks or headdresses for each of the planets and then embodied each other's council.

Over time, and with playful reverence, I've witnessed magic, even

miracles, in Star Council encounters. I've lost the sense of being alone, in sole charge of my fate and destiny. I've come to understand that I am a necessary and valuable member of some grander, wiser universe. I wish the same for you. Gretchen Lawlor © Mother

Tongue Ink 2019

For more information about the different influences of the planets and signs, see pages 10, 11 & 204

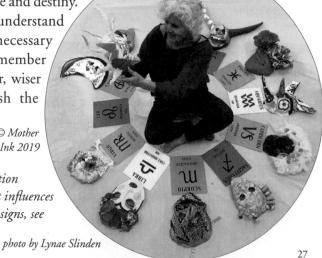

WHO WILL INHERIT THE EARTH? A WAKE UP CALL!

We'Moon 2020: Wake Up Call The ancient question rings now with radical new alarm! Can the earth be passed on intact to any human beings beyond ourselves?! At the time of this writing, the latest UN report by climate scientists has concluded that we have until 2030, at the current rate, before the cataclysmic consequences of climate change are irreversible, and our life support systems collapse. All of us currently alive on the planet today are collectively responsible for the answer to this question—in our lifetime! How we respond to this Wake Up Call, individually and collectively—here and now—will determine the outcome in the next decade.

The sustainability of life on Earth is hanging in the balance. The good news is that the cycles of nature regenerate, and have maintained eco-logical balance in the web of life for 3.8 billion years. What comes around, goes around. Life is continually transforming. The most difficult passages are in the dark moon phase at the end of one cycle, when things fall apart, and the new cycle of growth is just beginning. The pain and suffering of dying and letting go, like the labor pains of birthing new life, are part of the dark moon phase between life cycles. Women have long been the priestesses and midwives of this mysterious realm: the womb/tomb cauldron of deep transformation. What is the Goddess teaching us now?

2020: 20/20 Vision. Can you read the writing on the wall? We may not be able to see clearly what's right in front of us, but if we stay present, we can begin to sense the unknowns in the dark. Far-sightedness and intuitive experience broaden our perspective. Knowing where we are in the larger cycles of transformation, and understanding the influences bearing upon us (personally, politically, planetarily, spiritually), we can get through this dark moon phase. Is this roiling cauldron of transformation a sign of a flailing system about to go down? . . . and/or of labor pains birthing another more life-affirming way of being?

We'Moon 2020 / Tarot Card XX, Judgment: Judgment is a double-edged sword of truth. Discernment tries to slice through illusion; judgmentalism may obscure reality. In this

dissociated Age of (dis) Information, perception of truth is not necessarily anchored in anything besides individual identity, opinion and beliefs. Who has the power to define reality for whom? Inventing truth has become a new weapon of mass destruction for those in power. The system of male dominance and control over woman, nature, and all "others" feeds on conflict; it has metastasized from sexism to racism to classism to all intersecting oppressions that

Thunder Woman in the Far North

Sandy Eastoak 2010

pit one against another. Naming the source of this societal disease gives us power to fight the toxic system instead of each other. The systemic cause is finally being acknowledged and called out in public discourse by name: Patriarchy.

(XX) Judgment Call (XX+XX) 2020: the Future is Female!

Reverence for the Great Mother prevailed for eons of matriarchal time, interrupted by a few centuries of patriarchy whose time is up. What will it take for us to reclaim our female heritage—and be able to continue passing on the gifts of life? Conditioned "feminine" qualities that were devalued are needed now to be cultivated in everyone to heal the disconnects that we have inherited from the ruins of patriarchy. The impulse to reach out and "connect" with others, demonstrated predominantly by women, is an alternative to the endemic "fight or flight" response. Women are beginning to moonifest visions of a more just, fulfilling and life-loving paradigm—to rebalance human relations and restore the natural harmony among all beings. What roles do you want to play in creating more harmonious life on earth? What kind of earthly future do you want to pass on? It's your call!

INTRODUCTION TO THE HOLY DAYS

We are meaning-making animals, embedded with all of creation in circles of mutuality. In the modern world, it's easy to forget our connection to nature and to story. Ritual provides a gateway to the ageless cycles of planting, growth, harvest and winter sleep. As Earth passes through Her changes of weather, light and cosmic sky-drama, we re-member our kinship

with the world, as humans have always done. The Goddess we pray to is Mother Earth, that interdependent-brilliant-evolving Creation we're all a part of. Our rituals re-mind us of our harmony with Others, as we raise energy from the ancient, patient elementals and send conscious prayers spiraling forth, for life.

Ceremony, alone or with others, gives structure and order to our year. Holy Days are markers on the journey. Women's circles are the core of our feminist spiritual tradition. Gathered together we celebrate, finding deeper courage to feel our pain for the world's. We learn to witness this suffering so we can work to repair it. We're survivors of Post-Patriarchal-Capitalist-Stress Syndrome, where entire corrupt systems exist to compensate people with material bribes in exchange for giving up our ecstasy, our connection.

With every institution at the cliff-edge of ruin, creation and extinction are in a dead heat race. Will Earth's life support systems or the empires of capitalism crash first? How can we stay calm with so much beauty at stake? Earth-loving ceremony creates a way to elevate our imaginations, and live in the mythic terms of a larger story.

The most remarkable thing about this time in history, this wake up call, is not that we are destroying the world, but that we're beginning to awaken to a whole new relationship to the world, to ourselves and to each other. We gather together to turn the wheel. To sing songs of holiness. We shove, with all our collective strength, against this giant stone door of domination. From this space of communion with all, we can work to catalyze a mass psychic break and change the story. Oak Chezar © Mother Tongue Ink 2019

THE WHEEL OF THE YEAR: HOLY DAYS

The seasonal cycle of the year is created by the Earth's annual orbit around the Sun. Solstices are the extreme points as Earth's axis tilts toward or away from the sun—when days and nights are longest or shortest. On equinoxes, days and nights are equal in all parts of the world. Four crossquarter days roughly mark the midpoints in between solstices and equinoxes. We commemorate these natural turning points in the Earth's cycle. Seasonal celebrations of most cultures cluster around these same natural turning points:

February 2 Imbolc/Mid-Winter: celebration, prophecy, purification, initiation—Candlemas (Christian), New Year (Tibetan, Chinese, Iroquois), Tu Bi-Shevat (Jewish). Goddess Festivals: Brigit, Brighid, Brigid (Celtic).

March 19 Equinox/Spring: rebirth, fertility, eggs—Passover (Jewish), Easter (Christian). Goddess Festivals: Eostare, Ostara, Oestre (German), Astarte (Semite), Persephone (Greek), Flora (Roman).

May 1 Beltane/Mid-Spring: planting, fertility, sexuality—May Day (Euro-American), Walpurgisnacht/Valborg (German and Scandinavian), Root Festival (Yakima), Ching Ming (Chinese), Whitsuntide (Dutch). Goddess Festivals: Aphrodite (Greek), Venus (Roman), Lada (Slavic).

June 20 Solstice/Summer: sun, fire festivals—Niman Kachina (Hopi). Goddess Festivals: Isis (Egyptian), Litha (N. African), Yellow Corn Mother (Taino), Ishtar (Babylonian), Hestia (Greek), Sunna (Norse).

August 2 Lammas/Mid-Summer: first harvest, breaking bread, abundance—Green Corn Ceremony (Creek), Sundance (Lakota). Goddess Festivals: Corn Mother (Hopi), Amaterasu (Japanese), Hatshepsut's Day (Egyptian), Ziva (Ukraine), Habondia (Celtic).

September 22 Equinox/Fall: gather and store, ripeness—Mabon (Euro-American), Goddess Festivals: Tari Pennu (Bengali), Old Woman Who Never Dies (Mandan), Chicomecoatl (Aztec), Black Bean Mother (Taino), Epona (Roman), Demeter (Greek).

October 31 Samhain/Mid-Fall: underworld journey, ancestor spirits—Hallowmas/Halloween (Euro-American), All Souls Day (Christian), Sukkoth (Jewish harvest). Goddess Festivals: Baba Yaga (Russia), Inanna (Sumer), Hecate (Greek).

December 21 Solstice/Winter: returning of the light—Kwanzaa (African-American), Soyal (Hopi), Jul (Scandinavian), Cassave/Dreaming (Taino), Chanukah (Jewish), Christmas (Christian), Festival of Hummingbirds (Quecha). Goddess Festivals: Freya (Norse), Lucia (Italy, Sweden), Sarasvati (India).

* Note: Traditional pagan Celtic / Northern European holy days start earlier than the customary Native / North American ones—they are seen to begin in the embryonic dark phase: e.g., at sunset, the night before the holy day—and the seasons are seen to start on the Cross Quarter days before the Solstices and Equinoxes. In North America, these cardinal points on the wheel of the year are seen to initiate the beginning of each season.

© Mother Tongue Ink 2003 Sources: The Grandmother of Time by Z. Budapest, 1989; Celestially Auspicious Occasions by Donna Henes, 1996 & Songs of Bleeding by Spider, 1992

Introduction to We'Moon 2020

"Karma! Karma!" cries the Judgment Card—card #20 in Tarot's Major Arcana, and the symbolic underpinning for *We'Moon 2020: Wake Up Call*. Chickens come home to roost. We reap what we sow. The planet reels with catastrophe and crisis, heralding a plateful of just desserts for those who are hellbent on power and greed, refusing the humane imperatives for peace, justice and a sustainable earthhome. But it is not yet clear how and when the imperial bullies will be getting their due. Meantime, in this mean time, we the people, and all our relations, and the natural systems that support life, are suffering. As the prophet, Cassandra, insists on page 147, "Something's wrong. Something's very wrong." (Lucy H. Pearce).

We'Moon 2020 sets out to wake us, sometimes gently, sometimes with alarm, to our peril and our opportunities. This call summons and inspires us for the deepest, most loving and urgent rescue work we can imagine. From this year's Call for Contributions of Art and Writing: "We see with new eyes what we bring to the table of Transformation—as women from different cultures of origin, as women who live in and despite misogyny ... We urgently seek new possibilities for healing Earth and mending human community. Goddess-sight is here. 2020—Clear Vision."

2020 Vision sees far and beyond the visible. This collection is not, then, a book of gloom and doom, but an ingathering of devotional work grounded in earth-beauty and heart-hope. "Mokosh, Goddess of the Working Woman" (p. 70, Joanne Clarkson) can be counted on to bless seeds and dirt and effort. Girl energy takes brand new responsibility for a better world: "We are the ancestors of the future" (p. 65, Sophia Faria). There is fantasy that imagines society reborn; the passion of protest has verve and reverence: "Join a silent march for more snow and new glaciers" (p. 77, Lorraine Schein). Rage does not flinch from speaking its truth, but it dares to partner with the long view's focus on healing and renewal. On page after page, women are reframing the possible, honoring the unusual, rediscovering Love.

And on page after page, color and image lift us into extraordinary dimensions. Like our *Lioness* on the front cover, filled with discovery, we catch our breath, marvel that words and art so blend into new sensibility, surprising revelation. There is nothing quite like We'Moon, is there? This datebook is food for the spirit. Eat hearty. Enjoy a Wakeful feast.

Bethroot Gwynn © Mother Tongue Ink 2019

Sophia! Oshun! Goddesses of Wisdom! Steady us in your Temples of Discernment, even as this Earth quakes. Maat, clear the murky air with your Plume of Truth Hokmah, Spirit of Understanding, shine your Insight through fog of war Wake us to the moment of spirit-vision into the mystery of ally, enemy, beloved, stranger, self. Diké, Akonadi-Mothers of Justice. Themis, Lady of Good Counsel Give us your epiphanies of redress, balance, completion. The Harvest of Deeds is ripe. Reckoning has matured. We peer into our own verdict-mirror—Come clean Start fresh together to remake our precious, damaged world. Durga, Kali, Nemesis—Divine Avengers, Arbiters of Karma You dethrone the tyrant. You settle the accounts. Keep us fiercely creative as we stop oppression, defend earth-life. We call Tara, vast radical Sacred One Quintessence of Compassion, Liberation, Illumination You who dwell beyond Right and Wrong as passionate to forgive as to halt the brutal. Tara, Come to us. Keep our Actions Wise, our Hearts Open. Dare us, even in Emergency, to Trust Risk Heal Love © Bethroot Gwynn 2018

Call It In

Calling all forces for good, calling in the elemental energies, the spirits of the land and of the creatures that walk it, the spirits of the waters, and those that dwell within, the spirits of the air, and those who float and take wing on the wind. Calling to the ancient guardians of this planet, and of its peoples. Calling on the long-sleeping force of the "mythological" beings of old. Calling on the directions: North, South, East, West. Calling on the Above and the Below. Calling on Center. See us through this time in a powerful and protective way. Give us courage and inner calm, foresight and preparedness for the battles we are fighting, and wins for the ones that are ahead. Give us clarity to see the moments of peace, and to draw strength for our love and fortitude. Offer us answers in our dreams, and support in our waking. Calling on the Great Mystery, the benevolent powers of creation. Help us tap our higher calling, our magic and our bravery for the days to come, and for today.

© Earthdancer 2018

I. WAKE-UP

Moon I: December 25, 2019–January 24, 2020
New Moon in \$\mathcal{B}\$ Capricorn Dec. 25; Full Moon in \$\mathcal{B}\$ Cancer Jan. 10; Sun in \$\mathcal{A}\$ Aquarius Jan. 20

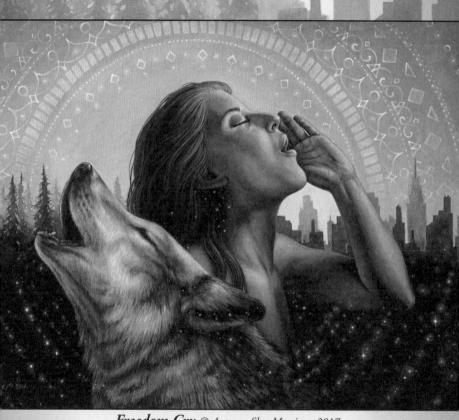

Freedom Cry @ Autumn Skye Morrison 2017

There is no mediator between goddess call and inspiration, so answer the call—in moonlight or sun.

excerpt \(\text{Kersten Christianson 2012} \)

December 2019

shí èr yuè

- ttt xīng qī liù

Saturday

Winter Solstice

2*4 3:14 am O*D 3:45 am D-111 4:57 am DUP 7:51 am

Dex 9:46 am D+4 12:20 pm ⊙→% 8:19 pm

Sun in Y Capricorn 8:19 pm PST

M.

- 000 lĩ bài rì Sundau

오□쌍 5:30 am O*P 6:32 am DAY 8:32 am Dxt 3:51 pm D*P 6:51 pm Dơơ 7:27 pm

- DDD XĪNG QĪ YĪ

M,

Monday

3□O 7:17 am D-1 8:34 am D×Q 4:37 pm

– ơơơ xĩng qī èr -

1

Tuesday

D□Ψ 12:56 pm ⊙∆₩ 1:44 pm

– ¥¥¥ xīng qī sān

1

Wednesday

D A は 6:45 pm の の D 9:13 pm Dag 3:18 am D-18 1:45 pm Do4 11:29 pm 4ApH 1:54 pm

New Moon in \(\cents \) Capricorn 9:13 pm PST

18

Thursday

- 444 XĪNG QĪ SÌ -

 $D \times \Psi$

7:23 pm

- PPP XĪŊ QĪ WŬ

18 22

Dot 4:08 am DOP 6:42 am Oơ4 10:25 am Friday

D*o" 1:03 pm D→ ≈ 9:20 pm

Gaia. Save Us

Earth's heart speaks in the wind, the moon, the stars, the flowers, the trees & the rivers, the fires. the lakes, the clouds and the ocean. "Wake up!" Earth says.

"Loosen your ears, your arms, your words, your singing.

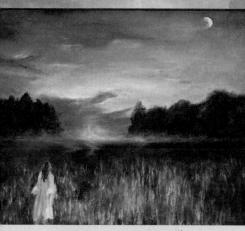

Relax your heart & wake to beauty & true freedom. Wake up! Look into my blue, green, brown eyes. Pay attention! Tell the truth! Wake up!

You can fix this if you try." excerpt @ Joyce McCallister 2018

Into the Mists © Melissa Harris 2013

the xīng qī liù

22

Saturday

DOW 2:32 am Das 6:07 pm 8:55 pm

.000 lĩ bài rì

22

Sunday

\$D\$ 8:57 pm

Dec. '19-Jan. '20

Ogrohacon / Poush

Monday 30

Dog 2:24 am $D \rightarrow H$ 7:41 am $D \times \emptyset$ 12:52 pm Dxy 1:04 pm ÅΔÄ 2:22 pm

D*4 8:37 pm

Datasha Stanton 2016

Raven's Breath

– ooo mongolbar -

 \mathcal{H}

⊙ + D 2:32 am DOY 4:15 pm Tuesday

- yyy budhbar -

 \mathcal{H}

Wednesday

January

Dxt 2:43 am DXE 4:38 am DApG 5:21 pm DAO 6:13 pm

- 444 brihospotibar -

8:00 pm

\$04 8:41 am D□4 10:19 am

D□ÿ 10:32 am ⊙□D 8:45 pm Thursday

999 sukrobar

Waxing Half Moon in TAries 8:45 pm PST

Friday

1:37 am D×Q

7:38 am Dot 3:49 pm

DOP 5:18 pm

Her Voice

For some She comes in a dream. For others in words as clear as a bell: *It is time, I am here.*

She may come in a whisper so loud She can deafen you, or a shout so quiet you strain to hear. She may appear in the waves or the face of the moon, in a red goddess or a crow.

The voice of She we were told did not exist, of She we were told not to trust. The voice of She we did not expect—ringing in the darkness, calling you home.

Who is She? She is your power, your Feminine source. Big Mama. Goddess. The Great Mystery. Web-weaver. The first time, the twentieth time, you may not recognize Her. You may pretend not to hear, as She fills your body with ripples of terror and delight.

But when She calls, you will know it. Then it is up to you to decide if you will answer.

© Lucy H. Pearce 2016

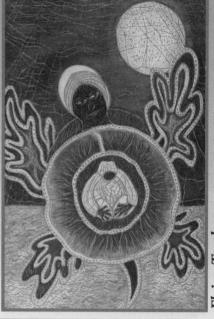

Flying Turtle @ Sandy Bot-Miller 2010

- the sonibar

8

Saturday 4

D→8 8:15 am D♂₩ 1:31 pm ¥ApH 8:08 pm D△4 11:20 pm

– ooo robibar

ŏ

Sunday 5

D△¥ 7:18 am ⊙△D 1:37 pm ♂△₺ 1:53 pm D★Ψ 4:15 pm January Sun The Sun and I have an Mí Eanair ppp Dé Luain agreement: No matter Monday what, it appears every day, ୪ on time. And it gives me the gift of the day. excerpt © Maria Strom 2017 $D \square Q$ 1:07 am DAt 3:07 am DAE 4:08 am $D \rightarrow II$ 6:11 pm ⊙*¥ 10:21 pm D&O 11:05 pm aga Dé Máirt Tucsdau I グ下∜ 12:13 am ggg Dé Céadaoin I Wednesday D□Ψ 12:27 am Ž¥Ψ 5:03 am DAQ 2:16 pm 444 Dé Ardaoin I Thursday D→95 12:43 am D*A 5:23 am D84 4:00 pm 999 Dé Haoine Friday 9 DAY 5:19 am 7:19 am ΘαΫ

Penumbral Lunar Eclipse 11:11 am PST*

Full Moon in S Cancer 11:21 am PST

O8D 11:21 am D&A

Det

DSE

ЖD

11:33 am

3:43 pm

3:58 pm

5:48 pm

Blooms

Our little child Time will not wait for us She is here, she is NOW Patience is not her forte.

Truth is I'll never be ready I'll never be as prepared As I am right Now.

When that call comes in When that wind starts blowing When the voice of destiny says rise to your feet -Shoes or not-It's Time to get up and walk.

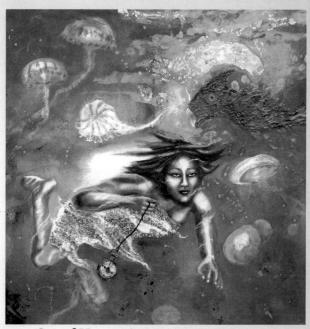

Sea of Uncertainty @ Catherine Molland 2015

excerpt \(\text{Nicole Nelson 2016} \) **555 Dé Sathairn**

9 2

Saturday

 $D \rightarrow \Omega$ 4:16 am DOW 8:43 am D△♂ 1:53 pm

⊙⊙ Dé Domhnaigh-

2

Sunday 12

Yoh 8:58 am

January

enero

DDD lunes

as C

Monday 13

ħApH 2:35 am ⊙σΕ 5:20 am №9 5:41 am D→117 6:06 am

7:15 am

00t

D△₩ 10:29 am ♀→ℋ 10:39 am DPrG 12:30 pm D□♂ 6:00 pm D△Ӌ 10:07 pm Wake Up!

How do we fall asleep right inside our lives?
For brief spells, we see beyond sleep's scrim.
Some parts of us are dreams it's time to wake from.

excerpt © Dawn Sperber 2013

- ooo martes

1177

Tuesday

DεΨ 9:27 am DΔE 7:51 pm DΔħ 8:12 pm ⊙ΔD 10:41 pm

- ¥¥¥ miércoles

₩ <u>~</u>

Wednesday

DΔ♥ 4:12 am D→△ 7:43 am EApH 3:17 pm Q+₩ 3:18 pm D+♂ 10:14 pm

- 444 jueves

 \hookrightarrow

Thursday 16

D□4 12:45 am ♥→≈ 10:31 am

D□P 10:16 pm D□ħ 10:56 pm

- 999 viernes

<u>~</u>

Friday 1**7**

○□D 4:58 am
D→Ⅲ 10:20 am
D□V 1:36 pm
D≥₩ 2:55 pm
V★₺ 3:08 pm
D△♀ 7:26 pm

Waning Half Moon in ← Libra 4:58 am PST

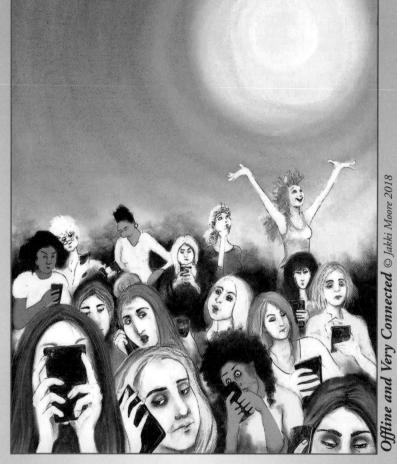

- 444 sábado

 \mathfrak{m}

Saturday 18

♥□₩ 12:32 am D★4 4:45 am D△Ψ 3:13 pm

-000 domingo

11,

Sunday 19

D*E 2:18 am D*b 3:19 am ⊙*D 1:21 pm D→✓ 2:41 pm January

yī yuè

- DDD XĪNG QĪ YĪ -

Monday 20

D+♥ 1:39 am
D□♀ 5:20 am
⊙→∞ 6:55 am
D♂♂ 11:46 am
D□Ψ 8:46 pm

- ơơơ XĪNG QĪ Èr-

Tuesday 21

⊅→% 9:00 pm

- ¥¥¥ xīng qī sān

19

Wednesday

D△₩ 2:00 am ⊙★₺ 10:03 am D★♀ 5:52 pm DơԿ 6:45 pm ⊙□₩ 10:54 pm

– 444 XĪNG QĪ SÌ -

79

Thursday 23

D ★Ψ 4:20 amQ ★ 4 5:07 amD σ E 4:18 pmD σ ħ 6:08 pm

- PPP XĪNG QĪ WŬ

79

Friday 2**4** Lunar Imbolc

D→ 25:20 am
D□ ₩ 10:34 am
O σ D 1:42 pm

New Moon in ≈ Aquarius 1:42 pm PST

2020 Year at a Glance for **Aquarius** (Jan. 20-Feb. 18)

dear aquarius, how are you settling into your madness? how are you learning to honor the voices in your head and keep them in check? saturn and pluto have been inviting you to shed ego/selves/ ideas/beings far too stagnant for the wild work you are here to do. when pluto and saturn join on january 12, what startles into clarity may stretch you to your limits. be so, so tender with yourself and others right now. work with the new moon in your sign on january 24 to cultivate the important practice of honoring your own version of reality.

jupiter will join with pluto three times in 2020 (april 4, june 30, and november 12), opportunities for deep truths to rise to your surface. reflect on whatever lightning insights come to you so you enact them with awareness, understanding, and compassion. on

august 3, ask the moon to support you in cultivating unconditional kindness; you will need this gift for your work.

in december, saturn and jupiter move into aquarius, ruler of your first house of self and identity, with your intuition as a solid foundation, deepen into your wildness and rest in your youness. no one can be or has ever been you. tremble.

naimonu james © mother tongue ink 2019

555 XĪNO OĪ liù

22

Saturdau

¥ o 5:09 am D+♂ 10:34 am Dơਊ 11:06 am Eve © Toni Truesdale 2017

- 000 lĩ bài rì

Sundau

5:37 pm 9:12 pm

The Standing People Are Moving

Bashing themselves about, stag horns clashing as cymbals of wood and wind.

The watchful mothers are stirring, shifting their burdens as they wait for their moment.

IT. IS. NOW.

Restless roots cleave the ground,
leaving behind their ancestral songlines
to form an unending procession.
Their breath opposite ours,
these Earth sentinels carry our earliest memories
as monkeys, untamed creatures.

They are cut down and so are we. They are sick and so are we. They are threatened and so are we.

Standing people are walking, now running, there is no more silent waiting.

Moving to a thunderous beat, primal, persistent.

The sky is open and marked by their absence. The axis of the world tilted, the four directions shifted. The trees are AWAKE and shaking the Earth!

Join flesh and branch, breath and dance,
The Tree Tribe is rising,
The Black Mother is calling us from drowsiness:
Awaken from your false security, your wild maturity,
Awaken to your all encompassing connectivity!

The trees thump and the Earth rocks, and the drums pulse in time,

To a vow of aliveness, pounding, pounding,

Pounding in our feet up to our hearts,

So that, my child,

we will never fall asleep again.

© Kendra Ward 2018

II. SPIRIT SIGHT

Moon II: January 24–February 23
New Moon in

Aquarius Jan. 24; Full Moon in
Leo Feb. 8; Sun in

Pisces Feb. 18

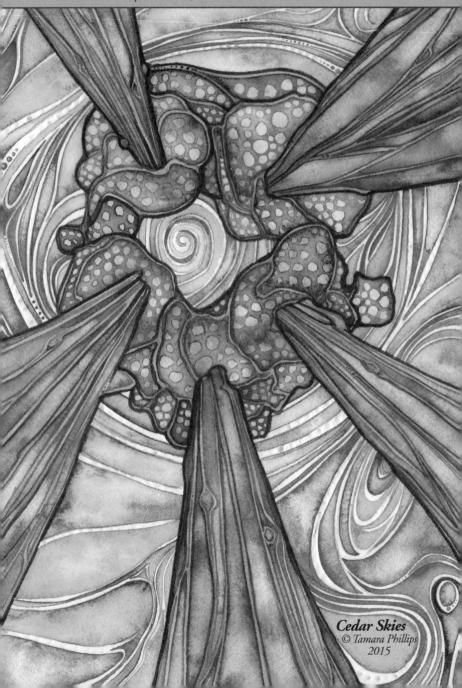

January / February

Poush / Magh

DDD sombar

 \mathcal{H}

QσΨ 12:00 pm D×4 5:13 pm Monday 27

Aequus Animus

be the candle burning on the windless night dive deep into the sea of tranquility insight is just a breath away excerpt © tanina munchkina 2007

ooo mongolbar

 \mathcal{H}

Tuesday

D□♂ 1:30 am D♂Ψ 1:34 am ♂□Ψ 2:34 am D♂♀ 3:02 am D★₽ 2:21 pm D★ħ 5:08 pm

- yyy budhbar -

H T

Wednesday 29

D→T 3:50 amDApG 1:32 pm⊙ ★ D 11:50 pm

- 444 brihospotibar

Υ

Thursday 30

D□4 6:54 am D△♂ 5:49 pm

999 sukrobar

T V

Friday 31

D□P 3:11 am D□ħ 6:24 am D★♥ 7:09 am D→O 4:28 pm D♂쌍 10:10 pm

Imbolc

Celebration of the hearth fire, and time to plant the future we want to see. Spirit wants your attention. A restlessness is growing to break the constraints of winter, and with it comes the fire of inspiration. The light is waxing, and what was born in darkness begins to manifest. Cabin fever. We gather our strength and vision, begin to wake up with nature to the creative work of fundamental change. For all its power, the patriarchy never dreamt of us. Imagine kicking in the rotten door of its powerhouse, igniting the fuse of revolution together! All we have to lose are our illusions! Being disillusioned is a great start; naked in the light of reality, we can visualize a personal/ global politics of Satisfaction, of enough-ness. This system can cope with most anything: protests, violence, voting, terrorism. But it can't cope with the radical act of peoples' refusal to participate in an economy of excess. As we become conscientious objectors in the battle for more, we find that experimentation is a great way to live. Join evolution in its holy work of making guesses.

Oak Chezar © Mother Tongue Ink 2019

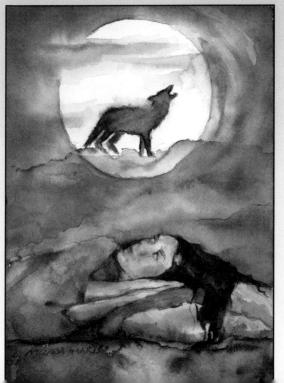

Answering the Call of the Wild © Melissa Harris 2013

In the Glorious Later

In the glorious later a great freedom was born. People went dancing in the streets, and honey was running down their legs through their toes and into the earth. The sky was falling and laughter ensued—Chicken Little at last validated and looked upon with great admiration. The woods became a meeting place where stockbrokers and landlords tore up their contracts. Chickens and cows, turkeys and pigs were set free from every factory farm. The dancing continued all night.

And all the birds . . . How they knew what a special day this was! In unison each color and type flew together, creating arches the colors of the rainbow, until a kaleidoscope of color filled the sky! Arches of rainbows flooded over oceans and mountains setting off waves of pulsing electrical energies. These waves penetrated the spines of all the humans and creatures who truly believed that love would find them.

Tomorrow came and they remembered. They slowed down and planted more food. They tended their gardens and spent time telling stories and brushing each other's hair. The grooming once known to other species became a way of life for a more affectionate existence. Hugging proliferated, and small yurts were filled with softness for rolling in. Yummy food was served twice a day, and everyone was just fat enough and happy. Dogs and cats danced under the moonlight to the chirp of coqui frogs. The only things that were forgotten were judgment and hate, isolation and fear.

Time passed and soon enough, all this too became a dream—a dream dreaming the dream, hoping for a better life where love wins and life is peaceful and abundant. The rocks know this, the stars know this, streams and rivers know this. Lakes and oceans and mountains never forget.

D Kauakea Winston 2017

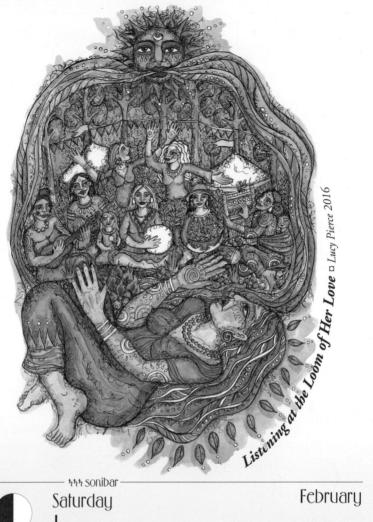

8

5:42 pm

ODD 8:11 pm 9×₽ 11:07 pm **ት**ትት Sonibar

Saturday

000 robibar

Sunday 2

Waxing Half Moon in ♂ Taurus 5:42 pm PST

Imbolc / Candlemas

8

2:54 pm

4:32 pm 6:24 pm

February

Mí Fcabhra

- DDD Dé Luain

Ĭ

Monday **3**

 $D \Box V$ 3:28 am $D \to II$ 3:29 am $V \to H$ 3:37 am V + V 2:01 pm

- ơơơ Đé Máirt

Д

Tuesday

⊙△⊅ 8:20 am ⊅□Ψ 11:50 am ⊅♂♂ 9:07 pm

- 🌣 ÞÝ DÉ Céadaoin

И 69

Wednesday

5

¥₩ 1:43 am D□Q 6:19 am D→∞ 11:03 am

D→S 11:03 am D+∀ 4:17 pm D∆∀ 6:00 pm

- 444 Dé Ardaoin

9

Thursday

6

Dε4 1:14 pm DΔΨ 5:15 pm

- 999 Dé Haoine

69

Friday

D&P 4:02 am D&ħ 7:43 am Q→↑ 12:02 pm

P→↑ 12:02 pm D→Ω 2:45 pm

DΔQ 2:59 pm D□₩ 7:43 pm

I've Heard if You Wanna Change Your Life, Start Waking Up at 4 a.m.

In the still ginger of morning, I sip pearl tea and watch flames from my stove and candles, flutter and lick, this way and that. Sensual relish of my skin, dim fiery tones, all those tender surroundings of not-yetdaybreak envelop me like a warm cocoon. I always thought it was writing in the quiet which made me new, but now I know better. It's the lingering play of delicate wee hours that inspire what is deep in me, to stir in the magic of discovery of this fresh awakening to life, today. © Anna Rose Renick 2010

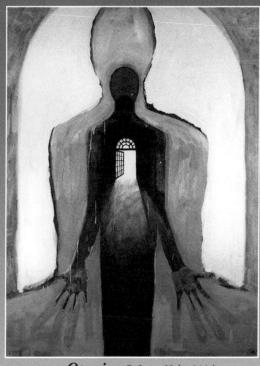

Opening © Jenny Hahn 2004

N

Saturday x

⊙8D 11:33 pm

⊙⊙⊙ Dé Domhnaigh

Full Moon in N Leo 11:33 pm PST

W C

Sunday 9

D△♂ 8:08 am D→TP 3:39 pm D△쌍 8:31 pm

MOON II 53

February

febrero

- DDD lunes

m

Monday

Mindfully, we care for the Dreamers, for it is the Dreamers who resolutely hold the world together by imagining and creating a future sustained by Love. © Denise Kester 2014

ඉර්ජ් 12:05 am D&A 6:51 am

DPrG 12:39 pm

DA4 4:55 pm D&Y 7:29 pm

ggg martes

DAP 5:36 am 9:37 am D□0 10:26 am

D→ _ 3:37 pm

Tuesdau

ggg miércoles

DAt

Wednesday

D8♀ 12:06 am D04 5:53 pm

444 jueves

111,

Thursday 13

DOP 6:20 am ODD 7:17 am D□5 10:46 am D×ď 1:40 pm D→M. 4:37 pm

- 999 viernes

111

Dey

9:54 pm

Friday

DVA 1:43 pm D*4 8:52 pm DΔΨ 10:25 pm

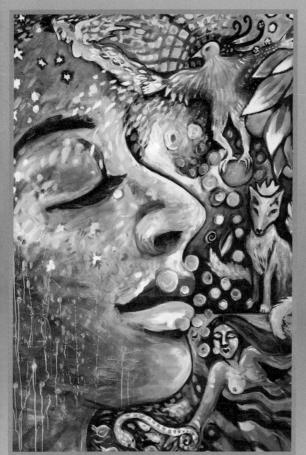

Just Begun: A Call to **Creative Action**

Come songwriters And priestesses of a new era Come now actors and activists. Creators, risk takers and mischief makers. Find your wings Your voice that sings And speak up! Sing out! Rise up and dance about!

excerpt D Casey Sayre Boukus 2018

Dreamer © Sophia Rosenberg 2017 **ት**ትት Sábado

11

Saturday 15

DXE 9:21 am ODD 2:17 pm 2:20 pm

8:07 pm

000 domingo

Waning Half Moon in M, Scorpio 2:17 pm PST

1

Sunday 16

3:06 pm 4:54 pm 7:10 pm DOA

February

— DDD XĪNG QĪ YĪ -

Monday

 $\Psi \square \mathbb{Q}$ 3:49 am

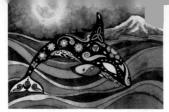

Blackfish

Melissa Winter 2016

– ơơơ XĪNG QĪ Èr -

Tuesday

O*D 1:03 am D-18 2:37 am Dag

5:16 am DAY 8:45 am O→H 8:57 pm

– yyy xīng qī sān -

Sun in H Pisces 8:57 pm PST

19

Wednesday 19

D×Þ 1:56 am DUP 4:08 am Do4 11:50 am D+¥ 12:05 pm

– 444 XĪNG QĪ SÌ -

18

Thursday

DoP 12:07 am Don 6:18 am 4+Ψ 7:56 am D→ ≈ 11:42 am

D□쌍 6:13 pm

– ♀♀♀ xīng qī wǔ

Friday

 $Q_{\Delta} \nabla A$ 1:10 am o'uk 5:16 am D+♀ 8:08 pm

2020 Year at a Glance for H Pisces (Feb. 18-March 19)

when you choose to care for your selves at the cellular level, you choose radiance. from this place, simply showing up as yourself is a sacred offering.

saturn and pluto will meet in your house of ideals and collective liberation january 12. hold yourself through any shifts in communities and friend groups you find home in. prepare to stand shoulder to shoulder with your people and sweat and shake toward freedom. wise jupiter meets pluto three times in 2020 (april 4, june 30, and november 12), an opportunity to integrate (and manifest!) any wild insights you may gather at the start of the year.

use the new and full moons in your sign on february 23 and september 1 to release disempowering relationships that no longer serve you. folks in your life need to be on team you!

by year's end, saturn and jupiter move into aquarius, ruler of your twelfth house of spirit. call in the rest and contemplation you need to stretch your selves in the directions you yearn to stretch. honor your intuition and center your own version of reality. if you are to guide us, you must speak your truths, no matter how wild they sound to unknowing ears.

ears.
naimonu james © mother tongue ink 2019
— \$\frac{1}{2}\$ the XING \$\bar{q}\$ liù \$\limes\$

Saturday 22

⊙+₩ 6:13 am D→H 10:37 pm

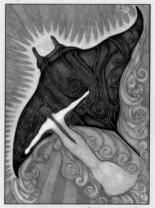

Manta and Mermaid
© Francene Hart 2017

000 lĩ bài rì

H

Sunday 23

D ★ ₩ 5:29 am O o D 7:32 am D ★ o 8:30 am

9□4 8:59 am Dσ¥ 4:39 pm

New Moon in H Pisces 7:32 am PST

Return, Girl

Return, girl of autumn golds frozen-blue lakes and velvet-moss summers girl of rising bread dough and luscious steam beckoning sun-warmed summer girl finding secret woodland truffles and girl of city-park hopscotch

return to us, girl of something wonderful is just about to happen girl of another brand-new life girl passionate with causes girl sashaying to today's best beat in her own head

girl of the most exciting thing I did that you absolutely will not believe but it is true! girl of new-attitude hair design girl skimming life-fed lakes carrying sun and moon simultaneously

girl of this older woman set the boring tinder of this world on fire flood our stale lives with the magnitude of your imagination swell and drench us with your conjurings and unshakable beliefs soak us to the bone with the possibilities of who we could become like you taught us so long ago, singing over the hot steam

of everyday soap and dishes return to us,
Girl of a Greater World and show us the way.

Stephanie A. Sellers 2018

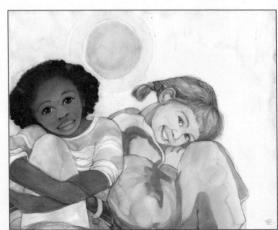

2 Girls © Elizabeth Diamond Gabriel 2007

III. SPROUTING
Moon III: February 23–March 24
New Moon in H Pisces Feb. 23: Full Moon in W Virgo March 9: Sun in T Aries March 19

Joy © KT InfiniteArt 2018

XT Luftwitz Hait

February / March

- DDD sombar

Monday 24

DσΨ 10:26 am D*4 11:45 am ⊙+o 6:06 pm D*P 10:57 pm

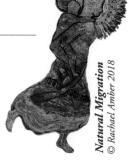

- ơơơ mongolbar -

Tucsday 25

6:12 am $D \rightarrow \Upsilon$ 10:47 am OαŘ 5:45 pm ♥*♂ 9:58 pm

- yyy budhbar -

Wednesday 26

D□♂ 12:32 am DApG 3:34 am

- 444 brihospotibar

Thursday

D04 1:22 am Das 9:05 am D□P 11:46 am Dot 7:25 pm D→8 11:30 pm

999 sukrobar -

X

Friday 28

Dow 6:50 am D×B 7:51 am ₽PrH 9:51 am

QUE 2:08 pm DAG 4:56 pm \$xx 7:13 pm ⊙ + D 7:40 pm

St. Anne, Patron of Mothers of Daughters

Whether or not I believe in scriptures, you resonate, Anne, mother of a head-strong girl-child. The older woman whose young daughter gets pregnant out of wedlock, won't say who the father is, scorns your hope of a wedding, marries the first guy who asks her, some carpenter who has a woodshop of his own.

Right when she should be nesting, they head out for the big city. She has the baby without you. With strangers in an old shed, singing and smoking god-knows-what in the cold. Then they move to Egypt for twelve years and never write or call, chasing a dream.

You stick it out at home with your husband who gets more forgetful by the day. When you complain about his little-girl-Mary-who-can-do-no-wrong, he smiles in his vague way, not comprehending your heartbreak.

Yes, she becomes famous. Even political. Yes, she is the heroine of hardbacks and stars in a feature-length film. You had tried to teach her open-hearth cooking and the weaving of soft cloth. Garden work. How to stay near home, the quiet place you wombed her. She becomes all about the sky.

I take you as my mentor, dear Anne, patron of how to let go through centuries of worry. There is no greater risk than a daughter. © Joanne Clarkson 2018

555 Sonibar

8

Saturdau

D*Ψ 11:50 am DA4 2:41 pm

ooo robibar

8

DAE 12:04 am D→X 11:21 am

7:52 am 3:05 pm Sundau

March

MOON III 61 March Mí Márta

- DDD Dé Luain

I

⊙□D 11:57 am D□Ψ 10:24 pm Monday

When Mother Nature shows her teeth the time has passed for false belief. D The Obsidian Kat 2007

ggg Dé Máirt

Waxing Half Moon in I Gemini 11:57 am PST

I 9

Tuesday

8:44 am

우미차 D*9 6:20 pm D-5 8:25 pm DAY 8:44 pm

- 🌣 ÞÝ Dé Céadaoin

9

Wednesday

ÿ→≈ 3:08 am D*# 3:25 am Ž¥Φ 1:24 pm

DSQ 6:24 pm 9→8 7:07 pm O△D 11:49 pm

444 Dé Ardaoin

90

Thursday

 $D\Delta\Psi$ 5:14 am D84 8:56 am

D&E 3:50 pm D84 11:11 pm

999 Dé Haoine

Friday

 $D \rightarrow \Omega$ 1:27 am DUP 4:00 am DOW 8:06 am

21st Century Girl Activism

they're breaking and entering, flexing their muscles letting in the delights of feet hitting pavement like a million clackers inside the Liberty Bell ringing across this country, until the systems of What Was crumble, and the reality of What Is is brought into being like two girls casting song-spells with a jump rope the politicians inside their hoop trying to keep up, jumping as quick as they can now, *Pepper!*

I asked my mother for 50 cents
to see a senator jump the fence
he jumped so far
he jumped so fast
when he came down
he was a thing of the past
no war, no guns, no hate remained
the senator said "betta change my name"
mamma's gonna fuss
mamma's election comes this spring.

D Stephanie A. Sellers 2018

y (

Saturday

555 Dé Sathairn

7

No Exact Aspects

- 000 Dé Domhnaigh

117

D&¥ 12:12 am D→117 3:47 am ⊙σΨ 5:23 am Sunday X

D Δ ♀ 10:00 am D Δ ሤ 10:11 am ♀ ሪ ሤ 12:38 pm

Daylight Saving Time Begins 2:00 am PST

March

marzo

- DDD lunes

Monday

ΨApH 1:48 am DAO 3:48 am Ψ 8 \mathbb{C} 8:56 am O8D 10:48 am

DA4 1:08 pm DAE 6:24 pm ğD 8:49 pm DPrG 11:22 pm

- ogo martes

Full Moon in TV Virgo 10:48 am PDT

Tuesday

DAt 1:32 am $\mathbb{D} \rightarrow \underline{\frown}$ 3:03 am

- ¤¤¤ miércoles

Wednesday

D□0° 5:06 am ⊙ * 4 5:27 am D□4 12:48 pm DOP 5:41 pm D∆ÿ 11:58 pm

- 444 jueves

Thursday

Dot 1:12 am D→111, 2:28 am Don 9:14 am

D89 4:10 pm

- 999 viernes

M,

Friday

D×ď 7:59 am $\Psi \Delta \Phi$ 8:53 am D*4 2:14 pm OAD 5:47 pm D*E 6:53 pm

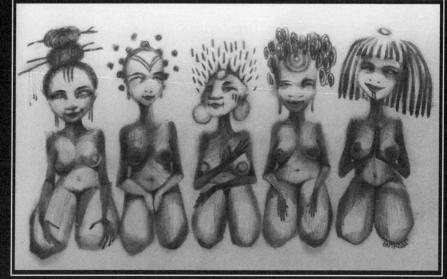

Expanding the Sisterhood Grid @ Qutress 2017

Stay

A knowing emerges around the actions I must take Recognizing my roots and responsibility We are the ancestors of the future

excerpt \(\text{Sophia Faria 2018} \)

- 555 sábado -

M.

Saturday 14

DUA 2:36 am 3:06 am 3:32 am

4:09 am 0×P

9:47 am

ooo domingo

Sunday 15

D□Ψ 12:51 pm

Spring Equinox

The return of spring, time of holy equality. The landscape is still winter-rough and wind-blown. Walk outside and feel the raw possibility. The world is made of stories, and we need to change the narrative. Poised in the season's symmetry, ask: what does another world look like? The anxieties hover—climate change, nuclear holocaust, environmental devastation—but let us not stress only existential apocalyptic tales. How do we stop devouring the planet and instead energize stories of plenty and repair?

From the ballast of balance, begin to notice The Commons, that entire life support system that we hold in trust for future beings. Envision a healing, parallel economy producing air, diversity, wilderness, asking only respect in return. Collect bits of wind-blown trash for a day. Gather in community, sharing the common wealth. Remember that the root word for "religion" is "re-linking"; when we speak in the language of longing, we re-enter the mystery.

Walking in the woods, see that trees aren't isolated individuals. Each one is Forest, Forest, Forest. I walk in the world, and I'm not even *me*; I am World. Gaze through the mirror. World. World.

Oak Chezar © Mother Tongue Ink 2019

The Awakening @ Susan Bolen 2

Out of the Nursery and Into the Streets!

Grandma and Little Red are tree-sitting in the Tongass defending the wolves against the woodsmen

Snow White has joined the ladies' auxiliary of the seven dwarves' union so she's out fighting for mine safety when the witch comes around with her two-faced apples

Goldilocks is camped on the National Mall,
explaining to the president
that Venus is tooooo hot
Saturn is tooooo cold
and the Earth is juuust right
© Nancy Schimmel 2014

March

sān yuè

- DDD XĪNG QĪ YĪ

Monday 16

I come up for air whipping my hair in an arch of splintered light and I am humming raw and incandescent excerpt © Meredith Heller 2018

¥→+ 12:42 am ODD 2:34 am

D-78 9:25 am D×V 9:49 am

ơơơ XĪNG QĪ Èr

Waning Half Moon in ✓ Sagittarius 2:34 am PDT

3

DAW

5:33 pm

Tuesday

D△♀ 10:31 am D×Ψ 8:36 pm

- ¥¥¥ xīng qī sān -

18

Dog

Wednesday

Do4 3:47 am DOE 7:53 am O*D 3:57 pm Doh

5:48 pm $D \rightarrow \infty$ 6:16 pm

- 444 XĪNG QĪ SÌ

DUA

⊙*5

3:04 am

4:50 pm ⊙→↑ 8:49 pm Thursday

Spring Equinox

- Pop Xīng qī wù -

Sun in ↑ Aries 8:49 pm PDT

Friday

PDQ 2:00 am o" o 4 4:35 am

2020 Year at a Glance for T Aries (March 19-April 19)

after years of shedding work out of alignment with you, 2020 demands you continue searching out your work in the world. use the radical energy of jupiter and pluto, conjunct on january 12 in your tenth house of persona and career, to clear the paths toward the gifts only you can bring through in this life. have courage, for wise jupiter meets pluto three times in 2020 (april 4, june 30, and november 12), three pillars of support to integrate (and manifest!) any new insights.

use the new and full moons in your sign on march 24 and october 1 to build momentum to leap toward work that nourishes you. deliberate and determined, gather the knowledge you need to set

yourself up for success. the north node of the moon will move into youthful gemini on may 5, a reminder to follow your curiosity, no matter how "childish" your journey may seem to others.

in december, saturn and jupiter move into aquarius, your eleventh house of collective liberation. offer your skills and talents to the freedom plight of the whole-not for glory, but because your liberation is wrapped up in the liberation of all beings.

Playing with Light (Hannah) D Catherine McGagh 2012

naimonu james © mother tongue ink 2019 - the xīng gī liù -

	1	**	2
		+)
		7	T

Saturday

D→\ 5:33 am Dag 1:39 pm D+쌍 2:51 pm

ħ→æ 8:58 pm

ooo lĩ bài rì

 \mathcal{H}

Sundau

8×H 6:19 am D*P 7:36 pm 7:38 pm

Q×Ψ 8:08 pm ooP 10:20 pm

Mokosh, Goddess of the Working Woman

Goddess of stamina, old world crone whose only altar was story, she is rough-hewn, statueless. Unearthed on Slavic steppes she was worshipped in breast-shaped stones, both the great rounded mounds stubborn in the fields and small nippled pebbles carried in pockets of farm women, the dust-rakers, the dry-eyed.

If they found one ringed with white, a child was on the way. A hopeful need for labor. Smooth agate was a teardrop of this quasi-goddess whose name means moisture, what field folk most prize. In dreams she was often green. Raindrop sister of seed.

Her sacred song was a hushed harsh lullaby: M K SH. M K SH. M K SH. Her animal, the plow horse, determined and earth-useful. Her favorite plant, flax, for she was a spinner, cousin of the Fates.

Some place her feast in October. Most say any Friday, even before there were week-ends. The one to pray to in times of drought and overwhelm. Saint of oh-yes-I-can.

© Joanne Clarkson 2018

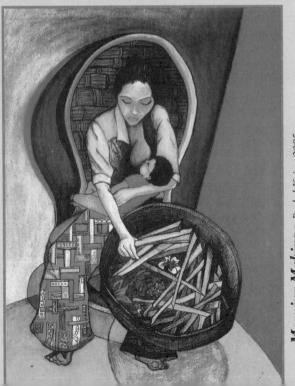

Morning Making a Rachel Kaiser 2005

IV. AWAKENED WOMAN

Moon IV: March 24-April 22

New Moon in T Aries March 24; Full Moon in 22 Libra April 7; Sun in 8 Taurus April 18

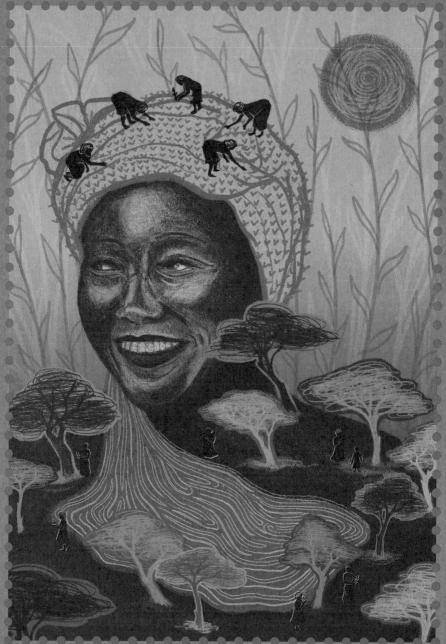

Wangari Maathai © Ruchiel Amber 2018

March

Falgun

- DDD sombar -

 \mathcal{H} Υ

Monday 23

D * 4 4:20 am D * C 7:18 am D * C 7:51 am $D \to \Upsilon$ 5:58 pm $D * \hbar$ 6:15 pm

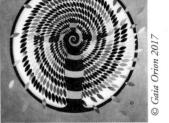

From the Heart

– ơơơ mongolbar

Υ 🚺

Tucsday 2**4**

Oc D 2:28 am DApG 8:21 am

- yyy budhbar -

New Moon in TAries 2:28 am PDT

Υ (

Wednesday 25

Oσ\$ 6:27 am
D□4 5:43 pm
D□B 8:02 pm

– 444 brihospotibar

8

Thursday 26

D□♂ 12:16 am D→Ծ 6:37 am D□ᡮ 7:15 am D♂₩ 4:29 pm &ApH 6:50 pm

- 999 sukrobar

ŏ

Friday 27

D*Ψ 2:03 am D*Ψ 9:02 pm QΔ4 9:24 pm

She Who Flies Helicopters

Estimate: in 2017, there were 15,355 licensed USA helicopter pilots. Women represented less than 3% of that total number. That's roughly one woman for every 33 men. This is our story—riddled with refusal, repression, oppression, denial, and blatant prejudice. Ripe with victories of unlikely pioneers, visionaries, conquerors, and luminaries. Women of courage, selflessly doing battle with the status quo. Living their truth and creating a path for the next round of warriors.

I am down in the trenches now. Wrapped in my suit of armor, I am giving thanks to those ladies who came before me. I am going through my initiation, being called "Sweetheart." I am turning heads as I walk into the room, full of men, who are wide-eyed and wondering. I am that one for every 33 incarnate, splashing out ripples in the water and stretching beyond my wildest imagination. I am unconventional. I am inspirational. I am a statistic whose number cannot be padded. I am working smarter and harder.

We are life's leading edge, blazing trails, and being heard. Divine consciousness is expanding. We are being seen around the world. We are creating a future for girls who are too young to know, cultivating the soil where rich feminine roots thrive, watering this garden with love and perseverance. We are nurturing an experience of appreciation, acceptance, and praise, basking in the admiration for scientific geniuses calling themselves "SHE." We are told we can be anything we want to be. I am being one for every 33.

	ttt sonibar	© Amy Alana Ehn 2018
H O	Saturday 28	
D △ 4 6:39 am D ♂ ♀ 7:20 am D △ B 8:19 am D △ O 4:05 pm	D→II 6:38 pm D△5 7:36 pm Q△P 7:57 pm	
	ooo robibar	
1	Sunday 29	
⊙ ★ D 1:32 pm D□ÿ 7:58 pm		

MOON IV 73

March / April

Mí Marta / Mí Aibrcán

I

00

o"→ 2 12:43 pm

D□Ψ 8:10 am

Monday 30

Spirit+Matter 1

Waxing Half Moon in S Cancer 3:21 am PDT

- ơơơ Đế Máirt

D→95 4:43 am o o t 11:31 am D + 쌍 2:24 pm Tuesday

31

- 🌣 🌣 Dé Céadaoin

9

Wednesday

April

⊙□D 3:21 am D∆♥ 10:51 am DAY 4:22 pm

- 444 Dé Ardaoin

9

Thursday

D84 1:49 am D&E 2:20 am

 $D \times Q$ 9:49 am $D \rightarrow \Omega$ 11:26 am

D84 12:49 pm DSO 3:13 pm

DUW 8:39 pm

- 999 Dé Haoine

N

Friday

Q→II 10:10 am O△D 12:29 pm ğσΨ 6:14 pm

Litany for Survival

after Audre Lorde

for those of us steeped in privilege
wrapped in the invisible blanket of entitlement
if we believe in justice
if our hearts hold compassion
we must own the inequities that favor us
we must not let this go unchallenged
our world balances on a sharp blade
we may be sliced in two

we are not meant to survive like this

those of us who have not been followed by security at Macys, who have not been stopped for driving while black, who walk down main street with ease must awaken

when one more bullet claims a life, we despair and yet it is not our child left fatherless, not our family, our community whose sorrow echoes up and down the generations

as the stink of slavery and genocide festers we must stand up, embrace resistance because none of us are meant to survive like this.

- 555 Dé Salhairn excerpt © Judith Prest 2017

Ω 1117

Saturday

4

QΔ[†] 10:09 am D→117 2:18 pm

D□9 4:08 pm 4σE 7:45 pm

4ơ만 7:45 pm D△쌍 11:06 pm

- ooo Dé Domhnaigh-

ΠP

Sunday 5

DεΨ 9:37 pm

from Billie Potts' New Amazon Tarot April © Carol Newhouse 1973 DDD lunes 117 Monday 2:48 am D&A DAE 6:15 am 6:29 am DA4 $D \rightarrow \underline{\sim}$ 2:16 pm Muse DAt 3:52 pm 6:56 pm DAQ Dムプ 10:20 pm add martes Tucsday DPrG 11:17 am グロザ 11:50 am ¥*P 2:28 pm ¥*4 7:20 pm 080 7:35 pm Full Moon in ← Libra 7:35 pm PDT - yyy miércoles Wednesday DOP 5:17 am D04 5:50 am ♂*\$ 10:23 am D→ML 1:17 pm Dot 3:03 pm D&A 10:09 pm D□♂ 11:41 pm - 444 jueves 11 Thursday DAY 8:32 pm - 999 viernes

Friday

D*E 5:15 am D * 4 6:08 am

DVA 12:35 pm 1:35 pm

D×t 3:37 pm 3*9 6:39 pm

9:48 pm

Rabble-Rousing

Call a strike against this world for a bluer, purpler one; one where arms will always embrace us against darkness. Protest science without magic.
Picket for an Earth with imaginary colors and more moons.

Picket for life in an alternate dimension, where all can fly and birds can speak.

This world force-feeds us logic and offices,

locks us out of childhood and nights prone to stars

Protest light pollution.

Demand equal pay for thoughts.

Demand cats' and flowers' rights for dandelions.

Boycott splinters and paper cuts. Boycott Mondays.

Be a troublemaker, be demonstrative.
Hug a cloud! Organize lightning strikes!
Incite a slowdown against time flying.
Join a silent march for more snow and new glaciers.

Provoke a riot against tight underwear.
Stage a walkout from nightmares.

This is a direct call to indirect action, an indirect call to direct action.

Resist gravity—uprise skyward!

© Lorraine Schein 2017

- 545 Sábado

1)

Saturday

D&Q 12:27 am D★♂ 3:03 am ∀★↑ 4:58 pm D□Ψ 10:53 pm

-000 domingo

*)

Sunday 12

O△D 4:46 am D→% 5:05 pm D□ÿ 11:00 pm Hina © Sudie Rakusin 1998

April sì yuè

- DDD XĪNG QĪ YĪ

18

Monday

DAW 3:36 am

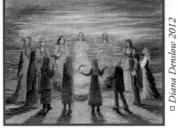

Woman Power

13

– ơơơ Xĩng qĩ Èr -Tuesday

ODE 4:07 am $\Psi \star \Phi$ 5:10 am DOE 3:01 pm ODD 3:56 pm

- ¥¥¥ xīng qī sān

Waning Half Moon in \(\gamma \) Capricorn 3:56 PM PDT

3

Do4

4:47 pm ೪ರ≴ 10:02 pm

Wednesday

D→ # 12:37 am Don 3:21 am ⊙□4 3:59 am D□쌍 12:09 pm D×A 3:40 pm DAQ 8:29 pm Dơơ 10:42 pm

– 444 XĪNG QĪ SÌ -

22

Thursday 16

No Exact Aspects

- QQQ XĪŊ QĪ WŬ

Friday

⊙ ★ D 7:34 am D→H 11:29 am ¥¥♀ 10:36 pm D ★ ሤ 11:46 pm

2020 Year at a Glance for of Taurus (April 19-May 20)

on january 12, jupiter and pluto will join in your ninth house of belief, ideology, and higher knowledge. use the potent energy of this conjunction to release rigid, stagnant teachings that no longer serve you. seek out faiths, adventures, and lands that (re)ignite your passions and align with your deepest held values, be wary of false prophets and stale mentorships!

pluto conjoins jupiter three times in 2020 (april 4, june 30, and november 12), offering wisdom (jupiter) and x-ray vision (pluto) to see through the bullshit. return to integrity again and again—what faiths and value systems model the ways you want to move?

work with the new moon in your sign on april 22 to become the enchantress of your own life. there is much newness for you to discover within your selves. allow your flirtations to carry you to new destinations, conversations, and values. on the full moon in your sign on october 31, bring your committed relationships into alignment with any newness that has arisen over the year.

in december, saturn and jupiter move into aquarius, your tenth house of work and career. the skills and talents you have been gathering to yourself are ready to create good in the world. be bold, the collective needs your wisdom, dear taurus.

> naimonu james © mother tongue ink 2019 - รรร xīna aī liù

Saturdau

D□♀ 11:57 am ¥+♂ 8:55 pm

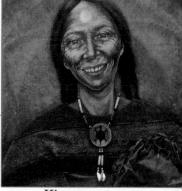

Hina © Dorrie Joy 2014

- 000 lĩ bài rì -

Sundau

3:32 am 7:45 am D*P

1:51 pm 4:31 pm

Sun in & Taurus 7:45 am PDT

I Wish You

I wish you mouthfuls of laughter and warm hands and bowls of nourishing soup and starry light glittering at the periphery of your eyes as if someone is tapping you gently on the shoulder, whispering a song from your childhood that makes you smile and weep at the same time, in a good way, like when you know who you are.

I wish you the scent of lime blossoms and the taste of salt on your lips, and the inviting rhythm of rain on your roof that wakes you up at night and draws you from your bed to dance a little in

the darkness with a prayer in your body.

I wish you a loving letter from an old friend when you least expect it, with words that warm you like small sticks of kindling that catch and smoke and smell of ancient sandalwood forests and the tiny blue birds that sing at night, and a low slung moon, lying on her back, points up, like a bowl of light.

I wish you pan-fried plantains drizzled with honey, and the lonely sound of a fog horn at dusk after it's rained all day, and the sweet, rich, gentleness you feel in every cell of your body when you're kind to another human being.

I wish you the stillness of the great blue heron as she fishes from her perch at the edge of the world, and the feel of your back, leaning against these rocks here, that have soaked up the sun all day.

I wish you the cool clean whiteness of shells, the sacredness of bones, the memory of flight that leaves its signature in the feather. I wish you the wide wingspan of a low swooping owl as it turns 90 degrees on its side, to fly between trees in the forest, as you walk home alone one night, listening for your song.

© Meredith Heller 2017

Blue Heron Takeoff
© Barbara Landis 2013

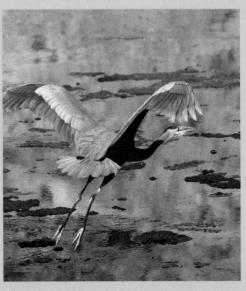

V. LOVE CALLS

Moon V: April 22–May 22 New Moon in 8 Taurus April 22; Full Moon in 机 Scorpio May 7; Sun in エ Gemini May 20

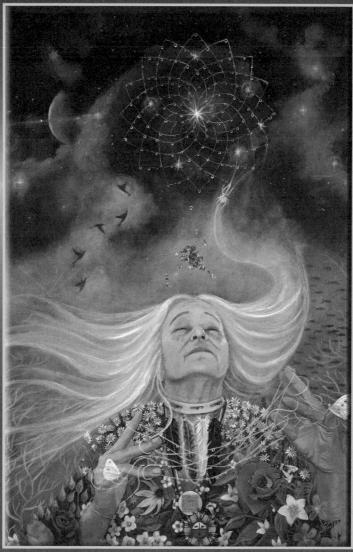

An Ode to Love

love is the tapestry of life, the string that weaves the fabric of creation

April Choitro

- DDD sombar

 \mathcal{H}

Monday 20

D→↑ 12:00 am D+5 3:16 am DApG 12:00 pm

ooo mongolbar

Υ

Tucsday

○□[†] 12:00 am D ★ ♀ 4:17 am D ★ ♂ 6:35 am D ♂ ♀ 1:06 pm

- yyy budhbar -

Д.

Wednesday

22

D□P 2:31 am D□4 5:32 am D→8 12:36 pm

D→8 12:36 pm D□4 3:59 pm ⊙๙D 7:26 pm

- 444 brihospotibar -

New Moon in 8 Taurus 7:26 pm PDT

 \aleph

Thursday 23

ิ Dơ쌍 1:28 am ปิ่⊐o 10:30 pm

- 999 sukrobar

ŏ

Friday

D×Ψ 4:38 am DΔE 2:27 pm DΔ4 5:43 pm let go of the millstone of worry the dullness of holding back the fear of not knowing

just listen to the morning's music birds darting through the plum thicket or perched on the branches cracking seeds this is it say yes

let love melt your heart enter your dreams wake you up

© Cathy Casper 2006

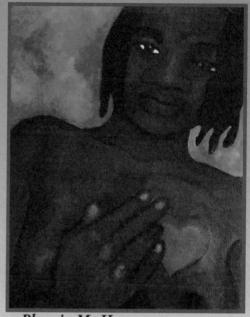

Place in My Heart @ Abena Addo 1993

ት ት ት Sonibar

N

Saturday 25

D→X 12:20 am ♥□P 12:36 am D△\$ 3:47 am PR 11:54 am ♥□4 9:31 pm

ooo robibar -

I

Sunday 26

○ o が 2:01 am D o ♀ 9:38 am D △ o 12:55 pm ∜ApH 1:47 pm D □ Ψ 3:31 pm

April / May

Mí Aibreán/Mí Bealtaine »»» Dé Luain

II 000

Monday 27

D+♥ 10:00 am D→9 10:28 am ♥→♂ 12:53 pm D+♥ 11:08 pm

– ơơơ Đé Máirt

9

Tucsday 28

Reach © Sophia Rosenberg 2014

- ¥¥¥ Dé Céadaoin -

S 69

Wednesday 29

DΔΨ 12:12 am DεP 9:01 am DεH 12:29 pm D→S 6:06 pm Dεħ 9:27 pm

– 444 Dé Ardaoin

S

Thursday 30

D□♥ 3:46 am D□♥ 6:20 am ⊙□D 1:38 pm ♥♂♥ 8:41 pm

- 999 Dé Haoine -

Waxing Half Moon in ℜ Leo 1:38 pm PDT

S? M?

Friday 1 May Beltane

D ★ ♀ 4:15 am D ♂ 9:04 am D → 117 10:35 pm

Beltane

Joyful time of flowers, softening the world; the chains of winter are broken. Break your symbolic bindings by planting seeds. As these seeds unclench in the darkness, ask what choices can you make in response to the needs of this sacred moment? What is it that you value and how can you align your life with that? In simpler times, communities gathered to jump over fires in the fields and participate in the great round of fertility. Listen to the voices of the universe saying YES—the sun shines, the birds sing, the flowers bloom. The purpose of the universe is to celebrate the delight of its existence. May that inspiration hot-wire us into the living voltage of the Mother. Renew your life with others.

What we all long for is relationship with other beings; it's the only thing that cures this massive alienation. Lying on your back in the woods, see how the trees lift themselves in a circle. Reach out and extend your circle. Community, the geography of Somewhere, is the We that balances the Me. Women know this, in the compass of our bones.

Oak Chezar © Mother Tongue Ink 2019

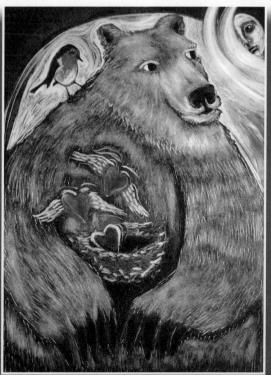

Love Awakens © Denise Kester 201

To Sing a Different Song

Dry strikes char and scar the West, firebrand fear.
Plumes of smoke soak October air with haze and soot
and prayers for rain. Lightning Creek is hushed, uncharged,
just rock tumbling dry bed. Fishes exiled.
Grasses and trees, birds and beasts, thirsting.
The river's evaporated dreams, wistful remains.
Autumn tiptoes across smoldering embers,
and we talk of climate change and human impact,
envisioning a collective do-over.

At the same time, you've returned home after a long while away. We fan old flames, reignite. We are firewalking, stepping gently from the heat of one another, our climate changing while we shift and adapt. In other ways, we trickle like Lightning Creek as mists shroud smoke, and rains once again fall. We flow around each other again, trade words and breath, merge after drought to flash stronger.

All around us beings gulp and crave—for clean air and water, love and connection, give and take, looking for a do-over of our own faults and those of humanity. You say love is bigger than words, and maybe so are natural rhythms we humans must measure and name. We are meant to dwell between abundance and lack, between flashes of rain and love, between smoke and the mirrors we all are to each other.

© Heather McElwain 2015

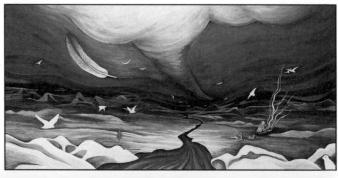

Passing Through

a Janis Dyck 2012

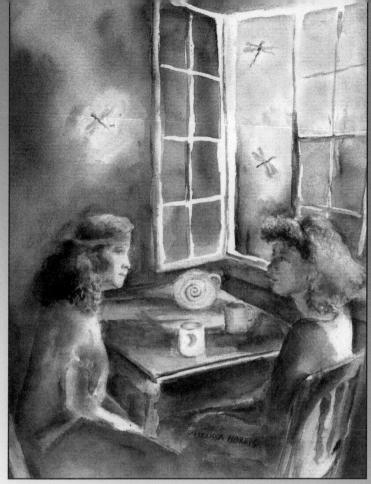

Precious Moments @ Melissa Harris 2001

555 Dé Sathairn

MP

Saturday 2

¥ApH D∆₩ D∆¤ 8:52 am 10:19 am 4:38 pm 8:40 pm ODD

- ⊙⊙⊙ Dé Domhnaigh-

117

Sunday 3

DUQ 8:06 am D8Ψ DΔE DΔ4 8:22 am 4:01 pm

7:24 pm ₽□Ψ 8:52 pm May

DDD lunes

MP

D→- 12:09 am DAt

OQA

3:15 am

2:41 pm

Monday

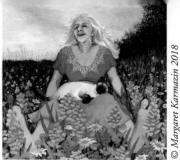

- ooo martes

Tucsday

DAQ 9:23 am DOP 4:05 pm DAO 4:13 pm 7:30 pm D04 DPrG 7:51 pm

- ¥¥¥ miércoles -

Wednesday

D→111, 12:05 am Dot 3:10 am D ያ 11:31 am

- 444 jueves -

M.

Thursday

ğ×Ψ 3:42 am 08D 3:45 am DAY 8:40 am D&A 9:30 am D*P 4:03 pm Dog 6:33 pm D*4 7:39 pm

- 999 viernes

Full Moon in 11 Scorpio 3:45 am PDT

Friday

D→ ₹ 12:15 am Dxt 3:27 am

A Wild Thing Full of Magnets

I've been a mind and ability; I've been plans and focus and fiery, hopeful belief. But when you speak, keys fall through your voice, and go unlocking me, freeing a body that erupts beneath my eyes and lips. My long-lost body, beautiful and imperfect, silken-haired and scarred—a wild thing full of magnets, now pulled toward you and all the keys falling though your voice.

It's magic, to grow legs and feet and breasts and hands, and yet, my body confuses time and disrupts my eagle-eye and dream strategies, by leaning forward, by wanting and ringing, ringing like that tinkling pile of keys left on the floor after your oblivious magic tricks. I don't fit on the chair anymore; my legs kick, my ass bumps the cushion off, and I'm a wild animal in the house.

My missing half of me returned, now I don't fit. Shoved from my logic dreams, in a body, I'm lonely. Yet how can I not be grateful for the trick, and replay how all you did was talk, and here I unlocked and went unfurling like I've been a jack-in-the-box all along.

So now I'm a tangle of hips and arms and belly, wrapped 'round with one-eyed plans, but for those minutes when you told a story, I remembered how to be complete. Thanks for the unlocking and zap and the beautiful electricity powering you, even if now all my hands get in their own way. Still, the trick was glorious, and terrible and more real than I'd remembered. Bless your voice's keys. And now here I go into this weird, blazing day.

© Dawn Sperber 2014 - 555 sábado -Saturday ğΔP 6:17 am D□Ψ 10:14 am D89 12:13 pm D*o" 11:11 pm -000 domingo Sunday 2:38 am ₽Δ4 7:36 am ⊙*Ψ 9:16 am DAW 3:38 pm 9:09 pm

89

MOON V

May

wǔ yuè

- DDD XĪNG QĪ YĪ -

79

Monday 11

 ♥□♂
 12:33 am

 ♥→Ⅱ
 2:58 pm

 D★Ψ
 3:05 pm

 ⊙△⊅
 5:24 pm

 DơE
 11:14 pm

Receive

– ơơơ XĩNg qĩ Èr -

79°

Tuesday

Dの4 3:30 am ダムヤ 1:14 pm D→ 22 8:39 am の → 3:17 pm D ム 25 12:07 pm D 口 35 10:52 pm D の 4 12:18 pm 9R 11:45 pm

- ¥¥¥ xīng qī sān

*

Wednesday 13

No Exact Aspects

– 444 XĪNG QĪ SÌ -

≈ ₩

Thursday

DΔ♀ 2:20 am ⊙□D 7:03 am 4R 7:32 am D→H 6:24 pm

D→H 6:24 pm Dơơ 9:06 pm ⊙∆E 11:49 pm

- 999 xīng qī wǔ

)(

Friday 15

D ★ ₩ 9:41 am D □ ♥ 9:57 am ♥ ★ ₺ 1:22 pm

Life Savings

An elderly man was walking across four lanes of traffic when his bag broke, vegetables rolling all over the intersection. He tried to grab a few things but gave up and hobbled to the curb—his food left laying in the street.

It was rush hour and the light had turned green. On a Friday.

I made the cars wait as I ran over to pick up

purple cabbage, lemons, tomatoes—

living colors splashed across the baking concrete.

The man waved me off, looking at the impatient drivers, "It's no use! There's too much." But I managed to collect every

errant vegetable into the broken bag and set it down next to him at the curb. Running back to my car another driver gave me the "thumbs up" sign.

We all know what it's like to have a bag break.

And probably many bags will unceremoniously break in the future for all of us.

Bags will break, cabbage heads will roll and no one is going to care about your credit score.

Everyone is going to care about you helping the elderly man with his vegetables.

That's our worth. Our currency. Our wealth. Our life savings.

We can invest it locally or use it as we see fit. It's real. It's priceless.

- ttt xīng gī liù

□ Amy Nicole Purpura 2017

 \mathcal{H}

Saturday 16

DσΨ 11:34 am D□♀ 1:35 pm D∗E 8:15 pm

– 000 lĭ bài rì

<u>ተ</u>

Sunday 17

⊙ + ⊅ 12:13 am ⊅ + 4 12:59 am

D ★ 4 12:59 am D → ↑ 6:36 am O △ 4 9:40 am

D*t 10:29 am

Mau

DDD sombar

DApG 12:42 am D+♥ 10:17 am Monday

Through the eyes of love The illusion of separation is removed We have chosen to stand in the middle And be our difference

> from The Queen of Sheba Wisdom Oracle © Miri Hunter Haruach 2014

Tucsday

ooo mongolbar

 $D \times Q$ 1:17 am DOP 8:50 am D04 1:33 pm $D \rightarrow \emptyset$ 7:10 pm Dot 10:58 pm

- 888 budhbar -

X

Wednesday

D ★ ♂ 5:10 am O→II 6:49 am Do쌍 11:07 am ♀□Ψ 4:03 pm

- 444 brihospotibar

Sun in I Gemini 6:49 am PDT

d

D+Ψ 12:19 pm D△P 8:29 pm Thursday

999 sukrobar

8 \mathbf{I}

Friday

Ϋ□Ψ DA4 1:01 am 8:43 am ŽαQ 1:41 am DΔ5 10:12 am ⊙Δ۶ 5:02 am ⊙ o D 10:39 am $D \rightarrow II$ 6:36 am D□0 7:43 pm

2020 Year at a Glance for I Gemini (May 20-June 20)

on january 12 jupiter and pluto join in your eighth house of deep truth and alchemy to aid you in shedding people, habits, and thought patterns that lock you away from your messy/sexy/ powerful selves. these two guides will work with you to conquer fears that keep you from stepping into the deep knowing that comes from lifetimes of living.

jupiter and pluto will join together three times in 2020, (april 4, june 30, and november 12)—opportunities to integrate what cracks open at the start of the year with wisdom and clarity.

when the north node of the moon moves into gemini may 5, your soul work comes to center, and we must all cultivate gemini qualities of sharing, communication and learning, learn yourself and be curious about your needs/wants/and desires. use the new moon in your sign on may 22 to call in exactly the kind of relationship you want with yourself. bravely restructure your relationships as needed on the full moon lunar eclipse in your sign on november 30.

by year's end, saturn and jupiter move into aquarius, your ninth house of belief and ideology, what wisdom are you called to sink into? what wisdom are you ready to share? what faiths allow you to move through your life with honesty and integrity?

> naimonu james © mother tongue ink 2019 - 555 sonibar -

I

Saturday

Sunday

Do9 8:14 pm D□Ψ 10:34 pm

Invocation © Kimberly Webber 2017

- ooo robibar

Dağ D→95 4:09 pm

9:26 pm ♂** 11:48 pm

Seeds of Promise

The Earth knows all the seeds that ever were so peace is already planted justice, too, is there beside empathy and reverence the seeds of awareness lie next to willingness and in a neighbor field are wisdom, trust and care the sprouts of every variety summoning our attention the season urges us to sow the seeds long planted to nurture and watch them grow © Cindy Ruda 2018

Feeding the Ancestors © Rachel Houseman 201.

VI. EARTH ANSWERS

Damp Earth, My Lover

The trees whisper to me in a language of lost words rooted so far down with arms that touch the universe they hold me to their core and gently heal me excerpt © Zoë Rayne 2016 9

Monday 25

D * * 7:34 am D ム で 7:58 am

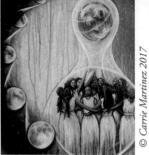

Sister Circle

- ơơơ Đế Máirt

69 0

Tuesday 26

DΔΨ 6:43 am ∀⊼ 4 8:35 am DεP 2:03 pm

D&E 2:03 pm D&4 6:06 pm D→ № 11:33 pm

– yyy Dé Céadaoin

N

Wednesday 27

D ያት 2:42 am ⊙ 米 D 12:02 pm D □ 쌍 2:34 pm

- 444 Dé Ardaoin

N

Thursday 28

- 999 Dé Haoine -

S? 177₽

Friday

D→M/ 4:40 am D+¥ 6:32 am ⊙+₺ 6:57 am ∀⊼₺ 5:25 pm

Waxing Half Moon in TV Virgo 8:30 pm PDT

Grandmothers' University

Vandana Shiva, the nuclear physicist, went back to her land in the Himalayas to save seed for the farmers.

Organic farms, five times more productive than monoculture, lead the way at Navdanya, "Nine Seeds," her farm and home. Saving fifteen hundred seeds, a biodiversity of seeds,

for local farmers to plant.

Farmers in the Cotton Belt of India committed suicide by the quarter million after Monsanto colonized the region.

Monsanto limited to five

the thousands of cotton types known, and from these five, genetically modified, extracting royalties for the farmer's use.

"We learn from the seed.

We learn from the seed generosity.

We learn from the seed diversity."

says Vandana, her smile huge and warm, her eyes alight.

Grandmothers, the elders, are the best link,

the true source of biodiversity.

"the link of the past and to the future,

The Grandmothers' University."

Vandana's way, at Navdanya, her ecological farm.

"I have deep trust in the Earth."

555 Dé Sathairn-

© Annelinde Metzner 2013

Saturdau

D&O" 12:34 am D□Q 8:18 am DεΨ 4:14 pm D∆P 10:46 pm

- ooo Dé Domhnaigh-

Sunday

D→- 7:38 am DΔ5 10:20 am 2:16 pm

MOON VI

June

DDD lunes

Monday I

⊙△D 2:28 am D△Q 8:20 am

– ooo martes

Tuesday

D□P 12:22 am D□4 3:40 am D→11, 9:05 am D□5 11:38 am ♀□♂ 5:41 pm ♪△♀ 7:41 pm ♪PrG 8:29 pm ♪♂₩ 11:16 pm

- ¥¥¥ miércoles -

Wednesday 3

DΔΦ 8:44 am \$PrH 10:10 am Θσ\$ 10:44 am DΔΨ 7:14 pm

- 444 jueves

™ ✓

Thursday /

D ★ P 1:26 am D ★ 4 4:36 am D → ✓ 10:17 am D ★ ħ 12:43 pm

– 999 viernes

Friday 5

 ♥□\$
 6:40 am

 D\$\$
 6:57 am

 ⊙\$\$
 12:12 pm

 D□\$
 12:44 pm

 D□\$
 9:10 pm

Full Moon in ✓ Sagittarius 12:12 pm PDT Penumbral Lunar Eclipse 12:25 pm PDT*

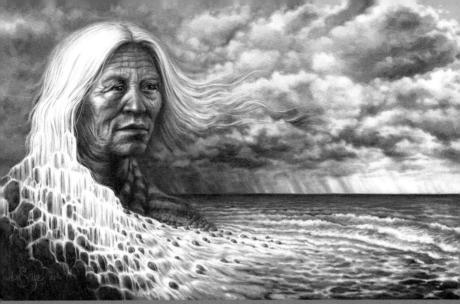

Eternal Waters © Autumn Skye Morrison 2018

Living Waters

Sister, how deep

is the ocean inside you?
swelling in this second,
currents stirring

brewing dreams

you have yet to fathom excerpt © Xelena González 2014

- 55 sábado

2 18

Saturday 6

⊙□♂ 12:11 pm D→% 12:44 pm

-000 domingo

75

D △ ∀ 4:08 am D ℰ ♀ 7:06 am D ★ ♂ 7:06 pm June liù yuè

- DDD XĪNG QĪ YĪ

3

Monday

DOE 8:01 am Do4 11:05 am D→ ≈ 5:54 pm Dot 8:17 pm

1:25 am

 $D*\Psi$

Women hold a vocabulary for joy in their mouths like a field of lavender and bee bellies buzzing a hum back into the earth. D Liza Wolff-Francis 2018

Vocabulary for Joy

ooo xīng qī èr

22

Tuesday

D□쌍 10:30 am D△♀ 12:15 pm

- ¥¥¥ XĪNG QĪ SĀN

22

Wednesday

⊙ Δ D 7:35 am

444 XĪNG QĪ SÌ

22 \mathcal{H}

Thursday

 $D \rightarrow \mathcal{H}$ 2:31 am $\odot \square \Psi$ 2:37 am 2*4 3:50 am

DUS 7:34 pm

8:20 pm

- PPP YĪŊ QĪ WŬ -

 \mathcal{H}

Friday

DAY 5:06 am Dog 7:12 pm DOY 7:51 pm

⊙□D 11:24 pm

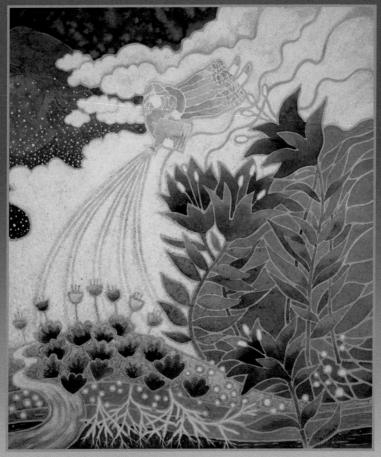

Spring Symphony © Barbara Levine 1997

- the xīng qī liù -

 \mathcal{H}

Saturday 13

D+P 2:56 am D+4 5:45 am σ'σΨ 7:13 am D→↑ 2:03 pm D+ħ 4:12 pm

-000 lĩ bài rì

7

Sunday **14**

D+9 5:24 am DApG 5:49 pm ⊙⊼P 6:57 pm D□ÿ 7:07 pm

Summer Solstice

Summit of full summer. Feel the sun within you shining with abundance, as we blink in the light of that glowing promise, resurrection from death. The triumph of light peaks, slides slowly to dissolve. This is the tipping point for everything: democracy, misogyny, racism, climate, freedom. All are on the cliff edge. We've reached the neon-bright entrance to The Great Turning. Change is the only thing that doesn't change. Are we ready? Trapped between a failed story and a future at risk, it's time to live in mythic terms, to change our language from techno-data to poetry. Gather together in circles; trade material bribes for the ecstasy of interconnection. Every conventional symbol system of our culture is bankrupt, and that's good, because now,

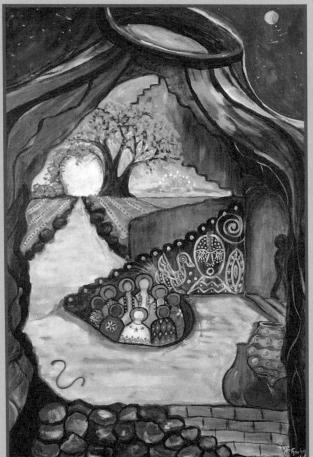

Into the Deep I Go . . . © Maryruth Chorbajian 2011

at last, we have the potential to open, to sway and to fall. Call in the sacred rescue workers: the cultural shamans. the clowns, the shape shifters, the change agents, and let's re-write the rules, now! What will save us? Not profit-driven technology and not imperial force. Only the imagination. What can you imagine?

Oak Chezar
© Mother Tongue Ink
2019

The Bees

A crystal grid beneath the earth's skin mapped their escape route only to be used in case of emergencies like ice caps falling too quickly.

The bees felt the quiver on their furry bodies and knew it was time, sorrowfully carrying out their divine instructions.

Some people who we never saw on the news were dancing their prayers for the ice caps and the bees to hold on, give humanity a little more time

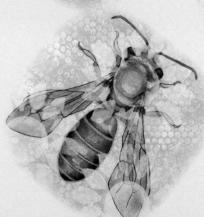

Local Heroes

© Nancy Watterson 2016

June Joishtho

- DDD sombar

Υ

Monday 15

D□P 3:22 pm ⊙ ★ D 5:11 pm D□ 4 5:49 pm

- ooo mongolbar

Υ Υ

Tuesday

- yyy budhbar -

X

Wednesday 17

D ★ ♥ 8:03 am D ★ Ψ 8:18 pm ♥R 9:59 pm

- 444 brihospotibar

Д

Thursday

D + O* 2:16 am D Δ E 3:01 am D Δ 4 5:02 am D - X 2:00 pm D Δ ħ 3:34 pm O* + E 4:08 pm

999 sukrobar -

Д

Friday 19

Dơ♀ 1:40 am

2020 Year at a Glance for S Cancer (June 20-July 22)

the beginning of 2020 is electric for you, dear cancer. two days after a full moon in your sign on january 10, saturn and pluto join across the sky in capricorn. prepare for radical (re)structuring within your relationships, including your relationship to yourself.

wise jupiter will join up with pluto three times this year (april 4, june 30, and november 12) to help you transform your relationships to better suit you. remember: endings make way for beginnings. above all else, be honest with yourself and others, even when sharing your truth feels difficult. your honesty is your magic. have courage.

on july 20 the new moon solar eclipse in your sign (the last for a while) is a potent invitation to call in what you yearn for. no fear, no drama—just your truth. by year end, saturn and jupiter move into aquarius, your eighth house of deep truth and alchemy. after years

of work in your relational realms, now it is time to deepen your contracts. explore your sex and sexuality, your desire for exchange, and allow your wildness to breathe. trust that there will be hard truths that rise to the surface for you to grapple with. worry not, you are ready.

naimonu james © mother tongue ink 2019

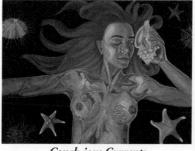

Conch-ious Currents

Monika Andrekovic 2018

99 O

 ♂ ★ 4 12:56 am
 Dr

 D□Ψ
 6:07 am

 ⊙→ ⑤
 2:44 pm

Saturday 20

D□♂ 2:47 pm D→ᢒ 11:02 pm ⊙♂D 11:41 pm

- 000 robibar

Summer Solstice

Sun in S Cancer 2:44 pm PDT New Moon in Cancer 11:41 pm PDT Annular Solar Eclipse 11:41 pm PDT*

ooo robib

Sunday 21

○木 7:14 am ♪ ★ ₩ 4:35 pm

The Frozen Ark

where the DNA of endangered species is being stored

Nested vials in cloudy cold, row on row of species sleeping curled into the single speckle of their DNA. Our Keeper ranks them tier on tier: over here, the big cats caught before they faded to a rumor stalking dreams. I could place them on one hand: Sumatran Tiger reeking of the swampland, Saudi Lioness with her eyes of pale lemon moon. Here, beside the top joint of my little finger sits the emaciated cheetah and look, on my thumb a single mark of rosette-printed snow leopard, whose long ancestral memory seems complicit with this ice.

And will they come back, ever? Will the centuries roll towards a time when we'll afford the grace of empty tracts of land: no wheatfields, war-zones, cities, no mines for rare earth elements or fuel? Will the cats come stepping slowly from their clouds of freezing mist, staring at the way we've engineered another Eden—a brand new wilderness to which we make no claim?

© Rose Flint 2017

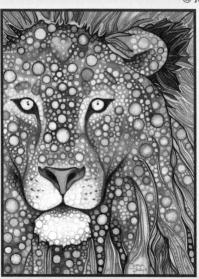

Lion© Tamara Phillips
2016

Moon VII: June 20–July 20 New Moon in S Cancer June 20; Full Moon in S Capricom July 4

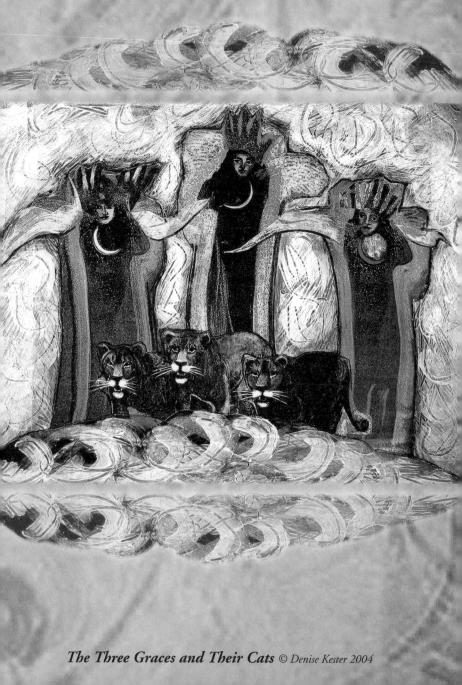

June

- DDD Dé Luain

9

Monday 22

Dag 1:01 am DAY 1:22 pm D&B 7:19 pm D84 8:29 pm ΨR 9:31 pm

- ơơơ Đé Máirt

9

Tuesday 23

D△♂ 12:20 am $D \rightarrow \Omega$ 5:33 am Don 6:31 am D*9 3:05 pm D□쌍 10:34 pm

- 🌣 ÞÝ Dé Céadaoin

S

Wednesday

QD

11:48 pm

- 444 Dé Ardaoin

N

Thursday 25

D→117 10:05 am O*D 6:33 pm 7:17 pm

- 999 Dé Haoine

MP

Friday

DAW 2:44 am D*¤ 7:18 am DeΨ 9:56 pm

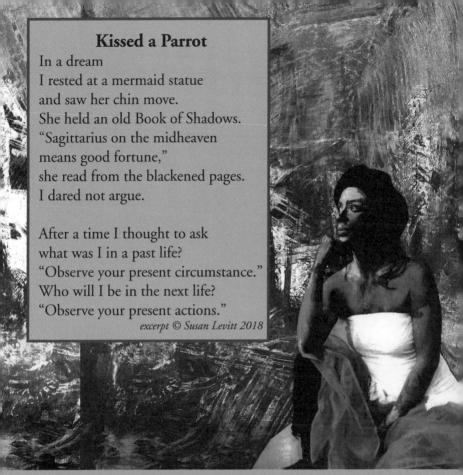

I Create D Rebecca Tidewalker 2013

- 444 Dé Sathairn-

Saturday 27

DΔP 3:24 am DΔ4 3:51 am D8O 1:02 pm DΔħ 1:44 pm ♂→↑ 6:45 pm DΔ♀ 10:34 pm

D&O 1:02 pm D→<u>△</u> 1:16 pm

— ooo Dé Domhnaigh-

Sunday 28

○□D 1:16 am ○** 3:59 am D□¥ 8:13 am PPrH 4:27 pm

Waxing Half Moon in ← Libra 1:16 am PDT

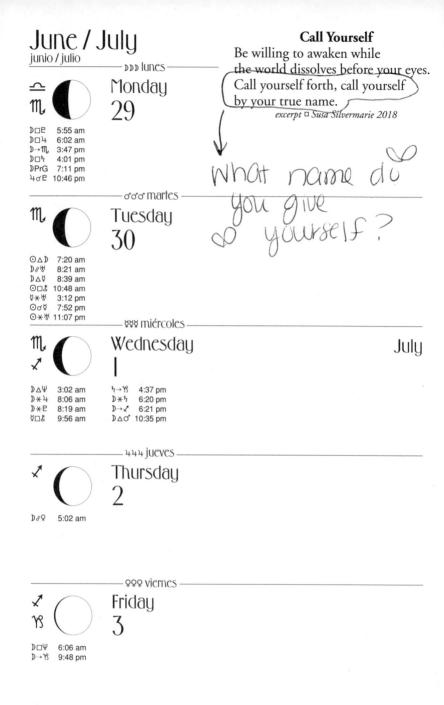

Burn

Please do not fight my fire let it burn devour the putrid remains of what is left of yesterday

your fire hoses and attack dogs keep them away from our bodies mr. officer

please don't arrest tomorrow or the day after

we need them for our planting

in times of war we save seeds from the species extinct from your blow

hide them under our tongues deep below the ground harvest peace long after the fragrance of her fruit has been forgotten

and we will feed you when you come to us on your knees weighed down from weaponry begging forgiveness and water

we will share our medicine until you weep at the resemblance of our faces

you will remember our names and your numbers will crumble to dust bankrupt

your blood money will be as worthless as your guns

excerpt from ClimbingPoeTree, Whit Press (2015).

© Naima Penniman, ClimbingPoeTree.

Used by permission of Whit Press

htt sábado Saturdau

4

D□O 4:28 am D&§ 11:13 am D△₩ 3:19 pm ⊙&D 9:44 pm

ooo domingo

Penumbral Lunar Eclipse 9:32 pm PDT* Full Moon in % Capricorn 9:44 pm PDT

Sunday 5

79

D*Ψ 10:44 am Dσ 4 3:13 pm Dσ E 4:14 pm July gryuè

- DDD XĪNG QĪ YĪ —

Monday

Doħ 2:35 am D→ 22 3:08 am D ★ 0 12:37 pm D △ 9 5:22 pm D □ ₩ 9:37 pm

El Portal, CA D Laurie Bauers 2007

- ơơơ XĩNg qĩ èr -

Tucsday

No Exact Aspects

- ¥¥¥ xīng qī sān

)

Wednesday X

□ 3:41 am

□→ H 11:12 am

□ Δ ▼ 10:34 pm

– 444 XĪNG QĪ SÌ

*

Thursday O

D□♀ 4:15 am D★♥ 6:50 am ⊙△D 11:08 pm

- 999 xīng qī wŭ

 Υ

Friday

DσΨ 3:57 am D ★ 4 7:47 am D ★ B 9:51 am Q ★ Δ 11:36 am D ★ ħ 8:49 pm D → ↑ 10:06 pm at this land known as "the breaks," above the Ogallala aquifer between the creek and the river, the buck stepped into our view just as sun set. we slowed to a crawl. he stood back, turning his heavily antlered head to watch the car pass.

a land, crossed by this road, yes, but never by plow. ragged, wild, rising and heaving in wave-echoes of sea that tossed here long ago, now covering the water you cannot see: ancient, pristine, fossil water, millions of years old.

we broke in a century ago. the water's not likely to last much longer—in places it's already gone. of course it builds up on its own, about an inch a year. the rain finds places to seep in, but not as fast as we can take it out.

the sun sets. our headlights pierce the night and we travel forward following the road. part of me contains the moment that we leave behind, a calm and silent witness of what we do to the earth: deplete, so little time to renew, always pushing on. what happens when the water's gone?

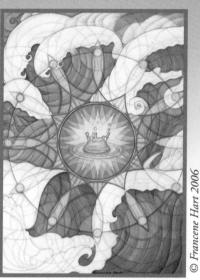

One Drop Wave Vibration

© Cathy Casper 2016

- ħħħ XĪNG QĪ liù

 $^{\Upsilon}$

Saturday 11

D□♥ 9:09 am Large Br 12:16 pm Doo 2:16 pm D★♀ 6:21 pm

-000 lĭ bài rì

Sunday 12

 O□D 4:29 pm D□4 7:25 pm D□P 10:03 pm

Waning Half Moon in T Aries 4:29 pm PDT

July Asharh

- DDD sombar

Υ 8

Monday 13

PPrH 1:49 am
D□ħ 8:54 am
D→Ծ 10:34 am
D★
9:56 pm

- ơơơ mongolbar

d

Tucsday

○84 12:58 am づける 2:07 am りつか 7:14 am

- yyy budhbar -

I R

Wednesday

15

¹+PrH 2:53 am ¹>+Ψ 4:16 am ¹>Δ+ 6:56 am ¹>0 × D 9:50 am DΔP 10:01 am ⊙ያP 12:12 pm DΔħ 8:21 pm D→II 10:19 pm

- 444 brihospotibar

I

Thursday 16

D+♂ 7:26 pm D♂♀ 11:40 pm

- 999 sukrobar -

I

Friday 17

D□Ψ 2:14 pm

Preparation

We can act as if the world of banks, chemical companies and multinationals has already fallen; As if the tide of rising waters has already washed out the ports; the roads already reclaiminggreen grass rising through the cracks, the paths we make, our own.

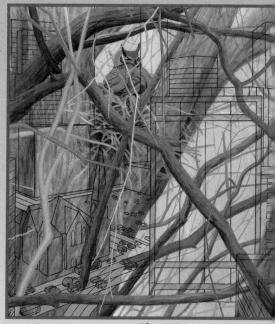

She Waits © Nancy Watterson 2014

We can learn to harrow and hallow, to barter, and join together for our survival-Skills known to Isis singing songs of grief and awakening over the decaying body of Osiris Making it fit for rebirth.

© Gail Nyoka 2018 - 555 Sonibar-

I 9

Saturday 18

D→95 7:24 am DaA 9:19 pm

- ooo robibar

Sunday

5:38 am DOG 9:00 pm

D84 10:27 pm

on the forest floor

i lay my body and ask to be reborn made of ferns and branches and bird calls that this earth she undresses me of my thoughts and connect me to her in the language my blood speaks that she grows tiny roots at the end of my limbs

so she be my anchor my only true home so i can belong to her anywhere the way animals do so that our hearts beat in harmony so that i know the only truth the one she whispers always so that she lives on my lips in my skin

© Sarah Satya 2017

VIII. TRUE HOME

Moon VIII: July 20–August 18
New Moon in S Cancer July 20; Sun in ₹ Leo July 22; Full Moon in ★ Aquarius August 3

You are Home © Rachael Amber 2017 July Mí Iúil

- DDD Dé Luain

S 69

Monday 20

D&P 2:04 am Oo D 10:33 am D&h 10:55 am D→ S 1:16 pm O&h 3:28 pm ካPrH 7:33 pm

Mystical Cat

- ơơơ Đé Máirt

New Moon in S Cancer 10:33 am PDT

N

D□₩ 7:22 am ♥□₺ 8:51 am D△♂ 12:23 pm D+♀ 5:27 pm Tucsday 21

- ¥¥¥ Dé Céadaoin

NP NP

Wednesday 22

⊙→ର 1:37 am ೪+୪ 1:25 pm ♪→୩୬ 4:40 pm

– 444 Dé Ardaoin

Sun in St Leo 1:37 am PDT

MP

Thursday 23

D△₩ 10:16 am D+♥ 11:47 am D□♀ 10:46 pm

- 999 Dé Haoine

₩ --

Friday 2**4**

DβΨ 3:22 am
DΔ4 3:57 am
DΔE 8:05 am
DΔ5 4:08 pm
D→ 6:54 pm
DPrG 10:01 pm
Θ* D 11:32 pm

2020 Year at a Glance for & Leo (July 22-Aug 22)

if you are to heal others you must be vigilant about the ways you need healing too, dear leo. pluto joins saturn in your sixth house of body-spirit reverence on january 12. beware ignoring any part of you; if you have been negligent, your silenced parts may rise up to meet you viscerally. notice the soles of your feet and the beat of your heart. find quiet often and (re)claim meditation practices that suit and support you. attune to your inner rhythms so you can step up into your divine work in this world.

jupiter joins pluto three times in 2020 (april 4, june 30, and november 12)—three opportunities to balance your body-spirit with your work in the world. the full moon in leo on february 8 offers deep insights into routines and rituals you need, to be well in your relationships. listen carefully. on august 18, a leo new moon reminds

you to love all of your selves—continue practicing acceptance, patience, and forgiveness.

by year's end, saturn and jupiter move into aquarius, your seventh house of intimate relationships. your determination to be well will nourish all others in your life.

naimonu james © mother tongue ink 2019

ት አካት Dé Sathairn -

Saturday 25

D□ÿ 6:11 pm D8O 8:50 pm

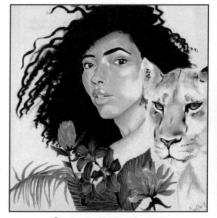

Queen © Chasity Bleu 2018

- ooo Dé Domhnaigh-

Sunday 26

DΔQ 3:44 am D□4 5:41 am D□P 10:12 am

D□P 10:12 am D□[†] 6:09 pm D→11, 9:12 pm July

DDD lunes

m (

Monday 27

○□♪ 5:32 am 4×Ψ 9:07 am ♀☆↓ 10:36 am ♀□Ψ 10:48 am ♀□♂ 2:46 pm ♪ℰ쌍 3:04 pm

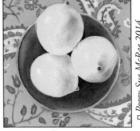

Lemons

Waxing Half Moon in 11, Scorpio 5:32 am PDT

Tuesday 2δ

D △ ♀ 2:04 am D ★ ♀ 8:08 am D △ ♀ 8:18 am D ★ ℮ 1:05 pm D ★ ♭ 9:01 pm

- yyy miércoles -

m, 2

Wednesday 29

D→√ 12:25 am ⊙△D 12:46 pm

– 444 jucves

1

Thursday 30

D□Ψ 12:20 pm DεΨ 5:08 pm Q⊼E 6:50 pm

- 999 viernes

√ 79

Friday 31

D→% 4:58 am ⊙△Å 6:15 pm D△쌍 11:56 pm

Lammas

Feel the passing of summer; as light lessens, we deepen the rhythms of rebirth. This is the first harvest—a time of abundance, our opportunity to assume conscious collective responsibility for creating the future. In this time of grains ripening, as we can also feel the Great Loneliness that wraps our human world, keep asking: What is it we value? How can we align our lives with that vision?

How can we control our population, transition from fossil fuels, eliminate toxic waste, practice wisdom without the sacrifices of technology? How can we stop feeding the world to our machines?

For most of human time we've lived connected to Nature. Over five thousand years of patriarchal values have bent us in the direction of domination by the few and pillage of Earth, but that's just a blink in evolutionary time. Wicca means To Bend. How can we channel the trust of this season, re-shape our lifestyles and re-join the spiral dance of creation and equanimity? A dormant mode of consciousness is willing itself awake within us. Grasp the authority to be cultural shamans and bend our society back to serving life. Rebirth. Re-shape. Re-join. Oak Chezar @ Mother Tongue Ink 2019

She Who Dances in Dirt

SHE who dances in dirt knows the joy of being clean.
SHE who dances in dirt eats a slice of darkness alongside her cup of sunlight.
SHE who dances in dirt can smell the stench and survive, won't hesitate to cry when she feels pain.
She screams until her anguish breeds laughter and her laughter breeds movement.
She proclaims her boundaries loud, proud, with conviction, and believes fervently that her input is valuable
SHE who dances in dirt breathes fully, breathes freely.

SHE who dances in dirt has also flirted with fire, swam in sadness, tasted tragedy, felt the forceful flames of fury rise within her soul then bubble up, out, and over into a salty sea. She has been there. She has gone deep. She knows the meaning of suffering, and has risen from her pain alive and clean—ruggedly scarred—but shining clean.

SHE who dances in dirt does so because she knows her dancing will cause her wounds to heal. Her dancing will connect her with the pulse of the great mother. Her joy atop a mass of confusion will help others learn to trust the dirt, befriend the pain, know its watery depths and in them find power to rise from the black hole. Her dancing will spread until

© Liz Darling 2018

SHE who dances in dirt does not dance alone.
SHE who dances in dirt is one of many who move their bare feet across and into the land dancing, dancing, dancing . . . joyfully, confusedly, wildly, in the dirt.

¤ Anna Ruth Hall 2016

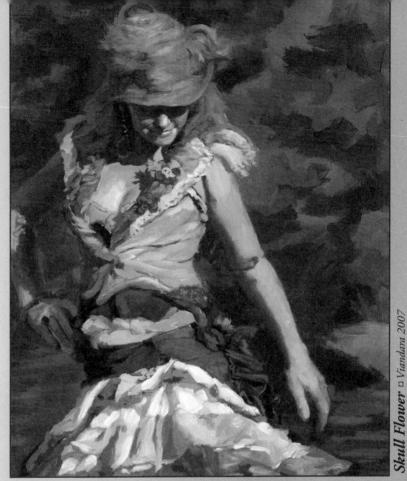

- 444 sábado

¹⁸ (

Saturday

August

ÿεP 3:52 am D□σ 2:22 pm

Dσ4 4:57 pm D×Ψ 5:55 pm DσE 10:57 pm

-000 domingo

79

D&¥ 1:53 am ⊙□₩ 4:19 am Doħ 6:59 am D→ # 11:11 am Sunday 2

Lammas

MOON VIII 123

August

bā yuè

- DDD XĪNG QĪ YĪ -

Monday

Lunar Lammas

DUX 6:52 am 080 8:59 am ¥84 2:00 pm D+♂ 11:45 pm

- ơơơ XĩNg qĩ Èr -

Full Moon in

Aquarius 8:59 am PDT

Tuesday

0"□4 6:06 am DAQ 2:45 pm ₽⊼₺ 3:07 pm $D \rightarrow H$ 7:27 pm À→IJ 8:32 pm

- ¥¥¥ xīng qī sān

Wednesday

 $D \times \forall$ 4:01 pm

- 444 XĪNG QĪ SÌ

Thursday

9:20 am

D*4 DσΨ 11:11 am D*P 4:38 pm

- QQQ XĪŊ QĪ WŬ

Friday

12:53 am D×t DUQ 5:53 am $D \rightarrow \Upsilon$ 6:05 am 9→9 8:21 am DAØ 5:12 pm

Riverbed

Looking though Time's wide-open eye, I remember what it feels like To be braided into the length of a body, to be poured into fleshed form And to breathe the exact number of breaths I have been given Without ever knowing what that number is.

Sometimes
We wake up
All at once
And every cell
Housed in our skin
Summons the way
Back home
To now,
That opens into forever
Without ever knowing
How long forever is.

Love caught me
Love without a face
Or even a song or word
It was love like water
That caught me as I fell
Easily into myself
The way a riverbed
Catches a stone.

¤ Emily Kedar 2018 ——— ħħħ XĪNG QĪ liù

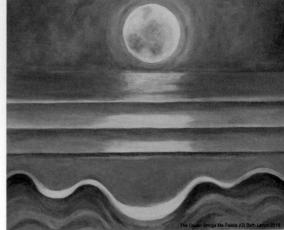

The Ocean Brings Me Peace

Beth Lenco 2018

Saturday 8

⊙△⊅ 3:49 pm ⊅□4 8:44 pm

000 lĩ bài rì

8 **)**

Sunday 9

Dơơ 1:35 am D□P 4:38 am DApG 6:51 am Ṣ△₺ 11:02 am D□5 12:50 pm D→8 6:28 pm D+9 11:23 pm August

- DDD sombar

Monday 10

Bringing it Home © Louie Laskowski 2017

♥□♥ 5:52 am ♪♂♥ 4:05 pm ♪□♥ 6:11 pm ⊙⊼4 11:34 pm

– ooo mongolbar -

8

Tuesday 11

D△4 8:51 am ⊙□D 9:45 am D★Ψ 11:32 am D△E 5:03 pm

– yyy budhbar –

Waning Half Moon in & Taurus 9:45 am PDT

Д

Wednesday 19

D Δ ↑ 12:55 am D → X 6:46 am ⊙ ⊼ ¥ 7:32 am

- 444 brihospotibar

I

Thursday 13

o^{*}□P 12:14 am D ★ ♥ 5:33 pm D □ Ψ 10:16 pm

- 999 sukrobar -

II 66

Friday 14

○ ★ D 1:32 am D ★ O' 4:19 am V T H 4:28 am D → S 4:35 pm

¥⊼Ψ 10:13 pm

Awakening to the Direction Called Home

She began with 8 hatchlings, but only 7 ducklings remain. Her brood follows her in a straight line, then plops awkwardly into the pond to eat bugs and algae, paddle about in safe waters. Sipping coffee, I know spying on them is the best part of my day.

Mother duck stands tall in their midst, a protective giant next to her midget hatchlings, tilting her head, watching for osprey, owls and other dangers. She lets her brood scatter, then feeds hungrily herself, ever vigilant and famished. She works so hard.

When it's time to leave, the ducklings line up to follow her, except for the most independent one, off feeding under a bush, missing the communal exodus. Realizing she's suddenly alone, the duckling panics, then frantically darts about, stridently peeping. If Mama Duck had heard, she would have surely returned for her.

My heart clenches to witness this survival drama. I want to rescue her little fuzzy body, return her to mommy. But this would terrify her, and rob her of the critical lesson: how to find her own way home.

Finally, the little lost one stands still and collects herself. Listens. Then, in this stillness it dawns on her where they often feed and she speedily heads in that direction. I begin to breathe again.

Next time I am lost, in a panic, I want to remember this tiny duckling, awaken to her deeper instinctual wisdom: stop and listen for home, then head there, straightaway. It is simply and always, awaiting my return.

* ななな Sonibar

9

Saturday 15

ooo robibar

১ ভ

Sunday 16

D&4 2:32 am D ΔΨ 5:28 am ダ大日 6:38 am ⊙ △ ♂ 7:02 am D&B 10:23 am D□♂ 12:32 pm ♀□ቴ 4:59 pm ᢧჅћ 4:59 pm Წ△♂ 10:29 pm

D→ຄ 10:38 pm

MOON VIII 127

Inviolate

I see her in the violet darkness through billowing swirls of steam the shadow of her strong, muscular frame Bold against the hardened lava river bed.

I see where she called the loyal alchemists of rock and rubble to rise up through the fissured scars to prepare a soft cradle of soil.

> I see her unwavering stance Arms framing a gateway between the Heavens and the Earth.

With one hand, her long nimble fingers encircle the charred clay vessel fiercely guarding the holy ancient seeds.

The other, raised to the sky
Palm open
Praying for rain.

D Sheryl J. Shapiro 2017

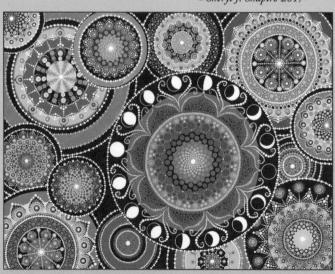

IX. 20/20 VISION

Moon IX: August 18—September 17
New Moon in ℜ Leo August 18; Sun in ∰ Virgo August 22; Full Moon in ℋ Pisces Sept. 1

For My Mother Penn King 2018

August Mí Lúnasa

- ppp Dé Luain

S

OGĀ

DUA

8:07 am

5:01 pm

Monday

Lightworker D Carrie Martinez 2017

- ơơơ Đế Máirt

S

Tuesday

Ϋ́Λ 2:17 am 오米쌍 12:28 pm DAO 4:51 pm OdD 7:42 pm ⊙⊼5 8:48 pm Dơਊ 10:38 pm 18

New Moon in S Leo 7:42 pm PDT

S MP

Wednesday 19

- 🌣 ÞÝ Dé Céadaoin

D→MP 1:20 am ¥→1117 6:30 pm 6:52 pm DVA $D \times Q$ 9:05 pm

MP

Thursday

- 444 Dé Ardaoin

7:13 am DA4 DεΨ 10:15 am DAE 2:48 pm 8:37 pm

- 999 Dé Haoine -

117

Friday

D→ _ 2:16 am DPrG 3:56 am

2020 Year at a Glance for W Virgo (August 22-Sept. 22)

saturn and pluto have been working with you for years to create a foundation for your creative life, dear virgo—to build, day by day, a clear channel to share your radiance, gifts and talents in service of the collective. your foundations undergo a reality check january 12 when pluto and saturn meet in capricorn. any place where integrity and truth are lacking may crumble. praise! for the rebuilding can bring your soul-work and earth-work into greater alignment.

when jupiter and pluto join three times this year (april 4, june 30, and november 12), orient yourself to integrity, truth, and your greatness so these two planets can work with you. cultivate your gifts!

work with the full moon in virgo on march 9 to fine tune the routines and rituals you need, to be well in your relationships to yourself and others. allow yourself to experiment, get it wrong, and make a couple of mistakes. the less pressure you put on yourself and others, the better.

on september 17 a new moon in your sign offers an opportunity to begin again. speak what you want and find the most gentle, nourishing, and kind ways to manifest it.

by year's end, saturn and jupiter move into aquarius, your sixth house, where you offer your unique gifts to the collective from a place of service and compassion. with these two in aquarius, you will be pushed to evolve past your fears of belonging, connection, and groups so you can get to work healing your peoples.

naimonu james © mother tongue ink 2019

Saturday

555 Dé Sathairn

22

D□♀ 1:25 am D□ + 7:45 am ⊙→∏ 8:45 am D□ B 3:34 pm ♥ApH 4:56 pm ♪&♂ 8:35 pm ♪□¹ 9:20 pm

⊙⊙o Dé Domhnaigh

Sun in TV Virgo 8:45 am PDT

Sunday 23

 $\mathbb{D} \rightarrow \mathbb{M}$, 3:16 am $\mathbb{O} \times \mathbb{D}$ 4:35 am $\mathbb{D} \times \mathbb{V}$ 3:42 pm

9:00 pm

August agosto

DDD lunes-

11

Monday 24

ŽΛŽ 6:35 am DAQ 6:51 am $D \times 4$ 9:21 am o"□5 11:19 am DΔΨ 12:47 pm D×P 5:35 pm D * ካ 11:27 pm

Women Will March O Adriana M. Garcia 2015

111.

Tuesday 25

ogg martes

5:49 am ÅΔÄ 8:18 am ⊙□D 10:58 am 284 3:26 pm

– yyy miércoles

Waxing Half Moon in ✓ Sagittarius 10:58 am PDT

Wednesday 26

DUA 2:46 am $\Psi \square \mathbb{Q}$ 4:43 pm

- 444 jueves

Thursday 27

D∆o 5:00 am D→18 10:37 am ΨΔΩ 2:12 pm ⊙△D 8:09 pm

- 999 viernes -

18

Friday

DAW 5:51 am DAY 5:04 pm Do4 6:56 pm

D+Ψ 10:54 pm

Hear Our Vote!

Your time is up. We will weed you out—vote you out of every election large or small—from dog catcher down to president. We will show up at every election and bring others with us. We will run against your tired rhetoric with strong-woman-wisdom of hope and truth. We will tear down walls that separate us and look for that which unites humankind, and with compassion bring together a divided nation. We will work to inaugurate ethics, honesty, trust, accountability and true justice.

Bless and protect all who stand here seeking peace and justice as we continue the Great Work. Help us set our intentions for this new cycle calling to the Wisdom of the Earth and to the Wise One within to guide us. Straighten our backs and warm our hearts as we stand on this cold place.

We are women—hear our Vote!

excerpt \(\mathbb{D} \) Lyrion ApTower 2018

Editor's Note: August 26 marks the 100th Anniversary of the 19th Amendment to the US Constitution. The right of US citizens to vote "shall not be denied ... on account of sex." We honor those determined women who fought so hard to win the vote. We also recognize that women of color struggled in vain to participate in the white-dominated suffragist movement, and were denied the vote for decades in many states and communities. Still today we are fighting underhanded white supremacist tactics that suppress the votes of black and brown people. It is no wonder the dominant forces continue to resist an open democratic process fiercely: They know that the power of the people can, and will, topple racist systems and patriarchy's control of the social order.

ซ Mother Tongue Ink 2019

% **≈** (

Saturday 29

– ooo domingo

Sunday 30

QያE 6:31 am ጀያΨ 11:44 am D□₩ 1:31 pm

August / September

bā yuè / jiǔ yuè

1:54 am

TU TO DATK CCC

22

D+♂ 9:56 pm

\$XO

Monday

Now is the time to stand upright and align our spines to the Goddess Wisdom that has been here the Whole. Fucking. Time . . . Divine! excerpt \(Amy Hyun Swart 2017 \)

ơơơ XĪNG QĪ Èr

22 \mathcal{H}

Tuesday

September

 $D \rightarrow H$ 2:34 am ğΔP 3:42 am

O8D 10:22 pm D + 쌍 11:04 pm

- ¥¥¥ XĪNG QĪ SĀN

Full Moon in H Pisces 10:22 pm PDT

H

Wednesday

284 5:17 am ⊙∆ ් 7:09 am D+4 12:48 pm

DOY 5:09 pm D*P 10:55 pm

- 444 XĪNG QĪ SÌ -

 \mathcal{H}

◊Δ٩

12:22 am

Thursday

Dxt 5:10 am D&A 5:56 am

DAQ 7:34 am 1:22 pm

- 999 XĪNG QĪ WŬ

Friday

2□0, 2:12 am ŽXQ, 6:15 am

Ž¥₽ 1:32 pm

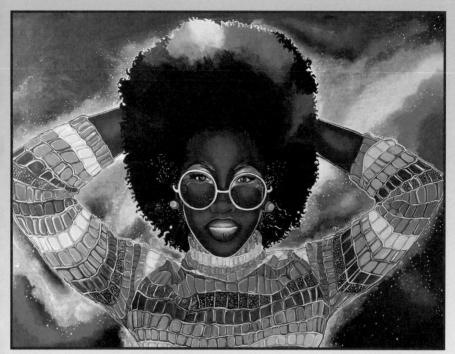

Colorful Queen @ Destiney Powell 2017

the xīng qī liù

T

Saturday 5

D□4 12:26 am D ወ 5:09 pm D o o 9:45 pm D A p G 11:26 pm

-000 lĩ bài rì -

Sunday 6

ଦ→ର 12:21 am $D \rightarrow \emptyset$ 1:43 am

D 🗆 🗣 1:52 am Do쌍 11:00 pm September

Bhadro

- DDD sombar

d

Monday

ODD 9:09 am DA4 1:08 pm $P*\Psi$ 5:35 pm D△P 11:39 pm

The Unsolved Puzzle

– ooo mongolbar

8 I Tucsday

DAt 5:46 am $\mathbb{D} \rightarrow \mathbb{I}$ 2:27 pm D*P 8:41 pm

- yyy budhbar -

I

Wednesday

DAY 1:38 am O∆4 9:04 am o'R 3:22 pm

- 444 brihospotibar -

I

Thursday

000 2:26 am $\Psi \square \mathbb{Q}$ 5:16 am 184 3:24 pm ΨPrH 5:44 pm 9:48 pm DXO

- 999 sukrobar -

Waning Half Moon in I Gemini 2:26 am PDT

I 9 Friday

D-95 1:22 am 08Ψ 1:26 pm D□Å 7:49 pm $D \times \forall$ 8:57 pm

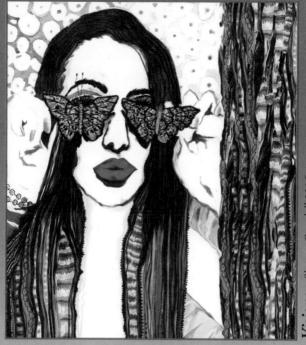

Visions a Shauna

Stand for the Divine

Know this deeply in your body: *The game is not over!* You have seen the weeds breaking though concrete, You have seen bravery in the darkest hour, You have seen the walls fall down.

You know that there is power and magic in the Divine.

555 Sonibar

excerpt © Patricia Dines 2016

99

Saturday

12

 ⊙ ★ D 3:44 pm 4D 5:41 pm D&P 7:19 pm

- ooo robibar

30

Sunday 13

D&ħ 12:37 am ♀△₺ 4:25 am D□♂ 5:05 am D→௳ 8:32 am D♂♀ 11:53 pm

Reclaiming

We are the descendants of generations of women who were told that they were sinful or crazy. We are the descendants of generations of women who were not believed. We are the descendants of the women who had to hide their ability to heal, on pain of death.

This is the time of reclaiming.

We are reclaiming the lost Feminine and birthing it through our shame-less female bodies, into the modern world. We are reclaiming lost Feminine voices and self-expression, and listening to them at last. We are reclaiming our communities as places where these values are cherished. We are reclaiming our magic.

We are reclaiming healing ritual. We are reclaiming our intuition as a valid and necessary way of knowing. We are reclaiming our connections with each other, the natural world, and directly to soul and spirit. We are reclaiming a direct connection to our own life force. We are reclaiming the wholeness of ourselves—our lightness and our dark.

We are reclaiming the traditions of our people—forgotten, punished, ignored, supplanted—gratefully relearning the ways

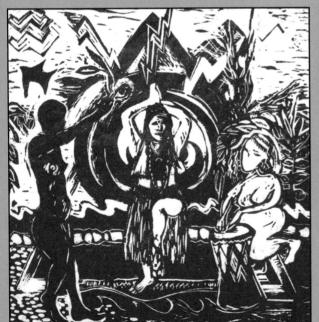

of other healers, from those who have kept their traditions alive against all odds, through times of peril.

In this, the time of the great unraveling, it is time to reclaim our birth-right.

© Lucy H. Pearce 2018

Wild Women
© Sara Steffey McQueen
2011

X. THE WITCHES ARE BACK

Moon X: September 17—October 16 New Moon in ™ Virgo Sept. 17; Sun in △ Libra Sept. 22; Full Moon in ↑ Aries Oct. 1

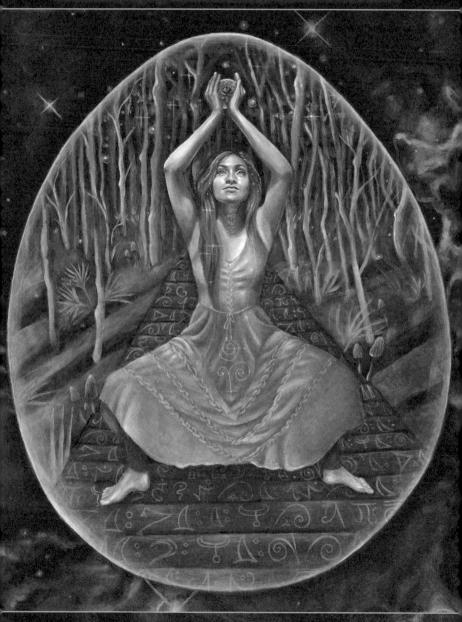

We Are The Ones We Have Been Waiting For © Emily Kell 2016

September Mí Meán Fomhair

ppp Dé Luain

S

Monday 14

May I be open to magic in all its wild, mysterious, and beautiful forms.

May I have no fear of my own power and may I walk through my other fears with courage.

excerpt © Molly Remer 2018

DUA 2:33 am D×A 7:53 am ⊙∆P 4:09 pm

- ggg Dé Máirt -

Tuesdau

8:09 am DAO 오□쌍 8:29 am D→117 11:37 am

- yyy Dé Céadaoin

117

Wednesday

DAW 4:24 am DA4 3:54 pm PSY 7:03 pm

444 Dé Ardaoin

Thursday

D△P 12:06 am **₽**□4 3:34 am

OdD 4:00 am DAT 4:42 am

D→ 11:56 am ⊙Δ۶ 2:36 pm

999 Dé Haoine

New Moon in TV Virgo 4:00 am PDT

Friday

DPrG 6:51 am $P \times Q$ 9:41 am

άΖΨ 1:05 pm

D04 3:35 pm DaA 7:08 pm

D□P 11:39 pm

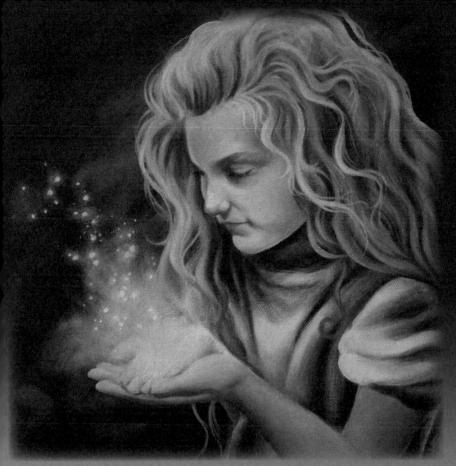

I Opened It @ A. Levemark 2010

+ รรร Dé Sathairn

<u>~</u> m

Saturday 19

⊙⊙ Dé Domhnaigh-

M,

Sunday 20

D&₩ 3:56 am D□♀ 1:42 pm D++ 3:51 pm

D★4 3:51 pm D△¥ 6:47 pm ♥□P 10:21 pm

Fall Equinox

Perfect balance returns, light and dark in harmony again for the final harvest. As we wheel in the last-lit days of seasonal symmetry, face the coming darkness together with gratitude for what we've learned about light. Autumn's grain is spring's seed; paradox surrounds us with ripening wisdom. If we lose hope, remember that Hope has two daughters to support our balancing acts: Anger and Courage. Instead of passive hope, embrace radical willingness. The good news is that an organism under attack creates blooming antibodies, devoted to restoring original health to the world's immune system. Activists are that devotion.

The season of barrenness mists her breath on our windowpanes—a foreshadowing—yet we're full of our gathering visions. What holds you back? Every minus is a plus that just needs a stroke of vertical awareness. Awake, ask what do you want to harvest into your life? Find the courage to move forward into action. Science and love, the two most powerful poles of humanity have been so fiercely separated. The truth is, we're all connected; the greatest disability is, we don't believe this. Believe it. Practice powerful participation in the great circus of life. Find balance on the wild trapeze.

Oak Chezar @ Mother Tongue Ink 2019

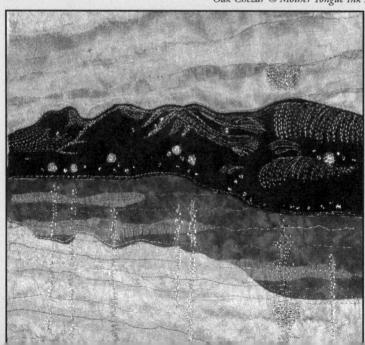

Jeweled Evening © Winter Ross 2002

A Hag's Guide to Spring Cleaning

Scrub your skin with the dirt from a hollow hill. Brush your body with raven feathers and the blessings of a million hags gone before who have never given a shit about what looks "nice" to others.

Take all the pots and pans out of your kitchen, clean them with black salt, and bring them outside with your spoons and knives. Make a racket to wake up the earth and let the neighbors know that their local

hag has woken up from winter slumber.

Water your garden with the tears shed by those suffering from fragile masculinity to help them grow towards their heart instead of their fear.

Stitch up your worn out clothes with the red thread of intersectionality and luck. Scare the life back into your heart by grinning so loudly in the mirror that you can see every tooth, fang, and monster song gurgling forth from the back of your throat.

Go to a crossroads, turn to the east, and spit three times so that you never forget how to find your way back. Stain your lips and fingers with the blood of berries. Braid thorns into your hair and rub rose dust into your eyebrows.

Never say you're sorry for making it to another spring. Cackle instead and celebrate the ugly bits that have kept you alive.

Lace up your boots with the stories of your ancestors raging against powers they were told were unbreakable but have long turned to dust.

Greet your witchen kin with right hands grasped, left hand over the heart of the other, foreheads touching. Breath in, breath out. Say, "I fucking love you." Remember that hags like you grow like weeds and springtime will never be the same.

□ L. Sixfingers 2018

September

septiembre

DDD lunes

111

Monday

D*P 12:07 am D×t 4:50 am ⊙ + D 11:13 am D→ ₹ 12:32 pm 9⊼4 6:12 pm

- or or martes

 $\Psi \square \Phi$

Tuesday

⊙→ <u></u> 6:31 am DAQ 8:34 pm 9:20 pm Fall Equinox

- yyy miércoles

Sun in ← Libra 6:31 am PDT

Wednesday 23

₽□ħ 3:38 am $\Psi \Lambda \Psi$ 5:45 am Dפ 8:31 am Dムプ 10:31 am D-18 4:16 pm $\odot \square D$ 6:55 pm

- 444 jueves

Waxing Half Moon in \(\gamma \) Capricorn 6:55 pm PDT

3:53 am D ム は 10:20 am Thursday 74

- 999 viernes

Friday

Do4 12:11 am D×Y 3:00 am DOB 9:09 am Dot 2:26 pm 4:12 pm DOG DUA 8:36 pm

D→ ≈ 11:08 pm

2020 Year at a Glance for \triangle Libra (Sept. 22-Oct. 22)

pluto joins saturn on january 12 in your fourth house of home, roots, and family. what is home to you? where is it? and how hard are you willing to work to (re)build it? there is deep, visceral work for you to do here, work that will support you in creating truly nourishing homes and familial environments. jupiter and capricorn join three times in 2020 (april 4, june 30, and november 12) to help shift the ways you relate to home, security, belonging and family.

the full moon in your sign falls on april 7. (re)strengthen your boundaries and deal with any relationship ish that rises up. are you able to find home in your beloveds, friends, and community? begin again on the new moon in your sign on october 16, remember this

life is yours to co-create with the divine!

by year's end, saturn and jupiter move into aquarius, your fifth house where you learn to balance your obligation to the collective with your obligation to your joy. both are important. is there a way you can bring them into alignment? dissolve any fears of belonging so you can get out of your heart's way and live in alignment with its desires.

naimonu james © mother tongue ink 2019

Mwelu (Inner Light)
© Jenny Hahn 2011

- ๖५५ sábado

Saturday 26

♀⊼₽ 2:22 am ⊙△⊅ 6:30 am ⊅□쌍 6:01 pm

-000 domingo

Sunday 27

Ŭ→¶, 12:40 am D&Q 10:04 pm

September / October

jiǔ yüc/ shí yuc̀

TU TD DAIX add -

Monday 28

D+o 12:17 am $\mathbb{D} \rightarrow \mathcal{H}$ 8:34 am **PrH** 8:42 am D∆¥ 11:44 am ♀⊼ち 1:23 pm ₽Δσ 6:01 pm ħD 10:11 pm

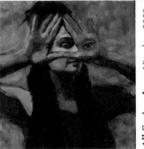

All Seeing Aye a Viandara 2008

 \mathcal{H}

- ơơơ XĩNg qĩ Èr -Tuesday 29

D*A 3:58 am 28€ 1:44 pm o"□t 2:49 pm D * 4 7:40 pm DσΨ 10:00 pm

- ¥¥¥ xīng qī sān

H

Wednesday

DXE 4:50 am D×t 10:29 am D→ ↑ 7:47 pm

444 XĪNG QĪ SÌ

Υ

Thursday

October

08D 2:05 pm

ŬW ĪĐ ĐNĪX QQQ−

Full Moon in TAries 2:05 pm PDT

Friday

D04 7:58 am 9→117 1:48 pm 5:00 pm DOP Dơơ 8:57 pm D□5 10:47 pm

⊙ 下 場 6:31 am

Remembering Cassandra

We have imbibed the story of Cassandra subconsciously. You may never have heard her legend before in your classroom or at your grandmother's knee, I certainly hadn't. But we know it in our bones.

Cassandra was a woman who was gifted by Apollo with the ability to prophesy. She spoke aloud what was going to happen. But no one believed her prophecies: they were too disturbing to the comfortable reality of those around her. And so she was confined to the care of a warden, driven mad from being disbelieved. Again and again she warned them . . . *Something's wrong. Something's very wrong.*

But they did not listen. The painful irony was that it was not really the truth that people could not heed. It was that it came through the body and voice of a woman. That was unbearable.

You see, Cassandra instructed her twin brother in the power of prophecy. Unlike his sister, people believed him. People listened to him when he said: *Something's wrong. Something's very wrong.*

We are the Cassandras of our world, gifted with highly sensitive bodies that feel what the System would have us ignore. We have been taught to distrust our own body systems, to distrust our inner knowing. We have internalized the message that there's something wrong with *us*, rather than that there is something wrong in the world.

Listen carefully. *Something is wrong. Something's very wrong.* It's time for us to believe ourselves and rewrite the story with this knowing.

© Lucy H. Pearce 2018 - 555 XĪNA AĪ liù Saturday D→8 8:12 am D△♀ 10:13 am DApG 10:21 am 10:17 pm 호조분 10:55 pm - 000 lĭ bài rì X Sundau Dow 3:59 am 6:32 am D△4 9:07 pm D+Ψ 10:37 pm

MOON X

October

- DDD sombar

d I Monday

D△P 5:50 am DΔ[†] 11:41 am D→II 9:03 pm

- ooo mongolbar -

I DOP

o'PrH 7:00 am

Tucsday

- yyy budhbar -

I

Wednesday

ODD 2:18 am D□Ψ 10:51 am A8A 1:56 pm D+♂ 6:57 pm

- 444 brihospotibar

I 9 Thursday

\$74 8:18 am D-5 8:45 am D*♀ 11:16 pm

> Time to order We'Moon 2021! Free Shipping within the US October 8-13th!

Promo Code: Lucky13 www.wemoon.ws

999 sukrobar

9

Friday

Dxy 3:14 am DAY 5:03 am O'DE 6:09 am 000 5:39 pm D84 8:17 pm DAY 8:43 pm

Waning Half Moon in S Cancer 5:39 pm PDT

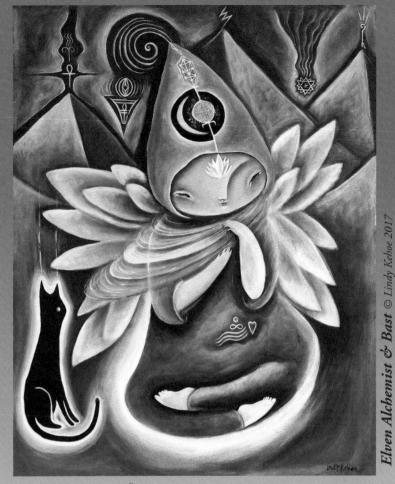

ትትት Sonibar -

9 N

Saturday 10

DOO DEE 3:05 am 3:36 am 9:04 am

D→8 5∇A 4:08 pm

5:24 pm

000 robibar

2

Sunday ||

⊙□4 6:34 am ⊙⊼Ψ 8:30 am D□₩ 10:27 am D□♥ 1:50 pm

October

Mí Deireadh Fomhair

N MP

 $\odot * D$

DAG

ά¥Φ

4:09 am

7:29 am

9:39 am D→117 9:56 pm Monday

12

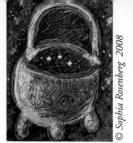

Cauldron

- ơơơ Đế Máirt -

117

Tuesday 13

DAW 1:35 pm 080 4:26 pm D×A 5:19 pm ğΒ 6:05 pm

- 🌣 ÞÝ Dé Céadaoin

MP

Dað

7:55 pm

Wednesday

14

D&W 4:47 am DA4 5:12 am D△P 10:55 am DAt 3:47 pm D→<u></u> 10:54 pm

- 444 Dé Ardaoin

Thursday

15

⊙□P 3:15 am

- 999 Dé Haoine -

Friday 16

D04 5:06 am D80 6:49 am D□P 10:22 am OơD 12:31 pm Dot 3:11 pm DPrG 5:00 pm D→111, 10:05 pm

New Moon in ← Libra 12:31 pm PDT

Remember Witch, Remember

Take your feathers, leaves, and bones. Add to them your roots, your stones. Mix them in your cauldron's womb. Dance for rain and add that, too. Your time is now, each heartbeat rings: Remember Witch, Remember.

You know the way, you know the song. You've walked this path your whole life long. Drumbeat sounding, heartbeat pounding The Ones before you, love resounding. With every turn of season, moon With every deosil swirl of spoon You chant the words, you hum the tune: Remember Witch, Remember.

The stars are out, your feet are bare. Your arms are raised into the air. No one told you what to do. You knew the way, the Way knows you. So let it go. Release it down. Heart and blood and bones to ground: Remember Witch, Remember.

> 🗆 Brandi Woolf 2017 555 Dé Sathairn

Don 12:37 pm Dağ 2:52 pm Saturday

000 Dé Domhnaigh-

DXQ 3:05 am PΔU 3:28 am D*4 4:39 am

0□5 6:58 am Ψ8₽ 7:49 am Sunday

9:42 am 2:43 pm

D-1 9:43 pm o"□4 10:37 pm A swirling mist rises as they descend and as they arise. They arrive cloud-hewn and dew-drenched from their travels through time, culture, and place at a convergence of lake, river, stream, and ocean. They ride oak brooms and lope in on shining braided horses. They whirl dervish on air streams and whoosh in on flying tapestries. Some ride chariots ablaze, some themselves not cloaked in purely human bodies, their fur ruffed from the long travels. Some are carrying the serenade songs of the holy waters, some bring the healing balm.

Some appear as black rock mothers, volcanoes, earth emerging. Others, ancient crones, wrinkles crazed with passion, savvy, and wisdom accompany fresher faces that shine with a resonant ardor, desire to share learning, and activate wisdom. Some carry babes in their arms or starmilk on the breast, while others heft lightning, arrows, balsam, or doves as they groundswell. The stars shine brightly from within, among, and upon this growing convergence.

Paints fly out across sacred texts, forming words. Strings, flutes, and tambourine delight and ripple out: music in a welcome echoes in the constellations. Women and goddesses awaken, on the move, converge. A bridgework forms from our worlds to this exceptional convergence. These sentinels—the wisdom carriers, the path blazers, summoners, stokers of powers, old friends, world makers, heart tenders, catalysts of gifts—turn to welcome us and crowd the bridge from their realms to ours.

🗆 marna 2013

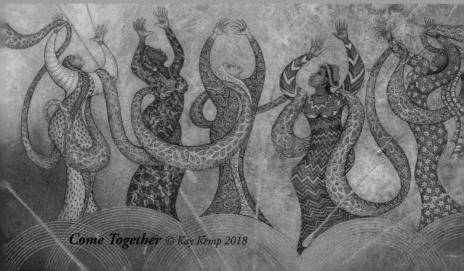

XI. ARISE, ANCESTORS

Moon XI: October 16-November 14

New Moon in \(\to \) Libra Oct. 16: Sun in \(\text{10. Scorpio October 23: Eurl M.} \)

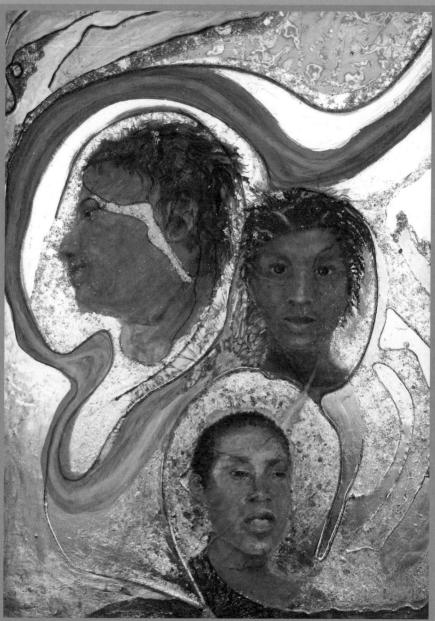

October

- DDD lunes

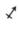

ଦ⊼ଟ 12:03 am QΔ4 12:35 am X8X 7:53 pm

Monday 19

Cry of the Raven
© Pat Malcolm 2007

aga martes

4:19 am

DUY 5:08 am DAG DOP 8:28 am ⊙ + D 8:38 pm D→% 11:44 pm Tuesday

- yyy miércoles -

Wednesday

D+♥ 12:49 pm PAP 2:42 pm D △ 쌍 3:32 pm

- 444 jucves

Dog

8:16 am

 $D \times \Psi$ 8:23 am Do4 10:44 am 3:40 pm Thursday

⊙→111, 3:59 pm DAQ 6:09 pm 3π 6:34 pm 9:35 pm Don

Friday 23

Sun in M. Scorpio 3:59 pm PDT - 999 viernes

18

 $D \rightarrow \infty$ 5:17 am ODD 6:23 am

DUA 2:49 pm D□쌍 10:02 pm

Waxing Half Moon in

Aquarius 6:23 am PDT

2020 Year at a Glance for M. Scorpio (Oct. 22-Nov. 21)

saturn and pluto have been working with you for years to take responsibility for your words and thoughts, as above, so below, as within, so without. what you think and speak is what will come to be! listen on january 12, when pluto and saturn join in your third house of listening, sharing and the mind, what lessons are pouring through? open yourself to new thoughts and new words. keep going, keep grounding, keep breathing.

jupiter meets pluto three times in 2020 (april 4, june 30, and november 12). cut away words, thoughts and actions that block your blessings. if you yearn to shift your external reality, start with

your inner mindscapes.

the full moon in your sign falls on may 7; be dynamic in your commitments and imbue them with your life energy and attention. begin again on the new moon in your sign november 14. what new terrain are you ready to navigate?

by year's end, saturn and jupiter move into aquarius, your fourth house, where you create foundations for the collective to thrive.

empower yourself as an innovative builder of family, community and space. you may be called to be a warrior for your people and to protect those who need shelter and care, there is no other better suited for this work, dear scorpio.

naimonu james © mother tongue ink 2019

555 Sábado

Saturday

ğΡrΗ 4:10 am 215 8:40 am D+♂ 2:54 pm

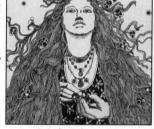

© Sudie Rakusin 1992

-000 domingo

Sundau

D→) 2:18 pm 6:59 pm ⊙△D 8:30 pm October

shí yūè

- TŲ TP DNĪX dad -

Monday 26

D + \ 7:44 am

— ơơơ xĩng qī Èr

Tuesday

DσΨ 2:40 am D++ 6:38 am D+P 10:58 am D++ 5:46 pm

D ★ ħ 5:46 pm ∀→ <u>Δ</u> 6:33 pm Q→ <u>Δ</u> 6:41 pm

– ¥¥¥ xīng qī sān

 \mathcal{H}

Wednesday 2δ

D→↑ 1:44 am DβQ 2:32 am ⊙⊼\$ 2:32 pm

– 444 XĪNG QĪ SÌ

^T (

Thursday 29

Dơơ 11:33 am D□4 7:39 pm D□E 11:26 pm

– qqq xīng qī wŭ

8 T Friday

D□ħ 6:30 am D&Ў 9:12 am DApG 11:43 am D→Ծ 2:19 pm &PrH 10:22 pm

Samhain

The witches' new year. Time when the fields lie empty and the year lies down. The gates of life swing open, the dead lean in. Our world's veil is at its thinnest; we peer through the lace to find that growing edge. We meet in Deep Time, everywhere and nowhere, to greet the triple goddess who is the circle of rebirth. Over one shoulder lean the ancestors; over the other, unborn future beings peer. Remember this: we are 4 billion years old. It's taken evolution all this time to produce us, and our action will express that genius. We're an unfinished animal, fighting metaphysical battles in the physical world; flesh and breath in confrontation with abstractions. This is the battle of the human epic. Modern stories of our powerful vision express a reclaimed, authentic future, a remedy. Exalt in the never-ending journey of change. Seed becomes fruit. Fruit becomes seed. The beloved dead surround us, calling us to use our lives while we can in the service of the bigger life. The unborn future crowds 'round, waiting. It's up to us. This chaos is a seedbed for the future. Oak Chezar © Mother Tongue Ink 2019

AND THE PROPERTY OF THE PROPER

I am You @ Owner 2018

Outraged Ancestral Mother Prayer

Outraged Ancestral Mother fill my veins with your singing

Sweep me up.
Stir my passion
until I might be worthy
of your chorus
of enraged beauty.

Embed your call for action in my feet that I may never again walk in thoughtlessness or inattention each step becoming a beat of your drum.

I will howl with you in the hurricane's roar and the tornado's fury

I will crack my lightning and split my life open gaze at the red pomegranate seeds within and I will eat Knowing that some part of me will belong in the underworld forever.

Lash the remainder of my heart to hope bind my heartstrings around destiny and open my throat that I might bellow on the winds of change and inspiration . . .

© Molly Remer 2013

Moondancer© Debra Hall 2016

Ancestral Healing

It is liberating to consider that when we heal an ancestral pattern, we are not only freeing future generations, but healing backwards through time, liberating all those souls who were left unresolved, unforgiven and misunderstood.

excerpt from Belonging: Remembering Ourselves Home © Toko-pa Turner 2017

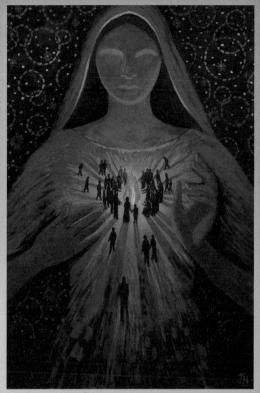

Refuge © Jenny Hahn 2016

əşə xing qi liù Saturday

31

Samhain

○ 8 D 7:49 am D o W 7:55 am ○ 8 W 8:53 am

-000 lĩ bài rì

Full Moon in & Taurus 7:49 am PDT

8 Sunday

D×Ψ 2:31 am D△4 8:07 am ∀□ 11:12 am November

Daylight Saving Time Ends 2:00 am PDT

November

Kartik

- DDD sombar

8 I Monday

 $\mathbb{D} {
ightarrow} \mathbb{I}$ 2:00 am DAQ 4:31 pm 3 Shelley Anne Tipton Irish 2009

Surrender

ooo mongolbar

I

Tuesday

9:50 am DXO 9:56 am $P\Box\Psi$ 2:43 pm タ大学 6:22 pm

- yyy budhbar -

I 9

Wednesday

DAY 5:48 am D-5 1:45 pm

- 444 brihospotibar

9

Thursday

Dxy 6:18 am D□♀ 10:22 am

ODD 5:07 pm Dog 8:08 pm

999 sukrobar

9

Friday

♥□ħ 1:08 am DAY 1:13 am D84 8:00 am

D&E 9:41 am Don 4:52 pm DUA 5:26 pm

D→ର 11:18 pm

Missing You

What would a celebration
of women be
without holding space
for the absence
of you? All of you.

You, who were taken leaving no trace but the salt of our tears. It has been years, yet all the red tape in the nation will not silence this endless grief.

Her auntie said that red is the only colour the spirits can see.

So this is my bleeding invitation to attend, to witness, to be among celebrated women,

to know you are honoured, to know you are missed.

In 2010, artist Jaime Black from Winnipeg, Manitoba started "The REDress Project." Empty red dresses were installed in public spaces, symbolizing murdered and missing indigenous women. "The REDress Project" installations and individual art pieces of all media have continued to demand attention across my nation.

555 Sonibar

© Janis McDougall 2017

a

3:41 am

Saturday 7

⊙⊼♂ 3:41 am ♪□쌍 2:49 pm

ooo robibar

N

Sunday 8

D+♀ 12:36 am D△♂ 3:39 am ⊙□D 5:46 am

November

Mí na Samhna

– ppp Dé Luain

য 1117

Monday

D*♥
 3:04 am
 D→TP
 5:30 am
 ♀♂
 8:08 am
 D△৬
 7:50 pm
 ⊙△Ψ
 9:11 pm

Doña Rosa

Carmen R. Sonnes 2014

– ơơơ Đé Máirt

MP

Tuesday 10

- 🌣 ÞÝ Dé Céadaoin

₩ <u>~</u>

Wednesday

D Δ ħ 2:58 am D→ <u>Ω</u> 8:09 am Q ⊼ Ψ 4:31 pm

– 444 Dé Ardaoin

<u></u>

Thursday 12

D&O' 8:50 am 4♂E 1:39 pm D♂Q 3:31 pm D□E 9:00 pm D□4 9:04 pm

- 999 Dé Haoine

<u>∽</u> M,

Friday 13

D□ħ 3:32 am D→Ⅲ, 8:19 am Dơឫ 1:44 pm ƠD 4:36 pm D♂Ყ 9:10 pm

I Will Fling My Wanton Heart

I will fling my wanton heart, with every fiber of my being, to touch the face of distant stars

I will dream the happiness life and live the happiness dream
I will live like an expanding universe and pop black holes like candy
hitch rides on shooting stars, travel in caravans of light
I will spiral through the galaxies, go skinny dipping in the Milky Way
I will fly into the sun
just to see how it's done

the crone's life may seem to be a shrinking a quieting, a disengaging into stillness and resignation a withdrawl to small, as one awaits the fading light and the closing of the curtain but, no.

the crone, in her marrow, knows otherwise tends her inner garden like an astronaut preparing for missions in space

the heart cannot but expand like the universe itself reaching outward, forever reaching outward with love, with resilience, with gratitude, into spirit into the realms, into the domains of spirit

I will fling my wanton heart, with every fiber of my being, to touch the face of distant stars

- 444 Dé Sathairn-

□ Shelley Blooms 2018

m ()

Saturday

Lunar Samhain

14

DPrG 3:43 am ⊙ ★ ₽ 11:48 am D Δ Ψ 1:05 pm ⊙ ★ 4 7:57 pm D*E 8:31 pm D*4 9:03 pm

⊙dD 9:07 pm

ooo Dé Domhnaigh-

New Moon in 111, Scorpio 9:07 pm PST

Sunday 1.5

₽⊼₺ 1:35 am D★5 3:13 am D→

7:47 am

ν→√ /:4/ am ♀□Ε 11:43 am ♀□Ч 9:33 pm

Awaken

We are in the wake of a great shifting awaken

you better free your mind before they illegalize thought

there's a war going on the first casualty was truth and it's inside you

the universe is counting on our belief that faith is more powerful than fear

and that in the shifting moment we'll all remember why we're here

in a world
where you're assassinated
for having a dream
and the rich
spend 9 billion a year
to control our ideas
and visions are televised
so things aren't what they seem

we gotta believe in a world where there's room enough for everyone to breathe we were born right now for a reason we can be whatever we give ourselves the power to be and right now we need

day dreamers
gate keepers
truth speakers
light bearers
bridge builders
web weavers
food growers
wound healers
trail blazers
cage breakers
life lovers
peace makers

give what you most deeply desire to give every moment you are choosing to live or you are waiting

why would a flower hesitate to open? now is the only moment

rain drop let go become the ocean

excerpt from Climbing PoeTree, Whit Press (2015)

© Naima Penniman, Climbing PoeTree. Used by permission of Whit Press

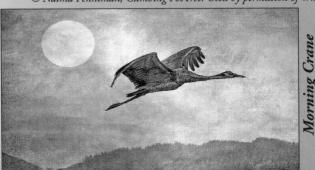

Morning Crane © Lyndia Radice 2018

Moon XII: November 14—December 14

New Moon in ¶, Scorpio Nov. 14; Sun in ✓ Sagittarius Nov. 21; Full Moon in 耳 Gemini Nov. 30

Solstice Song a Diana Denslow 2009

November

noviembre

- DDD lunes

DΔ0 8:21 am $\Psi \square \mathfrak{A}$ 1:06 pm D+♀ 11:54 pm

Monday

Shine Your Light for the Whole World to See

- ooo martes

ጀያሣ 12:07 am D→% 8:35 am D△₩ 10:00 pm Tuesday

- ¥¥¥ miércoles -

18

Wednesday lδ

D+♥ 12:31 am D□♂ 10:42 am D+Ψ 3:34 pm ⊙*\$ 11:17 pm Do₽ 11:58 pm

- 444 jueves

18

Thursday

Do4 1:43 am 우미차 3:28 am Dot 7:51 am D 🗆 🗣 8:16 am ⊙ + D 8:30 am D→ ≈ 12:25 pm

- 999 viernes -

Dロ쌍 2:41 am D□ÿ 12:15 pm D+♂ 4:49 pm Friday

2020 Year at a Glance for ✓ Sagittarius (Nov. 21-Dec. 21)

you are worthy, dear sagittarius, not because of the work you do, or the people you help, or your potent intuition. you are worthy simply because you are. saturn and pluto join in your second house of value, resources and worth on january 12. the pressure of these two may crush any external sources of worth that keep you slurping the illusion that you need something outside of yourself to be whole. these two may also bring some stark money realities to your surface. move breath by breath, moment by moment.

jupiter meets pluto three times in 2020 (april 4, june 30, and november 12). (re)build your resources and sense of self-worth from the ground up if you need to. tend to your physical, tangible reality—money, home, body—so your spirit is supported in its deep transformation work.

the full moon in your sign falls on june 5. how can you cultivate a practice of choosing joy in the face of uncertainty and challenge? begin again on the new moon in your sign on december 14. shake off anything threatening to dull your shine, and move firm and deliberate toward yourself.

by year's end, saturn and jupiter move into aquarius, your third house of communication and the mind. open yourself to new thoughts and new words to describe the shifts in your foundations.

MOON XII 167

November

shí yī yuè

- DDD XĪNG QĪ YĪ

 \mathcal{H}

Monday 23

DΔ♥ 5:37 am DσΨ 7:31 am D*E 5:17 pm &ΔΨ 8:40 pm D*4 8:47 pm

© Jan Kinney 1999

- ơơơ XĪNG QĪ Èr -

 \mathcal{H}

Tuesday 2**4**

D+5 2:44 am D→T 7:05 am ⊙△D 1:12 pm

- yyy xīng qī sān

Υ

Wednesday 25

Չ⊼፟ይ 8:46 am ⊅ơሪ 3:39 pm

- 444 XĪNG QĪ SÌ -

Х

Thursday 26

D□P 5:50 am D□4 10:15 am ⊙△\$ 1:52 pm D□ħ 3:46 pm DApG 4:27 pm

DApG 4:27 pm D→8 7:43 pm

- PPP XĪNG QĪ WŬ

X

Friday 27

 The Art of Load-Bearing and Distribution

Last night under a sky that was filled with more starlight than blackness I threw up my attachments Aiming the big, heavy bundle At a shooting star In a hope it would take my burden with its burning speed Dispersing it into the universe Shredding it to pieces

D Jules Bubacz 2018

Freedom from the Imprint

© Gaia Orion 2017

8

the xīng qī liù Saturday

D×Y 8:28 am ΨD 4:36 pm DAP 6:40 pm 6:51 pm DΔ4 11:53 pm

000 lĩ bài rì

⊙ 下 ₩ 12:20 am D&¥ 12:33 am 4:48 am

MOON XII

169

Nov. / Dec. Kartik / Ogrohaeon

DDD sombar

I

Monday 30

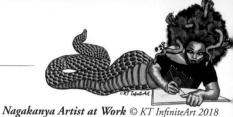

080 1:30 am ¥ * 11:01 am D×ď 6:12 pm $\Psi \square \Phi$ 8:22 pm

> Full Moon in I Gemini 1:30 am PST Penumbral Lunar Eclipse 1:43 am PST*

- ooo mongolbar -

I 90 Ŭ→√ 11:51 am

D→95 7:33 pm

Tuesdau

December

- yyy budhbar -

9

Wednesday

D + ₩ 10:00 am D∆♀ 11:42 pm

- 444 brihospotibar

9

Thursday

DΔΨ 6:32 am 4:21 pm D&B D84 10:52 pm

- 999 sukrobar -

9

D84 2:29 am $D \rightarrow \Omega$ 4:53 am

DAB 1:51 pm

ŞΔŞ 4:40 pm DUX 6:38 pm Friday

The Black Sheep Gospel

- 1. Give up your vows of silence which only serve to protect the old and the stale.
- **2.** Unwind your vigilance, soften your belly, open your jaw and speak the truth you long to hear.
- **3.** Be the champion of your right to be here.
- **4.** Know that you must accept your rejected qualities, adopting them with the totality of your love and commitment. Aspire to let them never feel outside of love again.
- **5.** Venerate your too-muchness with an enduring vow to become increasingly weird and eccentric.
- **6.** Send out signals of originality with frequency and constancy, honoring whatever small trickle of response you get until you reach a momentum.

- 7. Notice your helpers and not your unbelievers.
- **8.** Remember that your offering needs no explanation. It is its own explanation.
- **9.** Go it alone until you are alone with others. Support each other without hesitation.
- **10.** Become a crack in the network that undermines the great towers of establishment.
- **11.** Make your life a wayfinding, proof that we can live outside the usual grooves.
- 12. Brag about your escape.
- 13. Send your missives into the network to be reproduced. Let your symbols be adopted and adapted and transmitted broadly into the new culture we're building together.

excerpt from Belonging: Remembering Ourselves Home © Toko-pa Turner 2017

9 9

Saturday 5

⊙△⊅ 6:41 am ⊅□♀ 1:47 pm ⊅△♂ 2:28 pm ♀△Ψ 8:53 pm ♀⊼♂ 10:41 pm

- ooo robibar

as (

Sunday

♥⊼₩ 4:42 am D→117 11:46 am

December

Mí na Nollag

– DDD Dé Luain

M

Monday 7

D△₩ 12:45 am D□¥ 3:24 am ⊙□D 4:36 pm DεΨ 7:45 pm

Waning Half Moon in TV Virgo 4:36 pm PST

– ơơơ Đế Máirt

Tuesday

 δ

D+9 12:21 am
D△P 4:52 am
D△H 12:09 pm
D△h 2:35 pm
D→△ 4:01 pm

- 🌣 ÞÝ DĆ Céadaoin

Wednesday

⊙□Ψ 11:40 am D+∀ 1:13 pm ⊙+D 11:22 pm

– 444 Dé Ardaoin

Thursday

D&O* 12:31 am Q*E 3:52 am D□E 7:21 am D□4 2:58 pm D□1 4:56 pm D→11 5:58 pm

O∆o 10:01 pm

- 999 Dé Haoine

M,

Friday

Dε₩ 5:43 am DΔΨ 11:35 pm

No Fear

The year cancer came to ask me for the next dance i was booked solid. those sharp teeth cut through every other circumstance to bite my life clean and set an unforgettable edge on eternity.

one moment at a time, you learn the steps: when to lead, where to follow how to be still . . . floating on trust as on a deep pool while fiery hands and sterile rooms work their magic

Open the door to Pandora's closet, and unexpected miracles tumble out: angels, sharks, friends and lovers; strangers offering hope and healing. And at the bottom of the heap, love enough to transform the whole world. Open the door, and you're free.

Bathrobe Boogie
© Jakki Moore 2013

ุต Mimi Foyle 2013

M.

Saturday

12

D*E 8:17 am DPrG 12:52 pm DØQ 12:59 pm D ★ 4 4:23 pm D ★ 5:58 pm D → ₹ 6:39 pm

⊙⊙⊙ Dé Domhnaigh-

Sunday 13

ÿ□Ψ 3:38 am

MOON XII 173

For the Courageous

You who replants today despite unwelcoming soil so tomorrow can be worthy of the roots; Your children will grow up to be oak trees

You who cracks lies until the grass finds enough spine to break concrete and taste rain for the first time;
Your children will sing unconquered through hurricanes

You who have named the nameless and spoken of their suffering so we never forget the familiarity of their essence; Your children will be unashamed of their reflection

You who pushes against the jagged perimeters thrusting your weight until you can mold freedom regardless of the danger;
Your children will dance bravely through sorrow

You who goes barefoot and empty handed despite the boots heavy and gun you've been given leaving destiny untouched;
Your children will be prophets, have fate pressed against their eyes

You who has been brave enough to move through the earthquakes of heart-break and carry with permanence love into ancestry; Your children will forgive the ghosts who have haunted their nights and open the door for their departure in the morning

excerpt from Climbing PoeTree, Whit Press (2015)

© Alixa Garcia, Climbing PoeTree. Used by permission of Whit Press

XIII. HOLDING IT TOGETHER

Moon XIII: December 14–January 12, 2021 New Moon in ♂ Sagittarius Dec. 14; Sun in ℅ Capricorn Dec. 21: Full Moon in ℅ Cancer Dec. 29

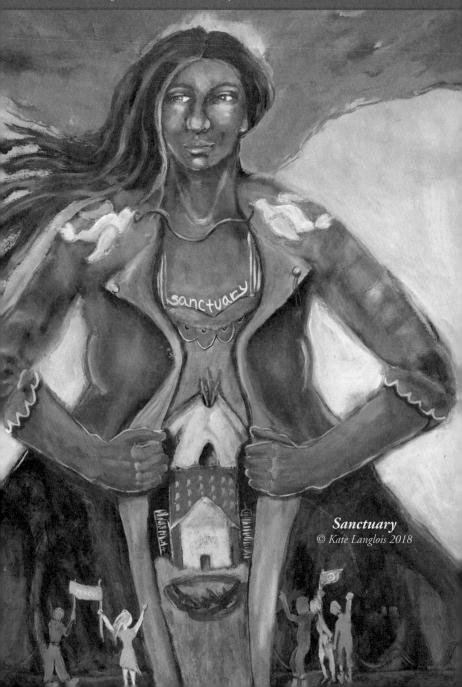

December

diciembre

DDD lunes

Monday

D□Ψ 12:15 am Dağ 2:42 am DAO 4:14 am OdD 8:17 am ♀×4 12:58 pm D→18 7:35 pm ΔΔΟ, 8:24 pm 14

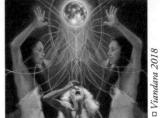

Primordial Prayer

Total Solar Eclipse 8:15 am PST* New Moon in ✓ Sagittarius 8:17 am PST

79

Tuesday

- ogg martes

9×5 5:00 am DAK 7:22 am 9→1 8:21 am \$D 1:08 pm

- ¥¥¥ miércoles -

18

Wednesday 16

D×Y 2:11 am DOG 7:32 am DoP 11:33 am h→æ 9:04 pm Do4 9:34 pm D→ 2 10:27 pm Dơħ 10:28 pm

- 444 jueves

22

Thursday

D*Q2:16 am D□₩ 10:50 am ¥ApH 11:46 am

- 999 viernes -

Friday

D+0 2:08 pm D+♥ 11:49 pm

My Grief, My Love for the World

I watch the dancer, one arm framing her face, one hip drawing upward in the belly's rhythm. The dance of mature women, Raqs Sharqi, born of the sensuous music of the Middle East. Her hips pull us into infinity, an inward-outward shout of beauty and desire.

In Cameroon, babies learn music while strapped to Mama's back.
Coming of age, boys leap high, beaming with the village's newfound respect.

In Bali, the gamelan orchestra cues the dancer with clangs and thumps, the bodies telling stories of monsters and gods, each movement of eyes, and fingers, and feet a perfectly timed posture of sacred geometry.

Oh humans, can't you love all this? Each culture born of each unique place, and each of us expressing in our own way? Doesn't this beauty tear at your heart, that everywhere we draw up our Earth's strength through our feet, though our hands, and we thank Her with leaps and turns? Oh humans, oh infinite diversity, aren't you breathtaken, aren't you amazed? Don't you treasure each other, for the vastness of what, together, we are?

ph Shodo

**excerpt © Annelinde Metzner 2014*

Saturday H 19

 ⊙*D 12:45 am
 D□♀
 2:40 pm

 D→H
 4:39 am
 D*₩
 5:50 pm

 4→∞
 5:07 am
 ⊙ơў
 7:26 pm

 ♀△₺
 7:22 am

______ 000 domingo

H

Sunday 20

§→% 3:07 pm ⊅ơΨ 3:34 pm ♀⊼쌍 10:11 pm

Winter Solstice

The longest night gifts us with time to enter the darkness, fully. We hold our breaths with nature, where life is suspended, waiting in extremis. The stillness behind action gathers as we empty and trust in our renewal. What will you give/lose to the night?

Death is a metaphor; learn to keep dying. The old symbol systems are dissolving at our feet. We need a new language to speak to the crisis of denial and despair. Imagine new models of love, work, health, education, security. Claim your inner resources, and fasten your seat belt. Like Copernicus, we're engaged in a cultural rescue attempt—we're not the center, but one species among millions. Like Cassandra, we shake others awake from the slumber overtaking them. We've got to see through the assumptions and fears, awaken to the warning signs of a world slipping away—in fire, in water, in our human collusion, in all directions. Our stories close their circle to enfold us. All the old laws are thrown into the cauldron of Solstice, as we embrace the ground of what death doesn't touch.

Oak Chezar @ Mother Tongue Ink 2019

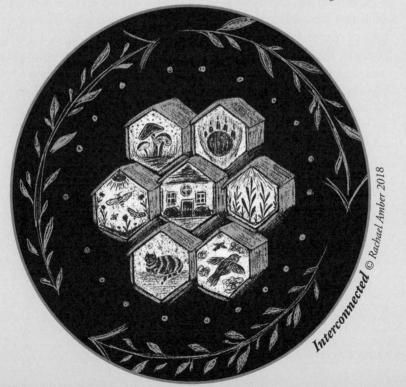

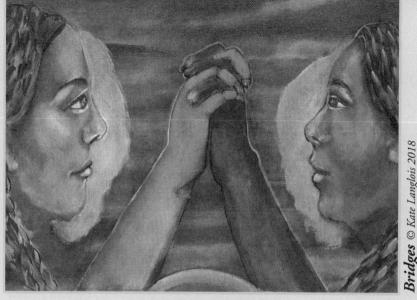

A Paradigm of Plenty

Our planet's ills are too many, too large, too seemingly hopelessdaily the tales of injustice and further insults to all I cherish bombard my awareness. What to do? I take heart from those, so often women, around the globe-planting crops in Kenya to nourish families and halt erosion; learning solar techniques to bring light to villages in Asia; winning battles to halt environmental degradation in Columbia, Canada, the United States . . . My spirit soars when I read of ecologically sound fish farming in Spain, of new methods of water purification in India, of the small house movement in the States. My goal is to focus on the local, the hopeful, the constructive,

to exchange despair for a paradigm of plenty.

I look to my own communal home—five diverse women sharing land, learning to honor differences, cooperate, thrive. Easy? Not always, though we grow accustomed now to the work of consensus. I take heart from small achievements: each struggle towards harmony a vital stitch in the world's glorious fabric we mend with our willingness to create new ways of living. Do we disagree on where to build a new chicken coop? How can we match our areas of agreement to the needs of the land, each other? What will work best for the environment? Can we each yield a little here, take a little there, strive for balance and contentment? Of course we can. And we do. The end result: healthy hens, delicious eggs, abundance. D Helen Laurence 2018

December

shí èr yuè

īu īd daīx ada -

Monday

Winter Solstice

O→18 2:02 am D*P 2:24 am 4ơቱ 10:20 am D→T 2:32 pm

3:33 pm D * 4 3:36 pm ODD 3:41 pm 6:04 pm DUA

Sun in YS Capricorn 2:02 am PST Waxing Half Moon in T Aries 3:41 pm PST

D∆9 7:56 am

Tuesday

- ơơơ XĪNA QĪ Èr -

- ¥¥¥ xīng qī sān

Wednesday

O,DE 6:53 am DOP 2:36 pm 2:51 pm Dag \$□\$ 6:11 pm

444 XĪNG QĪ SÌ -

D→8

Dot

D04

Thursday

9:48 am

3:57 pm

4:56 pm

OAD 2:55 am 4:31 am DΔĀ Dak 5:10 am ቑል₩ 11:05 pm DApG 8:35 am

. • PP X<u>Ī</u>Ng QĪ WŬ

d

Friday

D+Ψ 4:10 pm ⊙□å 11:37 pm

2020 Year at a Glance for \(\gamma \) Capricorn (Dec. 21-Jan. 19)

your shedding continues in 2020, commit to honesty with yourself and others, for integrity of spirit and soul is how you will make it through this high pressure, high stakes year.

on january 12, pluto and saturn will join together in your sign, an opportunity for soul-level (pluto) restructuring (saturn) of how you relate to your selves. what rises up for your gentle edits will likely change for good. praise! for even through heartbreak, you are heading toward your truth.

jupiter will join with pluto three times in 2020 (april 4, june 30, and november 12), open up to (re) membering who you are and what it is you are here to do. expect your relationships to change as you

do, particularly during the full moon lunar eclipse in your house of intimate relationships on july 4. work with the wild energies of pluto, jupiter, and saturn—they are key to your greatness and legacy.

saturn and jupiter move into aquarius, ruler of your second house of resources in december—vision what you yearn to manifest and go after it.

naimonu james © mother tongue ink 2019

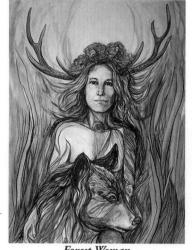

Forest Woman D Cary Wyninger 2018

- ttt xīng qī liù

d I

Saturday

DAE 3:32 am 3:32 pm $D \rightarrow II$

DAt 5:41 pm

6:54 pm

- 000 lĩ bài rì -

I

Sunday

⊙ Δ ∀ 7:25 pm D8♀ 10:47 pm

December 2020 / January 2021 Ogrohaeon / Poush DDD sombar I Mondau 28 $\Psi \square \mathbb{Q}$ 3:59 am D+♂ 7:01 pm - ooo mongolbar I Tuesday 9 D-5 2:28 am D*A 3:32 pm 7:28 pm 08D Full Moon in S Cancer 7:28 pm PST - ¥¥¥ budhbar -9 Wednesday ₽□Ψ 2:19 am Deg 8:04 am DAY 1:31 pm - 444 brihospotibar 9 Thursday S D&E 12:10 am 1:56 pm 4:05 pm DOG 5:45 am D84 D→ຄ 10:58 am D口쌍 11:26 pm -999 sukrobar January 2021 S Fridau 3:18 am **ት**ትት Sonibar S Saturday MP DAQ 3:24 am DAO 2:00 pm D→MP 5:13 pm

1 D△₩ 5:12 am

-000 robibar Sunday

⊙∆D 5:44 pm

Eclipse

Go home!
Light a bonfire
in the heart of your community.
Hang lanterns from the trees
like constellations.
Dance circles in the dark,
alone and together
as the wheel turns.

excerpt © Sophia Rosenberg 2015

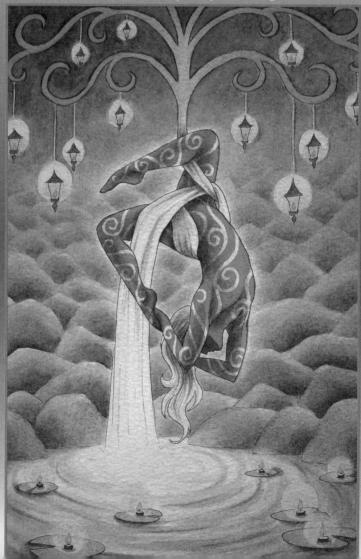

Ripple Effect © A. Levemark 2013

We'Moon Evolution: A Community Endeavor

We'Moon is rooted in womyn's community. The datebook was originally planted as a seed in Europe where it sprouted on women's lands in the early 1980s. Transplanted to Oregon in the late '80s, it flourished as a cottage industry on We'Moon Land near Portland in the '90s and early 2000s, and now thrives in rural Southern Oregon.

The first We'Moon was created as a handwritten, pocket-size diary and handbook in Gaia Rhythms, translated into five languages, by womyn living together on land in France. It was self-published as a volunteer "labor of love" for years, mostly publicized by word-ofmouth and distributed by backpack over national borders. When We'Moon relocated to the US, it changed to a larger, more userfriendly format as we entered the computer age. Through all the technological changes of the times, we learned by doing, step by step, without much formal training. We grew into the business of publishing by the seat of our pants, starting with a little seed money that we recycled each year into printing the next year's edition. By the early '90s, when we finally sold enough copies to be able to pay for our labor, Mother Tongue Ink was incorporated as We'Moon Company, and it has grown abundantly with colorful new fruits: a datebook in full color, a wall calendar, greeting cards, a children's book, an Anthology of We'Moon Art and Writing, a Goddess-poetry book.

Whew! It was always exciting, and always a lot more work than anyone ever thought it would be! We learned how to do what was needed. We met and overcame major hurdles along the way that brought us to a new level each time. Now, the publishing industry has transformed: independent distributors, women's bookstores and print-based publications have declined. Nonetheless, We'Moon's loyal and growing customer base continues to support our unique womyn-created products, including the Anthology and the new We'Moon translation *en Español!* This home-grown publishing company is staffed by a steady and highly skilled multi-generational team—embedded in women's community—who inspire, create, produce and distribute We'Moon year in and year out.

Every year, We'Moon is created by a vast web of womyn. Our Call for Contributions goes out to thousands of women, inviting art and writing on that year's theme (see p. 234). The material is initially

reviewed in Selection Circles, where local area women give feedback. The We'Moon Creatrix then collectively selects, designs, edits, and weaves the material together in the warp and woof of natural cycles through the thirteen Moons of the year. In final production, we fine-tune through several rounds of contributor correspondence, editing and proofing. Approximately nine months after the Call goes out, the final electronic copy is sent to the printer. All the activity that goes into creating We'Moon is the inbreath; everything else we do to get it out into the world to you is the outbreath in our annual cycle. To learn more about the herstory of We'Moon, the growing circle of contributors, and the art and writing that have graced its pages over the past three and a half decades of women's empowerment, check out the anthology *In the Spirit of We'Moon* (see page 229).

Sister Organizations: We'Moon Land, the original home of the We'Moon datebook in Oregon, has been held by and for womyn since 1973. One of the first intentional womyn's land communities in Oregon, it has continued to evolve organically towards a sustainable women's community and retreat center, on 52 acres, one hour from Portland. Founded on feminist values, ecological practices and earth-based women's spirituality, we envision growing into a diverse, generationally interwoven community of women-loving-women, friends and family, sharing a vision of creative spirit-centered life on the land. We host individual and group retreats, visitors, camping, workshops, events, periodic holyday circles, lunar/solar/astrological cycles and land workdays. FFI Contact: wemoonland@gmail.com We'Mooniversity is a 501c3 tax-exempt organization created by We'Moon Land residents for outreach to the larger women's community. WMU co-sponsors occasional events and projects on the land and aspires to become a hub—online and on land—for women's lands, herstory, culture, consciousness, spirituality, and for We'Moon-related publications, classes, and networking resources. wemooniversity.org, wemoonland.org, wemoon.ws OreGaia: Northwest Womyn's Fest, now in its 3rd year, is the newest annual event on We'Moon Land. Contact us for camping, visits and events on the land: wemoonland. org, oregaia.com, wemooniversity.org, wemoon.ws

Musawa

Mother Tongue Ink 2017

WE'MOON TAROT

Announcing a We'Moon Tarot Deck: now in the final stages of production . . . to be available next year with *We'Moon 2021*: the 40th Edition of We'Moon!

As a co-founder and editor of We'Moon since it began in 1981, I am excited to be able to sample the whole pallet of We'Moon art spanning the turn of this century—to

Wild Card© Jakki Moore 2013

create a We'Moon Tarot deck as an oracle for our times! We are tapping into the creative wisdom of We'Moon to re-configure a Tarot deck from a contemporary multi-cultural feminist perspective, grounded in earth-based women's spirituality/empowerment/consciousness, with diverse perspectives from international women's cultures and our individual life experiences.

A We'Moon Tarot deck has been a subliminal work-in-process since 1990, when we first started basing each annual edition on the archetypes of the Major Arcana cards in Tarot (the number of each card corresponding with the last two digits of the year). The spiritual quest of the Fool's journey (0) that started in 2000 comes full circle with The World Card (XXI) in 2021. The outcome—personally, planetarily or politically—remains to be seen. What we can foresee at this point is that it's In Her Hands! No matter what other forces are at play with The World card in *We'Moon 2021*.

While the 22 Major Arcana cards personify different aspects or stages of spiritual development, portraying the larger cosmic influences bearing upon us, the 56 cards of the Minor Arcana reflect the karmic influences that shape our individual personal life stories and how we respond to any given situation. The Minor Arcana consists of four elemental suits (like the four suits in an ordinary deck of playing cards) that represent the four elements in nature (earth, water, air and fire) and related dimensions in human nature (physical, emotional, mental, and energetic). By drawing from the treasure chest of We'Moon art over the years, the We'Moon Tarot provides intuitive keys to our inner guidance for finding our way through the transformations in our lives and in this pivotal period in herstory.

Musawa

Mother Tongue Ink 2019

WE'MOON ON THE WEB

Come see what we're up to at wemoon.ws! Stay up to date with what's going on by signing up for **Weekly Lunar News**, a brief and lovely reminder of upcoming holy days, astrological and lunar events, and **We'News**, a periodic mailing announcing Mother Tongue Ink releases, specials and events! You can browse our products, old and new, keep an eye on the creation and conversation around We'Moon Tarot, and explore our astrological connection by reading the sun sign and weekly Starcodes! There's so much to learn by browsing the site—from how to donate to our Women in Prison program to exploring the history of We'Moon land and We'Mooniversity. Then you can dive into our vast web of artists and writers, get lost in spirituality and astrology, health and wellness, and even music, eco-friendly practices and green building! We hope you enjoy and come back often!

Kim Crown Mother Tongue Ink 2016

From left to right: Top Susie, Sue, Bethroot, Leah & Sequoia Bottom: Ricky, Whiskey Pickle, Barb, Stella Bella & Dana

STAFF APPRECIATION

I want to send out big kudos to the amazing women I get to work with in the We'Moon office on a daily basis. Sequoia, crafty and agile graphic and web designer, brought more brilliant ideas to the table. Bethroot, wordwitch extraordinaire, also came out with a new book: *PreacherWoman for the Goddess: Poems, Plays, Invocations and Other Holy Writ* (see page 229). Leah, imaginative and resourceful production assistant and promo prodigy, energized us with innovative thoughts and perspectives. Sue, multitalented mastermind in production accounts and bookkeeping keeps the wheels of We'Moon oiled and lively. Susie, the many-armed goddess in the shipping department, and Dana, steadfast and hilarious shipping assistant, kept the office humming along and We'Moons flying out the door to their destinations, while keeping us laughing.

I also want to thank the talented and creative women whose work you see in these pages. You can read about each of them, starting on page 190, and become a contributor yourself! See page 234.

Barbara Dickinson © Mother Tongue Ink 2018

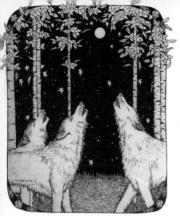

Moments of Prophecy and Promise © Sudie Rakusin 1992

We'Moon Ancestors

We honor wemoon who have gone between the worlds of life and death recently, beloved contributors to wemoon culture who continue to bless us from the other side. We appreciate receiving notice of their passing.

Beverly McClellan (1969–2018) An accomplished musician and singer in blues, rock and folk traditions, Beverly started playing piano at 4, and went on to learn guitar, trumpet, French horn, mandolin, ukulele, djembe, and a wide range of percussion instruments. She played with several bands before recording solo albums. An out lesbian, Beverly was a favorite performer at MichFest Women's Music Festival.

Sheila "Isis" Elaine Brown (1944–2018) lived in and around women's communities

since the 1980s. She was all about Love, as a mother, sister, networker and organizer, a spirited human rights activist and environmentalist. She loved truth and stillness, was a dancer, artist, and a hard worker who often worked on crew for MichFest, as land steward for the Women's Peace Encampment, and as a Chief Firekeeper for Sanctuario Arco Iris. Proud of both her African and Native American roots, Sistah Isis was a warrior of prayer, called upon at times of life crisis. She serves in Spirit now.

Jeanette "Running Mouth" Spencer (1942–2019) Prolific author, poet, playwright, photographer, comic, friend and miraculous Survivor, Jeanette wrote: "Death is a fool/inside of me/something I have learned to live with" (We'Moon 1990). She was an early WOC resident of WHO Farm, originator of Oregon Critters, a founder of the Portland Saturday Market, and dedicated We'Moon devotee. Jeanette signed the customs papers to bring some of the first datebook copies into the US for distribution circa 1983.

Marion Woodman (1928–2018) was a distinguished psychoanalyst and author, who wrote and taught in mythopoetic language about primal archetypes at the heart of feminine identity. She popularized Jungian psychology and brought its elements into therapeutic work with women, especially those dealing with eating disorders and depression. Her books and "BodySoul Workshops" broke new ground in the liberation of women from patriarchal constraints on consciousness and self–understanding.

Mary Oliver (1935-2019) was a beloved and celebrated poet. Author of 20 volumes of poetry, winner of the Pulitzer prize and many other honors, she shared with us her reverent, plain-spoken wonder at the natural world. Every encounter—with flower, insect, songbird, swampland—became a fascinated, observant inquiry into the essential life force and a gently surprising lesson in everyday holiness. She was attentive to sharp edges and dark undertow, but her straightforward joy to be alive, always to be discovering, created devotion even among the poetry-shy.

Melanie Kaye Kantrowitz (1945–2018) was a Jewish lesbian feminist and a devoted activist against racism and for economic and social justice. She authored poems and essays, and was an early editor of the lesbian cultural journal *Sinister Wisdom*. As an academic, she taught Jewish studies, race theory, queer and gender studies; and she insisted on the intersectionality of oppressions before that phrase was in common use. She taught the first Women's Studies course at UC Berkeley, and her work against domestic violence in Portland, OR, was among the first such programs in the US.

Ntozake Shange (1948–2018) wrote plays, novels, childrens' books, poetry and essays, and was a unique voice in American literature. She created innovative writings on racial justice and women's empowerment, centering strong black women. Her most influential work is the choreopoem *For Colored Girls Who Have Considered Suicide When the Rainbow is Enuf.* Growing up during the tumults of the US civil rights movement, she was one of the first black children to attend formerly all—white public school. In the early 1970s, she adopted two Zulu names: "She who comes with her own things" and "One who walks like a lion."

Oxana Shachko (1987–2018) was a Ukrainian artist and a founder of the feminist activist group FEMEN, known for topless demonstrations protesting against sexual exploitation of women, and demanding women's rights/civil rights for all, worldwide. Oxana's artwork, called *Iconoclast*, featured traditional Orthodox icons satirized to confront religious dogma. She died of suicide at age 31 after long—term disappointments in her political and professional work.

Singing Breeze (1956–2019) Beloved community member, We'Moon devotee and writer, published in *We'Moon 2015*. She gracefully ended her own life, leaving 55 years of journals, tasking two close friends with the production of her book, on reclaiming death. Singing Breeze leaves a legacy of love. "I have not really gone away, I am between the winds, I am the ocean...I am the embers in the campfire, lifting, up to the sky....I am everywhere. I AM LOVE."

Sue Hubbell (1935–2018) wrote *A Country Year, A Book of Bees* and other insightful and contemplative books about the natural world, including the world of beekeeping where she landed as a middle–aged divorcee. She explores how a solitary older woman can fit into the scheme of things. A self–reliant feminist joy inhabits these meditative essays, these encounters with a forced competence which, she writes, "I realize as I lie here on the creeper under my Chevy, has made me outrageously happy."

Winnie Madikisela Mandela (1936–2018) was an outspoken and defiant leader of the anti-apartheid movement in South Africa and was fondly know by many as "the Mother of the Nation." She was married to Nelson Mandela and was his lifeline to the freedom struggle during his 27 years of imprisonment. Divorced from Mandela after the first two years of his presidency, Winnie continued her activism and served several terms in Parliament; her political reputation was tarnished by a number of scandals, but her place of honor is enshrined in the hearts of South Africans, proud of their liberation and their sovereignty.

© COPYRIGHTS AND CONTACTING CONTRIBUTORS

Copyrights for most of the work published in We'Moon belong to each individual contributor. Please honor the copyrights: ©: do not reproduce without the express permission of the artist, author, publisher or Mother Tongue Ink, depending on whose name follows the copyright sign. Some wemoon prefer to free the copyright on their work: ¤: this work may be passed on among women who wish to reprint it "in the spirit of We'Moon." In all cases, give credit to the author/artist and to We'Moon, and send each a copy. If the artist has given permission, We'Moon may release contact information. Contact mothertongue@wemoon.ws or contact contributors directly.

CONTRIBUTOR BYLINES AND INDEX

SEE PAGE 236 FOR INFO ABOUT HOW YOU CAN BECOME A WE'MOON CONTRIBUTOR!

A. Levemark (Tranas, Sweden) I'm a gardener & an illustrator, who is passionate about permaculture. My roots are in Scandinavia and Britain, and I'm drawn to the folklore of both places. ihox.deviantart.com, levemark@protonmail.com **p. 141, 183**

Abena Addo (London, UK) works with acrylics and collage techniques, exploring a range of topics. Engage with her on @abenaartistaddo and on Facebook: Abena Addo_Artist. She has just launched a new range of thought-provoking and exciting T-shirts: represent.com/store/abena-s-t-shack **p. 83**

Adriana M. Garcia (San Antonio, TX) Intimacy abounds in lives encountered. I aim to extract the inherent liminality of a moment before action as a way to articulate our stories. adrianamjgarcia.com, adrianamjgarcia@gmail.com

p. 132

Alixa Garcia (New York, NY) is a professional poet, musician, and visual artist. Her work through Climbing PoeTree has taken her from the international halls of the United Nations and the world renown TED, to hundreds of stages nationally and internationally over the past 15 years. As a painter, she's received numerous grants and artists residencies. Her latest commissioned work was completed for Tony Award Winning playwright, Eve Ensler. climbingpoetree.com

p. 174

Amy Alana Ehn (Eugene, OR) Healing Arts Practitioner, helicopter pilot, animal wellness advocate, world traveler, dreamer, and lover of words. Inspiring blissful balance, playing with magical manifestation, and breathing in creation. exquisitehealing.com

p. 73

Amy Hyun Swart (San Francisco, CA) is a writer, artist, and psychotherapist living in San Francisco, CA. She can be contacted at amy@amystwart.com or visit her websites at visionkeeperart.com and amyswart.com.

p. 134

Amy Nicole Purpura (West Palm Beach, FL) Peace panther, truth talker, ritual dancer, star watcher, and animal rights activist working towards peace for all. Currently bathing in the healing waters and tropical flora of S. Florida. amynicole4love@gmail.com

Anna Rose Renick (Talent, OR) is an intuitive life coach, writer, dancer, and muse with a passion for living dynamically and loving well in depth non-predictive clairvoyant work. annaroserenick.com

p. 53

Anna Ruth Hall (Glendale, CA) A queer white woman from LA in her early 20s, Anna is a lover of nature, food, music, dance, clear communication, and travel. She is learning to listen to her intuition and follow its calling despite how wild the journey and strong the criticism.

p. 122

Annelinde Metzner (Black Mountain, NC) All my creative work, composing music and poetry, is devoted to celebrating the reemergence of The Goddess on Earth. See more of my work at annelindesworld.blogspot.com, annelinde@hotmail.com p. 97, 177

Autumn Skye Morrison (Powell River, BC) I offer my artwork as a m	
intimate personal reflection and a grand archetypical revelation. Within th	
may you recognize your own sacred heart, your cosmic divinity, and the in	nnate grace
that dwells within. autumnskyeart.com	p. 35, 99

Barbara Dickinson (Sunny Valley, OR) I'm doing what I love, and loving what I do. Homesteading, creating, getting muddy, and communing.

p. 187

Barbara Landis (San Francisco, CA) is a fine art photographer creating images locally and abroad. Practicing nichiren Shoshu Buddhism since 1968, she belongs to Myoshinji Temple in Pinole, CA. barbara-landis.com **p. 80**

Barbara Levine (Corvallis, OR) is painting on wood these days as she renovates a very old shabby house. Her paintings celebrate nature and strong, nurturing women as natural conduits for bringing peace, beauty and healing into the world. **p. 101**

Beate Metz (Berlin, Germany) was an astrologer, feminist, translator & mainstay of We'Moon's German edition & the European astrological community. **p. 205**

Becky Bee (Azalea, OR) Ex-cobber, gardener, horseback rider, crybaby, lover of the atmosphere and the planet. beckybee.net p. 23

Beth Lenco (Hubbards, Nova Scotia) Beth's art is inspired by the land, sea, and her experiences as a rural shamanic witch. She leads Ancient practices/retreats, and is the creator of Starflower Essences. Bethlenco.com **p. 125**

Bethroot Gwynn (Myrtle Creek, OR) 24 years as WeMoon's Special Editor & 44 at Fly Away Home women's land, growing food, theater & ritual. For info about spiritual gatherings, summertime visits send SASE to POB 593, Myrtle Creek, OR 97457. For info about her new book of poetry and plays, *PreacherWoman for the Goddess*, see p. 229.

p. 32, 33

Brandi Woolf (Crawford, CO) is a mama, witch and wild heart devoted to the Path of Priestess. A weaver of ceremony and words, she believes that courage and vulnerability are necessary and that the stories of women can heal the world. the the the the world. The p. 151

Carmen R. Sonnes (Phoenix, OR) creates paintings to bring beauty, healing and balance to our planet. By acknowledging culture, the feminine and spirit in each work, she fulfills her purpose. Visit carmenrsonnes.com; carmenrsonnes@yahoo.com

p. 162

Carol Newhouse (El Sobrante, CA) I am a photogrpher, writer, and Buddhist Meditation Teacher. My life's work seems to center on Womens' expression of Truth and Beauty through image, written word, spiirtual expression, and community. I can be reached at c.osmer.newhouse@gmail.com

p. 76

Carrie Martinez (Gainesville, FL) Artist, muralist, and tarot deck illustrator whose work embodies nature, mysticism, dreamscapes, and Goddess. Carriemartinez.com; info@carriemartinez.com

p. 96, 130, 166

Cary Wyninger (Trempealeau, WI) was born and raised in the Eastern Iowa river town of Lansing, Iowa. Receiving her BFA in Studio Arts from Viterbo University, just a few miles North along the Mississippi in Lacrosse, Wisconsin. She creates in oils, acrylics, watercolor and ink. carywyninger.com

p. 181

Caryl Ann Casbon (Bend, OR) Interfaith minister, spiritual director, NW poet and writer, authored: *The Everywhere Oracle: A Guided Journey Through Poetry for an Ensouled World.* She was recognized as one of the top spiritual writers for 2017. carylanncasbon@squarespace.com

p. 127

Casey Sayre Boukus (Nantucket, MA) is a collage artist, with a fabric addiction, dancer, performer, and eclectic witch. She lives on a beautiful island with her husband and two children and assorted critters. Esty: ByCasendra

p. 55

Catherine McGagh (Leitrim, Ireland) An artist & yoga teacher living in the northwest of Ireland; she is inspired by nature, people & all things mystical. Most of her work can be viewed on her website catherinemcgaghartandyoga.squarespace. com or newirishart.com/irish-artists/catherine-mcgagh-artist **p. 69**

Catherine Molland (Santa Fe, NM) is a professional artist, showing and selling her artwork. She loves her organic farm, living there with her dogs and chickens. Visit. Catherinemolland.com or email her at cmolland@Q.com

p. 41

Cathy Casper (Arvada, CO) celebrates life from the front range of the Rockies. Earth is the source of her inspiration and her love. **p. 83, 113**

Chantel Camille (Portland, OR) plays with words, and wool in the Pacific Northwest of America. When she is not doing that, she is tending her friends and family, studying ancestral and herbal wisdom, or working in the bookstore she loves. **p. 143**

Chasity Bleu (Keaau, HI) is an artist who draws inspiration from the Divine. She believes firmly in synchronicities, magic, and our connectedness with each other and the Universe, reflecting this through everything she makes. Chasitybleu. weebly.com

p. 119

Cheryl Braganza (1945–2016) (Montreal, Quebec) 2008 Montreal Woman of the Year, Painter, Writer, Poet, Pianist, Cancer Survivor. Cheryl was born in India, studied art and music in Italy and the UK before arriving in Montréal in 1966 where she took sculpture and painting at l'École des Beaux Arts and Concordia University."I want my art to play a role in lifting people's spirits, in challenging their assumptions, in provoking thought...thus promoting dialogue between peoples towards peace. It is my belief that women will be the dynamic force to inspire a more caring, loving world." cherylbraganza.com

Back Cover

Cinders Gott (Ashland, OR) M.F.A., is an expression ist visual/performance artist, melding ecofeminism with mysticism, a priestess of Arachne Circles, a wild woods witch, and love-shamaness in training. Cinders taught interdisciplinary arts in 50+ schools/colleges, Her Venus art is currently touring the world. lovecinders@gmail.com

p. 12

Cindy Ruda (Sedona, AZ) loves the earth we walk upon and cannot abide the recklessness that others loose upon the planet's back. Yet, whether sensible or not, she holds firmly to hope and a willingness to believe. **p. 94**

Darlene Cook (Townsend, GA) My art seems to create itself. Learn more at Healingartspace.com **p. 148**

Dawn Sperber (Albuquerque, NM) is a writer and editor in New Mexico. Her stories and poems have appeared in *PANK Magazine*, *NANO fiction*, *Gargoyle*, *We'Moon*, and elsewhere. Find her at dawnsperber.com Tell her your dreams. **p. 42, 89**

Debra Hall (Castle Douglas, Scotland) I am a soulmaker, writer, dancer, and mindfulness teacher. I love life and the life of life. I love to be contacted about my work at debra.ha@hotmail.co.uk.

p. 158

Denise Kester (Ashland, OR) is a mixed media printmaking artist, renowned teacher and founder/artistic director of Drawing on the Dream, an art distribution company. Announcing the new book *Drawing on the Dream—Finding My Way by Art.* drawingonthedream.com **p. 54, 85, 107**

Diana Denslow (Poulsbo, WA) mother, artist, crone, We'Moon fan, and cat person is living happily and thankfully under cedars, in a diverse neighborhood, working on the art of living very well on very little. dianaherself66@gmail.com **p. 78, 165**

Dorrie Joy (Somerset, UK) is an intuitive artist working in many mediums in celebration of our shared indigeny as people of Earth. Originals, prints, commissions of all kinds at dorriejoy.co.uk **p. 79**

Earthdancer (Golconda, IL) Forest dweller of the Shawnee Forest, co-creator and multitasking mystic at Interwoven Permaculture Farm. interwovenpermaculture.com p. 34

Elizabeth Diamond Gabriel (St. Paul, MN) is a professional artist, illustrator and art teacher—in love with the Great Mother. In art life since the day she was born, she loves long, loving walks, the canine world, and good food with good friends. **p. 58**

Elsie Ula Luna Sula (Byron Bay, Australia) Art is an access point to the great mystery, a map that is shaped and born from our surrender to something beyond us and our desire to explore that. I am here to be a voice to the remembering of the Great Mother, in all her many forms, to remember and sing again the song of our ancient origins in a reality that honours the sacred within all. FB: Lunacreations111 Email: elsie_peters@hotmail.com

p. 81

Elspeth McLean (Gooseberry Hill, Australia) creates her vivid and vibrant paintings completely out of dots. Each dot is like a star in the universe. Elspeth hopes her art connects people with their inner child and can bring some joy into their lives. elspethmclean.com

p. 15

Emily Kedar (Toronto, ON) ia a writer, dancer and therapist living and working in Toronto and Salt Springs Island, Canada. Please contact her for writing inquiries at emilykedar222@gmail.com **p. 125**

Emily Kell (Boulder, CO) Visionary Goddess Art, emilykell.com or visit her on facebook at facebook.com/emilykellart **p. 139**

Francene Hart (Honaunau, HI) is an internationally recognized visionary artist whose work utilizes the wisdom and symbolic imagery of Sacred Geometry, reverence for the natural environment and the interconnectedness between all things. Francenehart.com **p.** 57, 113

Gaia Orion (Seabright, ON) creates simple, geometric, colorful oils unveiling universal and unifying themes. She has participated in many worldwide projects working towards constructive change and has exhibited in major cities all over Europe and North America. Gaiaorion.com or email her at art@gaiaorion.com p. 8, 72, 169

Gail Nyoka (Lorain, OH) is a storyteller, writer and award-winning playwright. As a Druid and a Fellowship of Isis Priestess, she conducts rites of passage of all kinds. Gailnyoka-stories.com, cyclesandrites.blogspot.com

p. 115

Genevieve Scholl (Hood River, OR) is interested in how the mind finds refuge and healing amid suffering. Through painting, she seeks to offer the mind a place to rest. She believes in essential kindness. Genevievescholl.com

p. 24

Gretchen Lawlor (Seattle, WA and Tepoztlan, Mexico) We'Moon oracle, now mentor to new oracles & astrologers. Passionate about providing astrological perspective & support to worldwide wemoon re: creativity, work, love, \$, health. My first book, Windows of Time—Tools for Right Timing, is available through Amazon. For consultations & info, contact me at light@whidbey.com; gretchenlawlor.com p. 18,26

Heather L. Crowley (East Kingston, NH) is a mother, wife, sister, daughter, visual artist, poet, mindfulness meditation teacher, and M.D. Willow Road Watercolors & The Circle Studio, LLC. "Art exploring the beauty and mystery of nature and spirit." willowroadwc.com **p. 95, 228**

Heather McElwain (Sandpoint, ID) is a freelance essayist, poet, and editor who writes about exploring the natural world as well as the wilderness within. bardontheroam. wordpress.com

p. 86

Heather Roan Robbins (Ronan, MT) ceremonialist, spiritual counselor, & astrologer for 40 years, author of *Moon Wisdom*, *Everyday Palmistry* & several children's books (Cico books, avail. on Amazon), writes weekly Starcodes columns for We'Moon & The Santa Fe New Mexican, works by phone & Skype, practices in Montana, with working visits to Santa Fe, NM, MN, & NYC. roanrobbins.com p. 10, 12, 15

Helen Laurence (Roseburg, OR) lives at Rainbow's End, joyously tending garden, writing, teaching and learning from nature.

p. 179

Jakki Moore (Oslo, Norway) divides her time between Ireland, Norway and Bulgaria. An artist and storyteller, her books can be found on Amazon. Open to commissions, projects and exhibitions, she would love to hear from you. Jakkiart.com

p. 43, 118, 173, 186

Jan Kinney (Seattle, WA) I was inspired by the beauty of the Pacific Northwest to create the *Tarot of Compassion*. I work in education, sing, preach, create ritual, and work with beads. tarotofcompassion.com

p. 168

Janis Dyck (Golden, BC) is a mother, artist and art therapist who feels a deep connection to the earth and the power of the feminine to heal, renew and bring positive change. The creative process continues to teach her that it is through connection, community and creativity that we will come to know our potential as human beings. janisdyck@persona.ca

p. 86

Janis McDougall (Tofino, BC) I write poetry for discovery. For harmony, I sing with our community choir. For play, I explore collage painting. For inspiration, I go outside by the sea or the forest. I feel gratitude for having a daughter. **p. 161**

Jennifer Lothrigel (Lafayette, CA) is an artist, poet and healer in the San Francisco Bay area. Find her online at: JenniferLothrigel.com p. 103

Jenny Hahn (Kansas City, MO) captures the inward journey through bold, colorful expression using acrylic paint. As cofounder of Creative Nectar Studio, she offers workshops across the country using painting as a tool for mindfulness and self-discovery. jennyhahnart.com

p. 53, 145, 159

Jo Jayson (Harrison, NY) is a spiritual artist, teacher, author, and has channeled the Sacred Feminine in her work for 8 years now. Jojayson.com

p. 81

Joanne Clarkson (Port Townsend, WA) Her book of poems, *The Fates* won the Bright Hill Press contest and was published in 2017. Joanne is a retired RN and besides writing poetry, loves to read palms and Tarot. Joanneclarkson.com **p. 61,70**

Joyce McCallister (Albany, CA) is a California writer and poet. She is a working on her first novel, a historical romance set in the 1920's Bay Area. **p. 37**

Judith Prest (Duanesburg, NY) is a poet, photographer, mixed media artist and creativity coach. She believes that creativity is our birthright as human beings. She lives and works at Spirit Wind Studio in Duanesburg, NY. jeprest@aol.com and spiritwindstudio.net **p. 75**

Jules Bubacz (Portland, OR) I reside in Portland, OR where my partner,	my cat
and my garden are sources and receptacles of my inspiration and love.	p. 169

Katalin Pazmandi (Cottekill, NY) creates visionary paintings and sacred spaces that materialize through her from higher realms. Katalinpazmandi.com fufaeg@gmail.com p. 25

Kate Langlois (San Francisco, CA) In my creative practice, I bring beauty to shadows. Celebrating diversity through the many spaces of the feminine. I view ordinary lives as extraordinary. Through the fractures of experiences I strive to amplify wholeness. Katelangloisart.com **p. 175, 179**

Kauakea Winston (Honokáa, HI) is an astrologer and energy sound healer who lives in Honokáa on the Big Island of Hawaii. Healingresourcehawaii.com **p. 50**

Kay Kemp (Houston, TX) creates heart-centered art celebrating Mother Nature and the feminine spirit. Her visionary paintings amplify messages of love and respect intended to inspire positive change throughout the world. Kaykemp.com **p. 152**

Kendra Ward (Portland, OR) is a writer/teacher/healer, braiding these roles like sweetgrass to wear as a crown on her head. For the last 15 years she has worked as an acupuncturist/herbalist in mossy Portland, OR. kendraward.com **p. 46**

Kersten Christianson (Sitka, AK) is a raven-watching, moon-gazing Alaskan. When not exploring the summerlands and dark winter of the Yukon, she lives in Sitka, Alaska where she writes poetry. Kerstenchristianson.com **p. 35**

Kim Crown (Chicago, IL) is an artist and renaissance woman with a raging rash of wanderlust. **p. 186**

Kimberly Webber (Taos, NM) Priestess of painting, alchemy and bees. Advocate for the Divine Feminine, personal freedom, youth, pollinators, biodiversity, animals, oceans, forests. Planter of flowers and corn. Pollinator of empowerment. Amplifier of hope. Kimberlywebber.com **p. 93**

KT InfiniteArt (Freeport, NY) Creatrix, artist, writer inspired by sensuality and spirit. Instagram: KTInfiniteArt. Prints available. **p. 59, 170**

L. Sixfingers (Sacramento, CA) is an intersectional herbalist and witch helping folks to radically re-enchant their lives and re-member their way back home. She offers online and in-person courses for starry-hearted healers and magickal people at wortsandcunning.com

p. 143

Laurie Bauers (Hakalau, HI) is currently loving life in gratitude in Hawaii with her family. Constantly awed by Mother Earth's beauty, she gleefully paints in a harmonious relationship with her.

p. 112

Leah Marie Dorion (Prince Albert, SK) is an indigenous artist from Prince Albert, Saskatewan, Canada. leahdorion.ca **p. 1, 121**

Leah Markman (Williams, OR) aka Cerulean Tango, has been reading Tarot and studying astrology in the beautiful Applegate Valley of Southern Oregon. She spends her time in the sunshine with her dog, horse and VW Bus. She writes poetry and practices mounted archery. Leahdmarkman@gmail.com

p. 25

Linda James (Seattle, WA) is an intuitive watercolor painter, educator, and flower essence practitioner creating her life in the wondrous environment of the Pacific Northwest. Lindajamesart.com

p. 74

Lindy Kehoe (Gold Hill, OR) paints living portals of magic and love. She lives in beautiful Southern Oregon and is surrounded by the faerie realm. Visit me at Lindykehoe.com

p. 19, 149

Liz Darling (Pittsburg, KS) is a visual artist from Kansas. Deliberate and intricate, Darling uses watercolor, ink, and other water-based media to create cosmic, organic compositions that often center on themes of spirituality, transience, the divine feminine, and the natural world. lizdarlingart.com

p. 122

Liza Wolff-Francis (Albuquerque, NM) is a poet and writer with an M.F.A. in Creative Writing from Goddard College. She has a chapbook called *Language of Crossing* (Swimming with Elephants Publications) which is a collection of poems about the Mexico-U.S. border.

p. 100

Lorraine Schein (Sunnyside, NY) is a NY writer. Her work has appeared in Syntax and Salt, Mosaics, VICE Terraform and Tragedy Queens: Stories Inspired by Lana Del Ray & Sylvia Plath. The Futurist's Mistress, her poetry book, is available from mayapplepress.com

p. 77

Louie Laskowski (Brookston, IN) living in the small town of Brookston, IN, where I work in my art studio, is such a treat to me. I teach art as a spiritual path since it has been true for me. RCGI ordained priestess. louielaskowski@gmail.com, louielaskowski.com **p. 126**

Lucy H. Pearce (Co Cork, Ireland) is an award-winning author of life-changing women's non-fiction, including *Medicine Women, Burning Woman, Moon Time, The Rainbow Way* and *Full Circle Health*. She is founder of Womancraft Publishing. dreamingaloud.net **p. 39, 138, 147**

Lucy Pierce (Yarra Junction, Australia) Mother, artist, word-smith, musician, living by the Yarra River beside Mount Donna Buang in Victoria, Australia. My work is born of dream and myth, vision and dance, grief and quest, song and ceremony. lucypierce.com, etsy.com/shop/lucypierce, soulskinmusings. blogspot.com

p. 51

Lyndia Radice (Magdalena, NM) I live in rural NM, and I paint and portray the natural world around me. **p. 164**

Lyrion ApTower (Wilton, NH) has discovered the strength of the wisdom of the crone and its ability to alter the course of events; she urges others to lift up their voices. sbmillet@tds.net

p. 133

Mandalamy Arts (Topeka, KS) Amy is an artist, mother, teacher, nature lover, and a believer in respect for all life. Her mandalas and paintings primarily have themes of celestial objects and events, connection, and growth. Find her as Mandalamy Arts on Facebook and Instagram.

p. 128

Margaret Karmazin (Susquehanna, PA) Her artwork has appeared in regional, literary and national magazines and in galleries in PA, NY, and the Caribbean. Margaretkarmazin.blogspot.com

p. 88

Maria Strom (Athens, GA) is a feminist, artist, illustrator and cat lady. Her most recent creation is Hip Chick Tarot, a diverse, modern deck that's both spiritual and practical; it reminds women of their inner divinity and their worldly power. instagram: mariahipchicktarot

p. 40

marna (Portland, OR) frolics in Pacifica Cascadia bioregion nurturing Gaian thriving. She initiates programs at the convergence of creativity, ecological restoration and the living wisdom traditions (earthregenrative.org) and encourages womyn to Moonifest their artistic and earth-enhancing projects with micro-grants and service. Moonifest.org

p. 152

Maryruth Chorbajian (Racine, WI) felt the Goddess' presence when she created through painting, writing and tending to a garden. She was crazy about the moon, flowers and nature, and loved to image her beauty through all art mediums. Passionate about gifting her hand dyed silk scarves to homeless and abused women. **p. 102**

Melissa Harris (West Hurley, NY) Artist, author and intuitive. Join me for art-making workshops. Read my books on creativity and psychic development or have your Spirit Essence Portrait painted. I have created card decks and other products featuring my visionary art. melissaharris.com p. 37, 49, 87

Melissa Kae Mason, "MoonCat!" (Florida, Montana, Texas) Traveling Astrologer, Artist, Radio DJ, Photographer, Jewelry Creator, PostCard Sender, Goddess Card Inventor, Seer of Patterns, Adventurer and Home Seeker. See LifeMapAstrology.com, CatOvertheMoon.com and TravelingAstrologer.com Contact: LifeMapAstrology@gmail.com p. 204

Melissa Winter (San Antonio, TX) has been painting and drawing since she was a child. Her inspirations come through meditation and ceremony. Favorite themes in her work include: the Divine Feminine, LGBT, and Oneness. Honeybart.com **p. 56**

Meredith Heller (Tiburon, CA) is a poet, and singer/songwriter. She teaches creative writing classes for teenage girls, leads outdoor hiking and writing adventures, and hosts Siren Song, a women's music night. She is mused by nature, synchronicity, and kindred souls. meredithhellermusic@gmail.com

p. 68, 80

Mimi Foyle (Rio Guaycuyacu, Ecuador) My passion is for the rivers, forests, and people with whom I live and work for the well-being of self, planet, and all-our-relations. With gratitude. guaycuyacu@gmail.com

p. 173

Miri Hunter Haruach (Joshua Tree, CA) is a scholar, musician, writer and performance artist currently residing in the high-desert of Southern Ca. She fronts an Americana Folk Band, is the Artistic Director for Thought Theatre and co-producer of the Hi-Desert Fringe Festival. projectsheba.com

p. 92

Mojgan Abolhassani (Vancouver, BC) is an artist and Expressive Art Therapist living in Vancouver, Canada. She also obtained solid training in a wide variety of intuitive art programs, Cyclic Meditation, Theta Healing and many other healing modalities. mojgana66@gmail.com

p. 90

Molly Remer (Rolla, MO) is a priestess, artist, and educator in Central Missouri. She creates original story goddesses, publishes Womanrunes sets, and blogs about life in the hand of the Goddess at brigidsgrove.com **p. 140, 158**

Monika Andrekovic (Stratford, ON) A grateful volunteer for Cedar Farm Sanctuary in Ontario, Canada. Compassion for all beings is vital and healing in our collective journey. Nourishing energies to all. Veganmonika.com

p. 104

Musawa (Estacada, OR & Tesuque, NM) I am excited to be creating a We'Moon Tarot Deck drawn from art in We'Moon over the years! It will come out with We'Moon 2021 when the magic of We'Moon takes a new turn with We'Moon images as divinatory art for women in the 21st century.

p. 6, 28, 184, 186, 202

Naima Penniman (Brooklyn, NY) Co-founder & steward of WILDSEED Community Farm & Healing Village, performance activist through Climbing Poe Tree, food-justice educator at Soul Fire Farm, & healing practitioner at Harrier's Apothecary, Naima cultivates collaborations that elevate the healing of our earth, ourselves, our communities, lineages & descendants. climbingpoetree.com p. 111, 164

naimonu james (new orleans, la) is a writer and astrologer based in new orleans, louisiana. you can find them on facebook, instagram, and twitter: @naimonujames. you can also find free horoscopes and schedule a reading with them at naimonujames.com p. 19, 45, 57, 69, 79, 93, 105, 119, 131, 145, 155, 167, 181

Nancy Schimmel (Berkeley, CA) Songs, poems and stories are available at sisterschoice. com; political parodies at occupella.org, a website for activist song-leaders. **p. 67**

Nancy Watterson (Oakland, OR) is an artist, a mother, and a grandmother. She lives and works along the Umpqua River in Oregon where she finds an unlimited source for inspiration and balance. Nwattersonscharf.com

p. 103, 115,

Natasha Stanton (Sierraville, CA) Changing consciousness through art. natashastanton.com p. 38

Nicole Nelson (Topanga, CA) is an ARTivist, published poet, and photographer using words and images to explore Feminine empowerment, decolonization and self-inquiry—heavily influenced by Buddhism, Lakota spirituality and the wisdom of Earth. nicovisuals.com, nicolemiz.com **p. 41**

Oak Chezar (Jamestown, CO) a radical dyke, performance artist, Women's Studies professor, psychotherapist, writer, & semi-retired barbarian. She lives in a straw bale, womyn-built house. She just published *Trespassing*, a memoir about Greenham Common Womyn's Peace Camp. Whilst working & playing towards the decimation of patriarchy & industrial civilization, she carries water. oakchezar@gmail.com p. 30, 49, 66, 85, 102, 121, 142, 157, 178

The Obsidian Kat (Silver Spring, MD) Lucky number seven. The child who waited for the fairies under the pear tree. A conscious curator of wellness. Mother and grandmother, all girls, divine feminine expressed. Happy crone.

p. 62

Pamela Read (Solon, IA) I live on a beautiful lake with my husband and cat, where I paint, pray, play, and plant whenever I can!p. 17

Patricia Dines (Sebastopol, CA) I love the Divine and feel honored to serve her with my art and writing. Nurture yourself with my gorgeous full-color illustrated storybook, *The Goddess Who Forgot That She Was a Goddess.* Art and greeting cards available too! healthyworld.org/GB and patriciadines.info

p. 137

Pat Malcolm (Albuquerque, NM) My work has been focused on the understanding that we humans are an intrinsic part of the natural world. I began painting wildlife in the early 1990's and they evolved into "Icons of Nature," using egg tempera paints on traditional gesso boards to capture the essence of the animals I met in both the outer world and my own inner world. malcolm-bernal.com

p. 154

Paula Franco (Buenos Aries, Argentina) Italo-Argentine Artist, Shaman woman, visual and visionary illustrator, teacher in sacred art, writer and poet, astrologer, tarot reader, creator of goddess cards and coloring book: *The Ancestral Goddess and Heaven and Earth.* ladiosaancestral.com and paulafranco.net

p. 33

Peggy Sue McRae (San Juan Island, WA) Dancing the dharma of the Goddess in my little patch of woods on San Juan Island. manymoonsart.biz p. 120

Penn King (Enid, OK) Feisty old Romani womun, dream painter, Earth activist. Blessed by the Mother of All to know both tears and laughter, she loves soul-deep with boundless hope. lquixotly@gmail.com FB: Lady Quixote's Studio. **p. 129**

Pi Luna (Santa Fe, NM) is a visionary artist in Santa Fe. She is also a business coach for creatives. To learn more visit pilunapress.com

p. 136

Qutress (Chicago, IL) a Chicago artist with an afrofuturist touch to bruja realms. Visit more of her art on ig @qutress or write her via qutress@gmail.com p. 65, 157

Rachael Amber (Philadelphia, PA) is an ecofeminist illustrator and designer who focuses on environmental awareness and humanity's connection to nature in her artwork. She aims to deepen the roots, so we can more easily find our way back to nature. Rachaelamber.com **p. 60, 71, 117, 178**

Rachel Houseman (Santa Fe, NM) is an artist, gallery owner, and art therapist living in the Santa Fe railyard district. Her work has been featured across the southwest and in many major publications. Her goal is healing humanity through color and visionary symbolism. rachelhouseman.com

p. 94

Rachel Kaiser (Lake Havasu City, Arizona) Rachel designs ceramic tiles and paints bold bright murals. Her paintings of empowered woman in harmonious yet surrealist environments are close to her heart, as she hopes woman loving woman becomes ever more a reality to save our earth and each other. kaisercreates@gmail.com, instagram: @rachelkaiserart, FB: @Kaisercreates p. 70

Rebecca Tidewalker (Jacksonville, OR) an expressive arts therapist, artist, herbalist and dreamer dedicated to healing connections with our roots in transforming the wounds of our intergenerational lineages and reclaiming the wisdom of those ancestors who lived in balance and reciprocity with the earth. Rebecca passed away on August 11, 2016; her work was submitted to We'Moon via her dear friend Amara Hollow Bones. Saphichay.org **p. 109**

Rose Flint (Wiltshire, England) is a Poet-Priestess living in Wiltshire, UK. She has presented poetry at the Glastonbury Goddess Conference for 23 years. poetrypf. co.uk/roseflintpage.shtml p. 106

Rosella (London, England) Mandalas for meditation and self-empowerment. The mandalas are hand drawn and painted in iridescent watercolors. Rosellacreations.co.uk

p. 30

Ruth Gourdine (Milwaukie, OR) In today's world we are constantly thinking with our minds, but not reasoning with our hearts. Working with precious metal leaf (gold, copper, and silver) on oils represents the link between ourselves and a higher source. The vibration that feeds our spirit. This nourishment fosters connectivity and unity, and provides the foundation for healthy, loving communities to grow. Ruthgourdine.com

p. 153

Saba Taj (Durham, NC) is a Pakistani-American artist based in Durham, North Carolina. Saba can be found on instagram @itssabataj, and on the web at itssabataj.com

Front Cover

Sally Snipes (Julian, CA) A Californian native, raised on the coast, Sally Snipes has embraced the mountain for the last 40 years. Open spaces, shadows and light capture her imagination and fuel her art. Gardening keeps her spirit alive. **p. 116**

Sandra Pastorius aka Laughing Giraffe (Ashland, OR) has been a practicing Astrologer since 1979, and writing for We'Moon since 1990. Look for her collected We'Moon essays under "Galactic Musings" at wemoon.ws. As a Gemini she delights in blending the playful and the profound. Email her about Birth chart readings and local Astrology Study Groups at: sandrapastorius@gmail.com. Peace Bel p. 20, 22, 206

Sandy Bot-Miller (St. Cloud, MN) makes art and writes poetry. Art gives her the courage to express what she sees unfolding in her inner landscape as well as in the world-at-large. sandybotmiller@gmail.com and sandybotmiller.com **p. 39**

Sandy Eastoak (Sebastopol, CA) Shamanic painter and poet, prays for climate, habitat and spiritual healing. Her newest book, *Food as Love*, explores the consciousness of plants and animals before they are food. She thanks trees, water, and all our relations. Sandyeastoak.com

p. 29, 67

Sara Steffey McQueen (Bloomington, IN) Grandmother, sister and Tree Sister volunteer. A founding momma of an intentional community in the hills of Southern Indiana. Facilitator of Art of Allowing & Wild Soul Woman. Paints inner and outer Nature. Sarasteffymcqueen.com

p. 138

Sarah Satya (Salt Spring Island, BC) Intuitive mermaid, bringing form to dreams and songs of the heart. She breathes her art into form, blending spirit, human, animal, elements and energy into piercing images that evoke the wild nature of being. Her poetry is made of golden thread etched from her heart sown onto paper, relating her intimate experience of being alive and conversing with creation. **p. 116**

Serena Supplee (Moab, UT) has been "Artist on the Colorado Plateau" since 1980. An oil painter, watercolorist and sculptor, she welcomes you to visit her website if you are interested in purchasing her work. Serenasupplee.com

p. 3

Shauna Crandall (Driggs, ID) Artist, singer and seeker of the strange and beautiful. Shaunacrandall.com and skcrandall@yahoo.com p. 137

Shelley Anne Tipton Irish (Seattle, WA) Through passionate color and visionary storytelling, I infuse classically rendered oil paintings with transcendental exploration. It is my life ritual, sharing it with you, my bliss, best blessings. Gallerysati.com **p. 160**

Shelly Blooms (Cleveland, OH) is a Spirit Pilgrim, ever on the trail of cosmic breadcrumbs by which the muses choose to amuse the noodle, through picture, poem, kit and caboodle.

p. 163

Sheryl J. Shapiro (Seattle, WA) seeks to explore and reveal the depths of her Judaic roots, whispers from nature, and the complex beauty of community. Contact her at ruachhalev@gmail.com

p. 128

Sophia Faria (Salt Spring Island, BC) is a sex educator, retreat facilitator and writer. Her private practice and home are on Salt Spring Island. She supports individuals and couples in their sexual journeys and co-creates nature, based on retreats for women. soulfoodsex.com **p. 65**

Sophia Rosenberg (Lasqueti Island, BC) is continually grateful to We'Moon for supporting women artists and writers, and creating beauty. Thank you for your sustained vision and good work for so many, many moons. Sophiarosenberg.com and bluebeatlestudio on Etsy **p. 55, 84, 150, 183**

Stephanie A. Sellers (Fayetteville, PA) is a poet and homesteader in the mountains of Pennsylvania. I founded the virtual global organization Sedna's Daughters to raise awareness about family aggression against women. Sednasdaughters.com **p. 58, 63**

Sudie Rakusin (Hillsborough, NC) is a visual artist, sculptor, and children's book author and illustrator for established authors Mary Daly and Carolyn Gage. She lives in the woods with her dogs, on the edge of a meadow, surrounded by her gardens. Sudierakusin.com and wingedwillowpress.com

p. 77, 155

Sue Burns (Portland, OR) is a feminist, witch, writer, herbalist, teacher, mother. She is renewed in bodies of water, puts salt in her coffee, and looks for magick everywhere.

p. 24

Susa Silvermarie (Ajijic, Mexico) Waking Up has been accelerated by my living in Mexico for the past three years. Please visit me at susasilvermarie.com p. 110

Susan Baylies (Durham, NC) sells her lunar phases as cards, larger print charts and posters at snakeandsnake.com Email her at sbaylies@gmail.com p. 226

Susan Bolen (Mariposa, CA) is the artist Manterbolen, Represented by Williams Gallery West, in Oakhurst, CA. Her work can be found on Redbubble, Facebook, and Manterbolen.com. She lives in a fortress of semi-solitude with her loving husband, and five cats. **p.** 66

Susan Levitt (San Francisco, CA) is an astrologer, tarot card reader, and feng shui consultant. Her publications include *Taoist Astrology* and *The Complete Tarot Kit*. Follow her astrology blog for new moon and full moon updates at susanlevitt.com

p. 23, 109, 203

Tamara Phillips (Vancouver, BC) is inspired by the raw beauty of the natural world. Her watercolour paintings are woven together in earth tones, and she explores the connection between myth, dream, intuition and reality. Tamaraphillips.ca **p. 47, 106**

tanina munchkina (L'auberson, Switzerland) A lover of words, art, travels and the oneness of all. Tanina lives with her musician husband on a peaceful Swiss mountain. She draws and paints electric mandalas, childlike goddesses and faires. She also writes poetry and lyrics. taninamunchkina.com

p. 48

Toko-pa Turner (Salt Spring Island, BC) is the award-winning author of the book, *Belonging: Remembering Ourselves Home.* As a teacher and dreamworker, she blends Sufism with a Jungian approach to dreamwork in online courses and around the world. Toko-pa.com **p. 159, 171**

Toni Truesdale (Bidetorn, ME) Artist, muralist, teacher and illustrator, Toni celebrates women, the natural environment and the diversity of the world's cultures. Contact her at tonitruesdale@gmail.com Prints and cards available through tonitruesdale.com

p. 4, 45

Viandara (Tacoma, WA) I am an emissary of love, here to uplift humanity's vibration through the expressions of my soul's voice. I actively imagine a new cosmology. Painting mystic metarealism: pictorial poetry where image converages with myth. HeART offerings for our collective evolutions. Viandarasheart.com **p. 123, 146, 176**

Winter Ross (Crestone, CO) works in the medium of the imagination as an ecofeminist artist, writer and shamanic practitioner. She is convinced that the creative mind has the power to heal both individuals and the world. Info at ceremonialvisions.com **p. 142**

Xelena González (San Antonio, TX) has been writing daily in her We'Moon planner for the past 8 years. She has appeared in its pages as a muse of artist Adriana M. Garcia with whom she created the award-winning picture book, *All Around Us.* allaroundus.info

Zoë Rayne (Sydney, Australia) is an oil painter and word weaver whose works create a narrative of her spiritual Journeys and vivid dreams. Zoë aspires to follow a shamanic path of healing through nature, and to bring this into the world through her art.zoerayne.com **Page 2/Connections p. 95**

Errors/Corrections

In We'Moon 2019, we note a graphical error on page 7: the lunar phase progression in the inside circle is incorrect. You can see the corrected version on page 229 of We'Moon 2020.

We appreciate all feedback that comes in, and continually strive to get closer to perfection. Please let us know if you find anything amiss, and check our website near the beginning of the year for any posted corrections for this edition of We'Moon.

We'Moon Sky Talk

Gaia Rhythms: We show the natural cycles of the Moon, Sun, planets and stars as they relate to Earth. By recording our own activities side by side with those of other heavenly bodies, we may notice what connection, if any, there is for us. The Earth revolves around her axis in one day; the Moon orbits around the Earth in one month (29¹/₂ days); the Earth orbits around the Sun in one year. We experience each of these cycles in the alternating rhythms of day and night, waxing and waning, summer and winter. The Earth/Moon/Sun are our inner circle of kin in the universe. We know where we are in relation to them at all times by the dance of light and shadow as they circle around one another.

The Eyes of Heaven: As seen from Earth, the Moon and the Sun are equal in size: "the left and right eye of heaven," according to Hindu (Eastern) astrology. Unlike the solar-dominated calendars of Christian (Western) patriarchy, We'Moon looks at our experience through both eyes at once. The lunar eye of heaven is seen each day in the phases of the Moon, as she is both reflector and shadow, traveling her 29¹/₂-day path around the Earth in a "Moon" Month (from each new moon to the next, 13 times in a lunar year). Because Earth is orbiting the Sun at the same time, it takes the Moon $27^{1/3}$ days to go through all the signs of the Zodiac—a sidereal month. The solar eve of heaven is apparent at the turning points in the Sun's cycle. The year begins with Winter Solstice (in the Northern Hemisphere), the dark renewal time, and journeys through the full cycle of seasons and balance points (solstices, equinoxes and the cross-quarter days in between). The third eye of heaven may be seen in the stars. Astrology measures the cycles by relating the Sun, Moon and all other planets in our universe through the backdrop of star signs (the zodiac), helping us to tell time in the larger cycles of the universe.

Measuring Time and Space: Imagine a clock with many hands. The Earth is the center from which we view our universe. The Sun, Moon and planets are like the hands of the clock. Each one has its own rate of movement through the cycle. The ecliptic, a 17° band of sky around the Earth within which all planets have their orbits, is the outer band of the clock where the numbers are. Stars along the ecliptic are grouped into constellations forming the signs of the zodiac—the twelve star signs are like the twelve numbers of the clock. They mark the movements of the planets through the 360° circle of the sky, the

clock of time and space.

Whole Earth Perspective: It is important to note that all natural cycles have a mirror image from a whole Earth perspective—seasons occur at opposite times in the Northern and Southern Hemispheres, and day and night are at opposite times on opposite sides of the Earth as well. Even the Moon plays this game—a waxing crescent moon

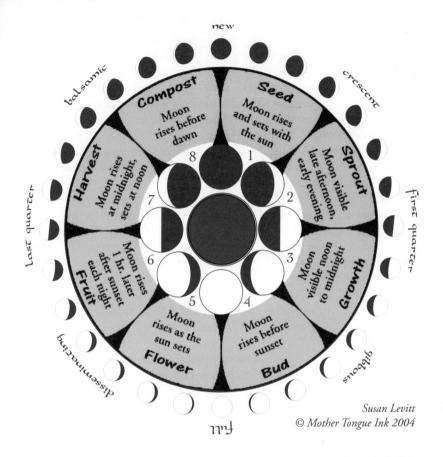

in Australia faces right (\mathbb{Q}), while in North America, it faces left (\mathbb{D}). We'Moon uses a Northern Hemisphere perspective regarding times, holy days, seasons and lunar phases. Wemoon who live in the Southern Hemisphere may want to transpose descriptions of the holy days to match seasons in their area. We honor a whole Earth cultural perspective by including four rotating languages for the days of the week, from

different parts of the globe.

Whole Sky Perspective: It is also important to note that all over the Earth, in varied cultures and times, the dome of the sky has been interacted with in countless ways. The zodiac we speak of is just one of many ways that hu-moons have pictured and related to the stars. In this calendar we use the Tropical zodiac, which keeps constant the Vernal Equinox point at 0° Aries. Western astrology primarily uses this system. Vedic or Eastern astrology uses the Sidereal zodiac, which bases the positions of signs relative to fixed stars, and over time the Vernal Equinox point has moved about 24° behind 0° Aries.

KNOW YOURSELF—MAP OF PLANETARY INFLUENCES

Most people, when considering astrology's benefits, are familiar with their Sun Sign; however, each of the planets within our solar system has a specific part to play in the complete knowledge of "The Self." Here is a quick run-down of our planets' astrological effects:

• The Sun represents our soul purpose—what we are here on Earth to do or accomplish, and it informs how we go about that task. It answers

the age-old question "Why am I here?"

D **The Moon** represents our capacity to feel or empathize with those around us and within our own soul as well. It awakens our intuitive

and emotional body.

A Mercury is "The Thinker," and involves our communication skills: what we say, our words, our voice, and our thoughts, including the Teacher/Student, Master/Apprentice mode. Mercury affects how we connect with all the media tools of the day—our computers, phones, and even the postal, publishing and recording systems!

Venus is our recognition of love, art and beauty. Venus is harmony

in its expressed form, as well as compassion, bliss and acceptance.

O' Mars is our sense of "Get Up and GO!" It represents being in motion and the capacity to take action and do. Mars can also affect

our temperament.

4 **Jupiter** is our quest for truth, living the belief systems that we hold and walking the path of what those beliefs say about us. It involves an ever-expanding desire to educate the Self through knowledge toward higher law, the adventure and opportunity of being on that road—sometimes literally entailing travel and foreign or international culture, language and/or customs.

*Saturn is the task master: active when we set a goal or plan then work strongly and steadily toward achieving what we have set out to do. Saturn takes life seriously along the way and can be rather stern,

putting on an extra load of responsibility and effort.

L'Chiron is the "Wounded Healer," relating to what we have brought into this lifetime in order to learn how to fix it, to perfect it, make it the best that it can possibly be! This is where we compete with ourselves to better our own previous score. In addition, it connects to our health-body—physiological and nutritional.

*Uranus is our capacity to experience "The Revolution," freedom to do things our own way, exhibiting our individual expression or even "Going Rogue" as we blast towards a future collective vision. Uranus inspires individual inclination to "Let me be ME" and connect to an

ocean of humanity doing the same.

Psychology and consciousness, leading to the experience of our soul. Psychic presence and mediumship are influenced here too.

204

E Pluto is transformation, death/rebirth energy—to the extreme. In order for the butterfly to emerge, the caterpillar that it once was must completely give up its life! No going back; burn the bridge down; the volcano of one's own power explodes. Stand upon the mountaintop and catch the lightning bolt in your hand!

Ascendant or Rising Sign: In addition, you must consider the sign of the zodiac that was on the horizon at the moment of your birth. Your Rising sign describes how we relate to the external world and how it relates back to us-what we look like, how others see us and

how we see ourselves.

It is the combination of all of these elements that makes us unique among all other persons alive! We are like snowflakes in that way! Sharing a Sun sign is not enough to put you in a singular category. Here's to our greater understanding! Know Yourself!

Melissa Kae Mason, MoonCat! © Mother Tongue Ink 2011

GODDESS PLANETS: CERES, PALLAS, JUNO AND VESTA

"Asteroids" are small planets, located between the inner, personal planets (Sun to Mars) that move more swiftly through the zodiac, and the outer, social and collective planets (Jupiter to Pluto) whose slower movements mark generational shifts. Ceres, Pallas, Juno and Vesta are faces of the Great Goddess who is reawakening in our consciousness now, quickening abilities so urgently needed to solve our many personal, social, ecological and political problems.

S Ceres (Goddess of corn and harvest) symbolizes our ability to nourish ourselves and others in a substantial and metaphoric way. As in the Greek myth of Demeter and Persephone, she helps us to let go and die, to understand mother-daughter dynamics, to re-parent ourselves

and to educate by our senses.

* Juno (Queen of the Gods and of relationships) shows us what kind of committed partnership we long for, our own individual way to find fulfillment in personal and professional partnering. She wants partners

to be team-workers, with equal rights and responsibilities.

Pallas (Athena) is a symbol for our creative intelligence and often hints at the sacrifice of women's own creativity or the lack of respect for it. She brings to the fore father-daughter issues, and points to difficulties in linking head, heart and womb.

Vesta (Vestal Virgin/Fire Priestess) reminds us first and foremost that we belong to ourselves and are allowed to do so! She shows us how to regenerate, to activate our passion, and how to carefully watch over

our inner fire in the storms of everyday life.

excerpt Beate Metz © Mother Tongue Ink 2009

EPHEMERIS 101

A Planetary Ephemeris provides astronomical data showing the

daily positions of celestial bodies in our solar system.

The planets have individual and predictable orbits around the sun and pathways through the constellations that correlate with the astrological signs of the Zodiac. This regularity is useful for sky viewing and creating astro charts for a particular date.

The earliest astrologers used these ephemeris tables to calculate individual birth and event charts. These circular maps plot planetary positions and the aspects—angles of relationships—in a "state of the solar system" as a permanent representation of a moment in time. The ephemeris can then be consulted to find when real-time or "transiting" planets will be in the same sign and degree as planets in the birth or event chart. For instance, use the ephemerides to follow the Sun through the houses of your own birth chart, and journal on each day the Sun conjuncts a planet. The sun reveals or sheds light on a sign or house, allowing those qualities to shine and thrive. Ephemerides can also be used to look up dates of past events in your life to learn what planets were highlighted in your chart at that time. In addition, looking up dates for future plans can illuminate beneficial timing of available planetary energies.

Read across from a particular date, ephemerides provide the sign and degree of all the Planets, the Sun and Moon and nodes of the Moon on that day. The lower box on the page offers a quick look at Astro data such as, when a planet changes sign (an ingress occurs), aspects of the outer planet, and their change in direction or retrograde period and much more. The larger boxes represent two different months as labeled.) Use the Signs and Symbols at a Glance on page 229 to note the symbols or glyphs of planets, signs

and aspects.

Sandra Pastorius © Mother Tongue Ink 2018

N	loon:	O hr=l	Midnig	ht and 1	Noon=1	2PM		R=Planet
Planet Glyphs				7	1			Retrograde
(p. 229)	Day	Sid.Time	▶ ⊙	0 hr)	Noon)	True	Å	shown in
Ingress:	1 Tu	6 41 26 6 45 22		12m,21 35 25 14 11	18M,49 44 1 ₹35 10	26\$52.2	23 151.2	shaded
January 1st —	3 Th	6 49 19 6 53 15	12 17 42	7 3 5 2 5 2	14 07 28	26 47.6	26 47.7	OOACS
the Sun moves	5 Sa	6 57 12	14 20 03	2134 27	26 28 04 8 13 38 27	26 45.5 26 43.9	28 16.7 29 46.2	2
into 10° Capricorn	6 Su 7 M	7 01 08 7 05 05	15 21 14 16 22 25	14 40 17 26 38 13	20 40 08	26 42.9 26D 42.6	1 1316.2 2 46.7	
•	8 Tu	7 09 01	17 23 36	8830 08	2%34 48 14 24 32	26 42.9	4 17.6	
Mars Ingress	Aries				ro Data Dy Hr Mn	Planet In		Last Aspe
January 1 @ 2				JON	2 0:50	o* ↑ 1	2:21	1 22:27 ♀
,,				l X D	6 20:28 7 0:06	¥ 13 5	3:41 11:19	4 17:43 ¥ 7 6:21 ♀

						LONG	ITUDE					Jar	nuary	2020
Day	Sid.Time	0	0 hr)	Noon D	True	Ā	Q	ď	2	14	ħ	ж	Ψ	Р
1 W 2 Th 3 F 4 Sa 5 Su 6 M 7 Tu 8 W 9 Th 10 F 11 Sa 12 Su 13 M 14 Tu	6 40 28 6 44 25 6 48 21 6 52 18 6 56 14 7 00 11 7 04 07 7 08 04 7 12 01 7 15 57 7 19 54 7 23 50 7 27 47 7 31 43 7 35 40	10 19 00 31 11 01 41 12 02 51 13 04 01 14 05 10 15 06 19 16 07 28 17 08 36 18 09 45 19 10 53 20 12 00 21 13 08 22 14 15 23 15 22 24 16 28	16+07 44 28 00 35 9 15 25 21 49 26 3 15 45 11 16 13 39 28 49 41 11 11 45 54 25 03 56 8 43 44 22 43 29 6 5 9 30 21 26 44 5 15 59 31 20 31 06	22±04 31 3 ↑ 56 32 15 50 21 27 50 45 10 ○ 02 19 22 29 18 5 11 50 81 18 22 09 1 © 51 11 15 41 18 29 49 45 14 \$\text{1} 12 04 28 42 42 13 \$\text{1} 15 04 27 45 07	8523.0 8R 22.8 8D 22.7 8 22.8 8 23.1 8 23.7 8 24.5 8 25.3 8R 26.0 8 26.2 8 25.9 8 24.9 8 23.4 8 21.4 8 21.4	4/b)22.9 5 57.6 7 32.5 9 07.8 10 43.5 12 19.4 13 55.8 15 32.6 17 09.8 18 47.3 20 25.4 22 03.8	14824.5 15 38.0 16 51.5 18 04.9 19 18.3 20 31.6 21 44.9 22 58.1 22 58.1 24 11.3 25 24.4 26 37.4 27 50.4 29 03.3 0\tag{6}16.2	28m,23.0 29 04.8 0 × 24.2 1 04.6 1 45.0 2 25.5 3 05.9 3 46.4 4 26.9 5 07.5 5 48.0 6 28.6 7 09.2 7 49.9	171354.3 18 18.3 18 42.3	6 17 40.2 6 54.0 7 07.9 7 21.7 7 35.5 7 49.3 8 03.0 8 16.8 8 30.6 8 44.3 8 58.0 9 11.7 9 25.4 9 39.1	211923.7 21 30.7 21 37.8 21 44.8 21 51.9 22 06.0 22 13.1 22 20.2 22 20.2 22 20.2 23 34.4 22 41.5 22 48.6 22 48.6 23 02.8	2041.6 2R 41.1 2 40.7 2 40.3 2 40.0 2 39.7 2 39.4 2 39.2 2 39.1 2 39.0 2 39.0 2 39.1 2 39.1 2 39.2	# 16\(\pm\15.9\) 16. 17.0 16. 18.2 16. 19.5 16. 20.7 16. 22.0 16. 23.3 16. 24.7 16. 26.1 16. 27.5 16. 28.9 16. 30.4 16. 31.9 16. 33.4 16.	22)323.1 22 25.1 22 27.1 22 29.1 22 31.1 22 35.1 22 35.1 22 37.1 22 41.1 22 43.1 22 45.1 22 47.2 22 49.2
16 Th 17 F 18 Sa 19 Su 20 M 21 Tu 22 W 23 Th 24 F 25 Sa 26 Su 27 M 28 Tu 29 W 30 Th 31 F	7 43 33 7 47 30 7 51 26 7 55 23 7 59 19 8 03 12 8 11 09 8 15 06 8 19 02 8 22 59 8 26 55 8 30 52 8 34 48	25 17 35 26 18 41 27 19 48 28 20 54 29 22 00 08 23 05 1 24 10 2 25 15 3 26 19 4 27 23 5 28 25 6 29 27 7 30 27 7 30 27 9 32 25 10 33 23	4 年 5 7 0 6 19 13 18 3	12 \$\triangle 06 37 26 16 52 10 \$\tilde{\pi}\$, 16 16 52 10 \$\tilde{\pi}\$, 16 16 52 20 7 \$\tilde{\pi}\$ 26 54 20 43 09 317 46 39 16 37 53 29 17 18 11 \$\tilde{\pi}\$ 45 21 24 02 42 6 \$\tilde{\pi}\$ 10 25 18 10 07 0 \$\tilde{\pi}\$ 0 \$\tilde{\pi}\$ 4 02 42 6 \$\tilde{\pi}\$ 10 5 24 23 47 42		12 19.5 14 02.9 15 46.4 17 29.8 19 12.9 20 55.6 22 37.7	17 08.7 18 20.4	11 13.3 11 54.1 12 34.9 13 15.7 13 56.5 14 37.3 15 18.2 15 59.0 16 39.9 17 20.8 18 01.7		10 20.0 10 33.5 10 47.1 11 00.6 11 14.1 11 27.6 11 54.4 12 07.8 12 21.1 12 34.4 12 47.6 13 00.8 13 14.0	23 10.0 23 17.1 23 24.2 24.2 23 31.3 23 38.4 23 45.5 23 52.5 23 59.6 24 06.7 24 13.7 24 20.8 24 27.8 24 34.8 24 41.8 24 48.7 24 55.7		16 36.5 16 38.1 16 39.7 16 41.3 16 43.0 16 44.7 16 46.4 16 49.9 16 55.7 16 55.3 16 57.1 16 59.0 17 00.9	22 53.2 22 55.2 22 57.2 23 01.2 23 05.2 23 05.2 23 07.2 23 11.2 23 15.2 23 17.1 23 19.1 23 23.0 23 23.0
	2.5				~]	LONG	TUDE					Febr	uary	2020
Day 1 Sa	Sid.Time	0	0 hr)		True	Å	Q	ď	3	4	ħ	ж	Ψ	Б
2 Su 3 M 4 TW 5 Th 7 F 8 Sa 9 Su 110 Tu 12 W 113 Th 117 M 118 Tu 117 M 20 Th 21 F 22 Sa 23 Su 24 M 25 Tu 26 W 27 Th	8 46 38 8 50 34 8 54 31 8 58 28 9 02 24 9 06 21 9 10 17 9 14 10 9 22 07 9 26 04 9 33 57 9 37 53 9 45 46 9 49 43	14 36 59 116 38 40 117 39 28 118 40 15 119 41 00 20 41 44 21 42 27 22 43 09 23 43 49 24 44 28 25 45 06 26 45 27 46 19 28 46 54 29 47 28 27 46 19 31 48 31 2 49 00 31 49 28 4 49 54 4 50 54 6 50 42 7 5 51 92	11'047 36 24 02 07 6 6133 57 19 27 31 22 46 19 16 32 07 0 0 44 27 15 15 19 59 0 10 12 29 15 13 28 0 21 32 88 0 21 38 15 13 28 15 13 28 17 17 18 17 17 18 18 17 27 18 18 18 11 28 18 11 28 18 14 29 46 28 18 28 18 42 20 28 12 31 14 29 46 28 28 21 28 8 42 20 20 40 23 22 73 41 44 25 41 46 25 41 46 26 16 56	50'45 20 17 52 59 10 II 534 12 50'38 95'35'48 23 35 07'79'59 39 22 44 36 779'42 30 22 44 01 42 22 24 11 015'44 05 13 28 37'26 00 32 88'22 12 20 35 26 22 44 139 14 42 02 26 37 43 88'72 08 20 21 10 22 10 20 10 20 10 20 10	7D 47.8 7 48.4 7 49.8 7 51.5 7R 52.6 7 50.3 7 46.3 7 46.3 7 26.6 7 20.3 7 15.7 7 D13.1 7 12.4 7 13.9 7 10.8 7 10.8 7 50.3	27 37.4 29 14.0 0)+(48.2 2 19.5 3 47.4 5 11.3 6 30.5 7 44.2 8 51.8 9 52.5 10 45.5 11 30.2 12 31.8 12 47.8 12 48.6 12 33.4 12 05.8 11 33.8 12 47.8 11 33.8 12 48.6 12 33.4 11 33.8 10 50.9 10 00.6 6 59.9 5 5,9 5 5,9 9 5,9 9 5,9 10 4,5 11 30.5	23 06.2 24 17.4 25 28.5 26 39.5 27 50.3 29 01.0 0 11.6 1 22.0 2 32.3 3 42.5 4 52.6 6 02.5 7 12.2 8 21.8	7 56.2	0 39.5 1 03.2 1 26.8 1 50.5 2 14.1 2 37.7 3 01.2 3 02.2 3 04.7 4 35.1 4 58.5 5 21.9 5 6 31.7 6 7 18.1 7 7 41.3 8 04.4 8 27.4 8 9 36.3 9 36.3 9 36.2 10 24.8	13 53.2 2 14 06.1 2 14 19.0 2 14 31.9 2 14 57.5 2 15 10.2 2 15 35.4 2 16 00.4 2 16 12.8 2 16 25.2 2 16 37.5 2	66 56.3 7 02.7 7 09.0 7 15.3 7 21.6 7 27.8 7 33.9 7 40.0 7 46.1 7 52.1 7 58.1	2 51.5 2 52.6 2 52.9 2 55.1 2 57.8 2 59.2 3 02.1 3 03.7 3 06.9 3 10.3 3 12.1 3 13.8 3 17.7 3 19.6 3 21.6 3 23.6 3 27.8 3 32.2 3 34.4 3 34.4	17 06.7 17 08.6 17 12.6 17 12.6 17 12.6 17 14.6 17 16.6 17 16.7 17 22.7 17 22.8 17 27.0 17 27.0 17 27.0 17 27.0 17 27.0 17 37.5 17 37.7 17 37.7 17 37.7 17 42.1 17 44.3 17 46.5 17 48.7 17 55.4 17 55.4 17 55.4 17 55.4 17 55.4 17 55.4 17 55.8	23 j 24.9 23 j 24.9 23 28.8 23 30.7 23 34.5 23 36.3 38.2 23 36.3 38.2 23 41.9 23 45.6 23 47.4 23 45.6 23 47.4 23 45.6 23 47.4 23 52.7 23 52.7 23 52.7 23 52.7 24 02.9 24 06.2 24 07.8 24 07.8 24 07.8 24 10.9
DDDDDDDDDDDDDDDDDDDDDDDDDDDDDDDDDDDDD	y Hr Mn 3 4:28 3 4:52 9 1 1:50 2 17:00 6 12:13 7 13:03 2 20:21 2 1:29 6 9:02 8 16:26 2 18:54 5 22:22	が * 3 : 2 H 13 1: 4 M 16 1: 2 M 20 1: 4 M 31 : 2 M 31 : 2 M 7 2: 6 M 16 1:	Ir Mn Dy F 19:39 2 4 4 4 4 4 4 4 4 4	t Aspect ir Mn 2:15 o △ ↑ 1:19 E □ ↑ 2:09 E △ ↑ 2:17 ♀ △ ↑ 2:13 ♀ △ ↑ 3:43 ♀ ♂ ↑ 1:23 ⊙ ★ ↓ 4:47 ¥ □ ↑ 9:08 ♀ ♂ ↑ 1:10 ♭ ★ ↑	7 2:1: 6 9 8:44 1 11 12:1: 9 13 14:00 1 15 15:44 1 17 18:2: 1 19 22:42 2 2 5:01 2 24 13:22 4 26 23:45	In Dy Hr M 2 31 15:1 6 3 11:2 2 5 14:2 4 7 15:4 7 9 16:1 8 11 18:2 15 22:2 18 9:0 1 20 14:1 2 22 4:0 5 25 14:1	In 19 ¥ ♀ ♀ △ □ ※ ※ ○ □ ○ ○ ○ ○ ○ ○ ○ ○ ○ ○ ○ ○ ○ ○ ○	5 19:04 7 22:46 9 23:40 11 23:38 14 0:39 16 4:08 18 10:38 20 19:43 23 6:38 25 18:48	n Dy Hr N 3 4:4 10 19:2 10 19:1 17 13:0 24 21:4 2 1:4 9 7:3 15 22:1 23 15:3	7	1 J Jul SVI	Astro anuary 20 ian Day # P 4+59'0 27\$-07. s 23Υ13. 1Υ35. lean Ω 8 ebruary 2 ian Day # P 4+59'0 27\$-07.2 s 23Υ15. c 2Υ30.6 lean Ω 6	220 43830 6" 1	21.8 06.4 20.2 28.1

^{*}Giving the positions of planets daily at midnight, Greenwich Mean Time (0:00 UT)

Each planet's retrograde period is shaded gray.

March 2020

LONGITUDE

Day	Sid.Time	0	0 hr	1	Noon)	TrueΩ	Ā	Q	o ⁿ	3	4	5	ж	Ψ	P
1 Su 2 M 3 Tu 4 W 5 Th 6 F 7 Sa	10 40 58 10 44 55 10 48 51	11 52 07 12 52 18 13 52 27 14 52 34 15 52 39	14 4	2 12 8 40 5 34 7 26 7 45	26 \(\) 15 05 8 \(\) 33 12 21 09 16 4\(\) 08 07 17 33 53 1\(\) 29 08 15 53 52	5549.2 5D 47.0 5 46.5 5R 46.9 5 47.0 5 45.6 5 42.0	1 02.6 0 18.4 29%40.6 29 09.5		10 00.5 10 42.0 11 23.4 12 04.9 12 46.4	11 52.8 12 15.4 12 37.9 13 00.3 13 22.7	19 43.7 19 54.6 20 05.4 20 16.2	28 21.4 28 27.1 28 32.8 28 38.4	3 541.4 3 43.8 3 46.2 3 48.7 3 51.2 3 53.7 3 56.3	18 08.9 18 11.1 18 13.4 18 15.7 18 18.0	24 18.5 24 19.9 24 21.3 24 22.7
9 M 10 Tu 11 W 12 Th 13 F	11 04 37 11 08 34 11 12 30 11 16 27 11 20 24 11 24 20 11 28 17	18 52 41 19 52 38 20 52 32 21 52 25 22 52 16	8™1 23 3 8≏5 24 0 8™5	8 01 4 02 3 19 4 21	0™44 48 15 54 53 1≏14 00 16 30 33 1™33 33 16 14 38 0 ₹ 28 57	5 26.8	28D 12.8 28 14.9 28 23.0 28 36.9	3 07.8 4 12.8 5 17.4 6 21.8 7 25.9 8 29.6 9 33.1	14 51.0 15 32.5 16 14.1 16 55.7 17 37.3	14 29.6 14 51.7 15 13.8 15 35.8 15 57.8	20 58.1 21 08.3 21 18.4 21 28.4 21 38.4	29 00.1 29 05.4 29 10.7 29 15.8	3 58.9 4 01.5 4 04.2 4 06.9 4 09.6 4 12.4 4 15.1	18 24.8 18 27.1 18 29.4 18 31.6 18 33.9	24 26.8 24 28.1 24 29.4 24 30.7 24 31.9
16 M 17 Tu 18 W 19 Th 20 F	11 32 13 11 36 10 11 40 06 11 44 03 11 47 59 11 51 56 11 55 53	25 51 39 26 51 24 27 51 06 28 50 47 29 50 27	20 5 470 16 5 29 2 11%3	8 06 5 29 1 28 0 15	14 15 09 27 34 44 10 17 30 53 23 07 44 5 29 30 17 40 05 29 42 47	4 39.0 4D 38.1 4R 38.1 4 37.7 4 35.8 4 31.4 4 24.0	29 49.6 0+23.3 1 01.2 1 43.0	11 39.1 12 41.5 13 43.7 14 45.5 15 46.9	19 42.1 20 23.8 21 05.4 21 47.1 22 28.8	17 03.3 17 25.0 17 46.6 18 08.2 18 29.6		29 30.9 29 35.8 29 40.6 29 45.4 29 50.1	4 18.0 4 20.8 4 23.7 4 26.6 4 29.5 4 32.5 4 35.5	18 40.7 18 43.0 18 45.2 18 47.5 18 49.7	24 35.5 24 36.6 24 37.7 24 38.8 24 39.9
23 M 24 Tu 25 W 26 Th 27 F	11 59 49 12 03 46 12 07 42 12 11 39 12 15 35 12 19 32 12 23 28	4 48 14	29 3 11 1 2 23 1 5 0 0	7 35 0 41 2 41 4 54 8 46	11 H 40 12 23 34 21 5 T 26 45 17 18 41 29 11 31 11 0 06 55 23 07 05	4 13.7 4 00.9 3 46.4 3 31.5 3 17.4 3 05.2 2 55.6	6 03.4 7 04.3 8 07.9 9 13.9	18 48.9 19 48.7 20 48.1 21 47.1 22 45.6	24 33.8 25 15.5 25 57.2 26 38.9 27 20.6	19 33.6 19 54.8 20 15.8 20 36.8 20 57.8	23 02.4 23 11.1 3 23 19.7 3 23 28.2 3 23 36.6 3 23 44.8 5 23 52.9	0%03.7 0 08.1 0 12.4 0 16.7 0 20.8	4 38.5 4 41.5 4 44.6 4 47.7 4 50.8 4 53.9 4 57.0	18 56.5 18 58.7 19 00.9 19 03.1 19 05.3	24 42.9 24 43.9 24 44.8 24 45.7 24 46.6
30 M 31 Tu	12 27 25 12 31 21 12 35 18	10 44 26	11 11 2	9 49 2 44 8 53	511453 17 3354 020816	2 49.0 2 45.2 2D 43.8	12 45.5	25 38.3 26 34.8	29 25.7	22 00.0	3 24 00.8 24 08.6 24 16.3	0 32.9	5 00.2 5 03.4 5 06.6	19 11.8	

April 2020

LONGITUDE

Day	Sid.Time	0	0 hr)	Noon)	True	Å	Q	ď	2	4	ħ	Ж	Ψ	В
3 F	12 39 15 12 43 11 12 47 08 12 51 04	13 42 02	19 38 19 3 ຄ 09 53	13©02 27 26 20 40 10 ស 06 13 24 20 31	2543.6 2R 43.5 2 42.3 2 39.1	17 56.0	28 26.2			24 31.2 24 38.4	0%40.5 0 44.2 0 47.8 0 51.3	5 09.8 5 13.1 5 16.3 5 19.6	19 18.3 19 20.4	24 % 50.5 24 51.2 24 51.9 24 52.6
6 M 7 Tu 8 W 9 Th 10 F	12 55 01 12 58 57 13 02 54 13 06 50 13 10 47 13 14 44 13 18 40	16 39 16 17 38 17 18 37 15 19 36 11 20 35 05	1≏43 35 17 03 47 2™,20 41	9™02 05 24 05 54 9≏23 21 24 43 23 9™,54 21 24 46 15 9⊀12 12	2 33.2 2 25.0 2 14.9 2 04.3 1 54.4 1 46.4 1 40.8	22 07.9 23 35.3 25 04.3 26 34.9 28 07.1	1 08.9 2 01.9 2 54.1 3 45.7 4 36.5 5 26.6 6 15.9	3 35.9 4 17.6 4 59.3 5 41.0 6 22.7 7 04.4 7 46.1	24 21.9 24 41.8 25 01.5 25 21.2 25 40.8	24 59.3 25 05.9 25 12.4 25 18.8 25 25.0	0 54.7 0 58.1 1 01.3 1 04.5 1 07.6 1 10.6 1 13.5	5 22.9 5 26.2 5 29.5 5 32.8 5 36.1 5 39.5 5 42.9	19 26.7 19 28.8 19 30.8 19 32.8 19 34.9	24 54.4 24 54.9 24 55.4 24 55.9
13 M 14 Tu 15 W 16 Th 17 F	13 22 37 13 26 33 13 30 30 13 34 26 13 38 23 13 42 19 13 46 16	23 31 37 24 30 24 25 29 10 26 27 54 27 26 36	29 56 22 13 17 10 21 25 59 39 8 28 39 20 42 05	23 08 59 6 ft 36 41 19 37 50 2 16 24 14 37 01 26 44 24 8 + 42 52	1 37.8 1D 36.9 1R 37.2 1 37.5 1 36.8 1 34.1 1 29.0	6 12.2 7 53.9 9 37.3	7 04.5 7 52.2 8 39.0 9 24.9 10 10.0 10 54.0 11 37.1	11 14.6 11 56.3	26 38.9 26 58.0 27 17.0 27 35.9 27 54.7	25 53.7 25 58.9 26 04.0	1 16.3 1 19.1 1 21.7 1 24.3 1 26.7 1 29.1 1 31.4	5 46.2 5 49.6 5 53.0 5 56.4 5 59.8 6 03.3 6 06.7	19 40.8 19 42.8 19 44.8 19 46.7 19 48.6	24 57.1 24 57.5 24 57.8 24 58.1 24 58.4
20 M 21 Tu 22 W	13 58 06 14 02 02 14 05 59 14 09 55	0 to 22 31 1 21 06 2 19 39 3 18 11 4 16 40	26 31 53 8 7 23 00 20 15 27 2 0 10 53	14 18 57 26 12 42	1 21.4 1 11.7 1 00.6 0 49.1 0 38.1 0 28.6 0 21.3	14 57.0 16 46.8 18 38.2 20 31.3 22 26.0	13 00.1 13 40.0 14 18.7 14 56.2 15 32.5	14 01.3 14 42.9 15 24.5 16 06.1 16 47.6	28 50.3 29 08.6 29 26.8 29 44.8 0+02.7	26 18.2 26 22.6 26 26.9 26 30.9 26 34.8		6 10.1 6 13.6 6 17.0 6 20.4 6 23.9 6 27.3 6 30.8	19 54.2 19 56.0 19 57.8 19 59.6 20 01.4	24 59.1 24 59.2 24 59.3 24 59.4
27 M 28 Tu 29 W	14 25 42	8 10 19 9 08 39	20 51 48 3526 11 16 15 26	14 39 15 27 07 20 9⊊48 45 22 46 37 6ฦ 04 03	0 16.5 0D 14.1 0 13.6 0 14.4 0R 15.5	28 19.7 0 0 20.8 2 23.3	17 13.3 17 44.1 18 13.4	18 52.2 19 33.7 20 15.1	0 38.1 0 55.6 1 12.9 1 30.1	26 42.0 26 45.4 26 48.6 26 51.6	1 47.7 1 49.0	6 44.6	20 06.5 20 08.2 20 09.9	24 59.5 24 59.5 24 59.4

30 111 14 30 30 10 30 30 12	00(04 00 011 10.0		0 00.0 1 47.2	20 0	4 0 40.1 20 11.5 24 55.5
Astro Data Dy Hr Mn Q D 2 19:46 Q R 4 15:09 Q R 4 15:09 Q B 15:00 Q B 17:00	15:53 \$\(\triangle \) \(\tri	MM Dy H Min 22 2 16:50 9 ★ 9 26 3 19:30 ○ △ 10 29 6 613:30 4 △ □ 40 613:30 4 △ □ 40 10:936 ¥ △ ⊉ 12 11:47 ○ △ 1 10 14 23:49 4 ○ □ 17 14:23:49 4 ○ □ 17 14:23:49 4 ○ □ 17 14:23:49 4 ○ □ 17 14:23:49 4 ○ □ 18 23:32 4 ← ↑ 17 19 23:32 4 ← ↑ 17 19 23:32 4 ← ↑ 18 22:33 4 □ □ 18 23:32 4 □ □ 17 17:01 ¥ ⊕ ② 18 29 29 19:31 4 ⊕ 0 19 39 29 19:31 4 ⊕ 0 19 39 29 19:31 4 ⊕ 0	Dy Hr Mn Dy Hr 1 2 18:27 2 19:2 4 21:20 9 17:6 21:17 16 9: 10 20:36 13 0:06 1 10: 15 7:38 8 2: 17 18:31 14 22: 20 7:01 23 2: 22 19:37 30 20: 27 17:29	59) 12 II 42 49	Astro Data 1 March 2020 Julian Day # 43890 SVP 4459'58' GC 27√07.3 ♀ 151/48.1 Eris 237'26.3 ★ 20≏13.0R ₹ 37'56.7 ★ 23'0'14.2) Mean 12 \$5203.6 1 April 2020 Julian Day # 43921 SVP 4458'55' SVP 4458'55' GC 27'√07.3 ♀ 241/48.8 Eris 23'744.3 ★ 315-59.5) Mean 12 \$525.1

						LONG	ITUDE						May	2020
Day	Sid.Time	0	0 hr)	Noon)	True	Å	Q	ď	2	4	ħ	Ж	Ψ	В
1 F 2 Sa	14 37 31 14 41 28	11 005 12 12 03 25			0515.9 0R 14.9	6 8 39.2	19II07.1 19 31.5	21\iii38.0 22 19.4	2)(04.1 2 20.8	26 59.5 26 59.5	1%52.4 1 53.3	6 55.0	20\(\mathref{+}13.1\) 20\(\mathref{+}14.7\)	24Y)59.1 24R 59.0
3 Su	14 45 24	13 01 36	107057 21	18 13 16	0 12.0	10 46.8	19 54.1	23 00.7	2 37.4	27 01.7	1 54.2	6 58.4	20 16.3	24 58.8
4 M 5 Tu	14 53 17	13 59 46 14 57 53	10≏28 15	17 59 31	0 07.3 0 01.3	12 55.4 15 04.7	20 14.8 20 33.7	23 42.0 24 23.3	2 53.8 3 10.1	27 03.8 27 05.7	1 54.9 1 55.6	7 01.8 7 05.3	20 17.8 20 19.3	24 58.6 24 58.3
6 W		15 55 58 16 54 02		3M,04 52 18 05 54	29 II 54.7 29 48.4	17 14.6 19 24.7	20 50.7 21 05.7	25 04.6 25 45.8	3 26.2 3 42.2	27 07.4 27 08.9	1 56.1 1 56.6	7 08.7 7 12.1	20 20.8 20 22.2	24 58.0 24 57.7
8 F 9 Sa	15 05 07 15 09 04	17 52 04 18 50 04	25 31 50	2 2 53 20	29 43.3	21 34.9 23 44.9	21 18.6 21 29.3	26 27.1 27 08.2	3 58.0 4 13.6	27 10.3 27 11.4	1 56.9 1 57.2	7 15.5 7 18.9	20 23.7 20 25.1	24 57.4 24 57.0
10 Su	15 13 00	19 48 03	24 23 39	11920 45	29D 38.6	25 54.4 28 03.1	21 38.0	27 49.4	4 29.1 4 44.4	27 12.4	1 57.3	7 22.3	20 26.5	24 56.6
11 M 12 Tu	15 20 53	20 46 01 21 43 57	21 31 24	28 02 00	29 39.9	0Д10.7	21 44.4 21 48.5	29 11.6	4 59.5	27 13.2 27 13.8	1R 57.4 1 57.4	7 25.7 7 29.1	20 27.8 20 29.2	24 56.2 24 55.8
13 W 14 Th	15 28 46	22 41 52 23 39 46	17 00 22	23 10 25	29 41.4 29R 42.6	2 16.9 4 21.5	21R 50.3 21 49.8	29 52.6 0 11 33.6	5 14.4 5 29.2	27 14.2 27R 14.4	1 57.3 1 57.0	7 32.4 7 35.8	20 30.5 20 31.7	24 55.3 24 54.8
15 F 16 Sa	15 32 43 15 36 40	24 37 38 25 35 29	29 16 43 11 + 20 25	5 1 19 51 17 18 57	29 42.7 29 41.4	6 24.2 8 24.7	21 46.9 21 41.6	1 14.6 1 55.5	5 43.8 5 58.1	27 14.4 27 14.2	1 56.7 1 56.3	7 39.1 7 42.5	20 33.0 20 34.2	24 54.3 24 53.7
17 Su 18 M	15 40 36 15 44 33	26 33 19 27 31 08		29 12 10 11 1 03 30	29 38.6	10 23.0 12 18.8	21 33.9 21 23.8	2 36.4	6 12.3 6 26.3	27 13.9 27 13.3	1 55.8 1 55.1	7 45.8 7 49.1	20 35.4 20 36.5	24 53.2 24 52.6
19 Tu 20 W		28 28 55 29 26 42	16 59 35	22 56 26 40 53 48	29 29.6	14 12.0 16 02.4	21 11.3 20 56.4	3 57.9 4 38.7	6 40.2	27 12.6	1 54.4	7 52.4 7 55.7	20 37.7	24 51.9
21 Th	15 56 22	0 П 24 27	1005453	16 57 52	29 19.2	17 50.0	20 39.1	5 19.3	6 53.8 7 07.2	27 11.6 27 10.5	1 53.6 1 52.7	7 58.9	20 38.8 20 39.8	24 50.6
22 F 23 Sa	16 00 19 16 04 15	1 22 11 2 19 53	23 02 57 5 II 20 09	29 10 20 11 II 32 33	29 14.8 29 11.7	19 34.6 21 16.2	20 19.5 19 57.6	5 59.9 6 40.4	7 20.4 7 33.4	27 09.2 27 07.7	1 51.7 1 50.6	8 02.2 8 05.4	20 40.9 20 41.9	24 49.9 24 49.2
24 Su 25 M	16 08 12 16 12 09	3 17 34 4 15 15	17 47 40 0%26 32	24 05 37 6% 50 34	29D 09.9	22 54.7 24 30.1	19 33.6 19 07.5	7 20.9 8 01.2	7 46.2 7 58.7	27 06.0 27 04.2	1 49.4 1 48.1		20 42.9 20 43.8	24 48.4 24 47.6
26 Tu 27 W	16 16 05 16 20 02	5 12 53 6 10 31		19 48 28 30 00 27	29 10.0	26 02.4 27 31.4	18 39.4 18 09.5	8 41.6 9 21.8	8 11.1	27 02.1 26 59.8	1 46.8 1 45.3	8 15.0	20 44.7 20 45.6	24 46.8 24 46.0
28 Th 29 F	16 23 58 16 27 55	7 08 06 8 05 41	98 42 04	16 27 37 0 m 10 47	29 12.8 29 13.9	28 57.2 0©19.7	17 37.9 17 04.8	10 02.0 10 42.1	8 35.1	26 57.4	1 43.7	8 21.3	20 46.5	24 45.2 24 44.3
30 Sa	16 31 51	9 03 14	7™08 28	14 10 08	29R 14.5	1 38.9	16 30.3	11 22.1	8 58.2	26 52.0	1 40.3	8 27.5	20 48.1	24 43.4
31 Su	16 35 48	10 00 45	21 15 40	28 24 49	29 14.2	2 54.7	15 54.8	12 02.0	9 09.4	26 49.0	1 38.5			24 42.5
						LONG							June	
Day 1 M	Sid.Time 16 39 44	O 10 ■ 58 15	0 hr) 5≏37 14	Noon) 12≏52 30	True € 29 11 13.0	¥ 4©07.1	Ф 15П18.3	o [™] 12)(41.9	⊋ 9∺20.4	261345.9	ხე 1‰36.6	₩ 8∀33.6	¥ 20∺49.6	Р
2 Tu	16 43 41	11 55 44	20 10 03	27 29 14	29R 11.3	5 16.0	14R 41.2	13 21.6	9 31.1	26R 42.6	1R 34.6	8 36.6	20 50.3	24Y341.6 24R 40.6
3 W 4 Th	16 51 34	12 53 12 13 50 38		12 ^M ,09 37 26 47 12	29 09.2 29 07.3			14 40.9	9 51.9	26 39.1 26 35.4	1 32.5	8 42.6	20 51.6	24 39.6 24 38.6
5 F 6 Sa		14 48 03 15 45 28	4×02 52 18 24 06	11 ₹15 24 25 28 22	29 05.8 29D 05.0	8 21.3 9 15.7		15 20.5 15 59.9	10 01.9 10 11.6	26 31.6 26 27.6	1 28.1 1 25.7	8 45.5 8 48.5	20 52.2 20 52.8	24 37.6 24 36.6
7 Su 8 M		16 42 51 17 40 14	21927 41 16 10 06	91721 41 22 52 48	29 04.8 29 05.2	10 06.2 10 52.8		16 39.2 17 18.5	10 21.1 10 30.4	26 23.4 26 19.1	1 23.3			24 35.5 24 34.5
9 Tu		18 37 36 19 34 58	29 29 47 128827 07	6801 10		11 35.5 12 14.0		17 57.6 18 36.7		26 14.6 26 09.9	1 18.2 1 15.6		20 54.3	24 33.4
11 Th 12 F	17 19 10	20 32 18 21 29 39	25 04 00 7+23 36	1+15 44		12 48.4 13 18.5	9 16.7	19 15.6 19 54.5	10 56.5	26 05.1 26 00.1	1 12.8	9 02.7	20 55.2 20 55.6	24 32.3 24 31.1 24 30.0
13 Sa	17 27 03	22 26 58	19 29 53	25 29 25	29R 08.6	13 44.2		20 33.2	11 12.5	25 55.0	1 07.1	9 08.2	20 55.9	24 28.8
14 Su 15 M	17 34 56	23 24 18 24 21 37	1 1 27 16 13 20 19	7 16 36		14 05.6 14 22.4		21 11.8 21 50.3		25 49.7 25 44.3	1 04.2			24 27.6 24 26.4
16 Tu		25 18 55 26 16 13	25 13 27 7 0 10 48	1 0 11 21 13 12 14		14 34.8 14 42.5		22 28.6 23 06.8	11 34.5 11 41.2	25 38.8 25 33.1	0 58.0 0 54.8			24 25.2 24 24.0
18 Th 19 F	17 46 46	27 13 31 28 10 49	19 16 02 1 II 32 07	25 22 34 7 II 44 59		14R 45.7 14 44.4	6 22.8		11 47.6 11 53.8	25 33.1 25 27.3 25 21.3	0 51.6 0 48.3	9 21.4	20 57.2	24 22.8 24 21.5
20 Sa	17 54 39	29 08 06	14 01 20	20 21 21	29 07.0	14 38.7	5 53.0	25 00.7	11 59.6	25 15.2	0 44.9	9 26.5	20 57.4	24 20.2
21 Su 22 M	17 58 36 18 02 32	0505 23 1 02 39	26 45 08 9\$44 07			14 28.5 14 14.2			12 10.4	25 09.0 25 02.7	0 41.5 0 38.0			24 18.9 24 17.7
23 Tu 24 W	18 06 29 18 10 25	1 59 55 2 57 10	22 58 11 6 ໓ 26 32			13 55.9 13 33.9				24 56.2 24 49.7	0 34.4 0 30.8	9 33.8 9 36.2		24 16.3 24 15.0
25 Th	18 14 22	3 54 25	20 07 50	27 02 49	29 06.0	13 08.4	5D 20.3	28 07.3	12 24.1	24 43.0	0 27.1 0 23.4	9 38.5 9 40.8	20 57.6	24 13.7 24 12.4
26 F	18 18 18	4 51 40	4m00 25	111m00 21 I	29 05.41	12 39.9	5 20.81	28 44.21						
26 F 27 Sa	18 18 18 18 22 15	4 51 40 5 48 53	4™00 25 18 02 22	25 06 12	29 05.4 29 04.9	12 08.8	5 23.6	29 20.8	12 31.6	24 36.3 24 29.4	0 19.6			24 11.0
26 F 27 Sa 28 Su 29 M	18 18 18 18 22 15 18 26 12 18 30 08	5 48 53 6 46 07 7 43 19	18 02 22 2≏11 34 16 25 45	25 06 12 9≏18 12 23 33 56	29 04.9 29D 04.6 29 04.7	12 08.8 11 35.7 11 00.9	5 23.6 5 28.6 5 35.7	29 20.8 29 57.3 0 33.6	12 31.6 12 34.9	24 29.4	0 19.6 0 15.7 0 11.9	9 45.3	20 57.2	24 09.6
26 F 27 Sa 28 Su 29 M	18 18 18 18 22 15 18 26 12	5 48 53 6 46 07	18 02 22 2≏11 34	25 06 12 9≏18 12 23 33 56	29 04.9 29D 04.6 29 04.7	12 08.8 11 35.7	5 23.6 5 28.6	29 20.8 29 57.3 0 33.6	12 31.6 12 34.9	24 29.4 24 22.4	0 19.6 0 15.7	9 45.3	20 57.2	24 09.6
26 F 27 Sa 28 Su 29 M 30 Tu	18 18 18 18 22 15 18 26 12 18 30 08 18 34 05	5 48 53 6 46 07 7 43 19 8 40 31	18 02 22 2≏11 34 16 25 45 0™,42 24	25 06 12 9≏18 12 23 33 56 7m,50 46	29 04.9 29D 04.6 29 04.7 29 05.2	12 08.8 11 35.7 11 00.9 10 25.1	5 23.6 5 28.6 5 35.7 5 45.1	29 20.8 29 57.3 0 33.6 1 09.7	12 31.6 12 34.9 12 37.9 12 40.5	24 29.4 24 22.4 24 15.4 24 08.3	0 19.6 0 15.7 0 11.9 0 07.9	9 45.3	20 57.2 20 57.0 20 56.8	24 09.6
26 F 27 Sa 28 Su 29 M 30 Tu	18 18 18 18 22 15 18 26 12 18 30 08 18 34 05	5 48 53 6 46 07 7 43 19 8 40 31 Planet ing	18 02 22 2≏11 34 16 25 45 0™,42 24 ress Las Hr Mn Dy	25 06 12 9≏18 12 23 33 56 7m,50 46 st Aspect Hr Mn	29 04.9 29D 04.6 29 04.7 29 05.2	12 08.8 11 35.7 11 00.9 10 25.1	5 23.6 5 28.6 5 35.7 5 45.1	29 20.8 29 57.3 0 33.6 1 09.7 D Ingress Dy Hr M	12 31.6 12 34.9 12 37.9 12 40.5 Dy Hr I 7 10:4	24 29.4 24 22.4 24 15.4 24 08.3 ses & Eclip	0 19.6 0 15.7 0 11.9 0 07.9	9 45.3 9 47.5 9 49.7 Astro	20 57.2 20 57.0 20 56.8	24 09.6
26 F 27 Sa 28 Su 29 M 30 Tu Astro	18 18 18 18 22 15 18 26 12 18 30 08 18 34 05 Data Dy Hr Mn 5 1:59 0 9:01	5 48 53 6 46 07 7 43 19 8 40 31 Planet Ing Dy Q IR 5 ¥ II 11	18 02 22 2≏11 34 16 25 45 0™,42 24 ress La Hr Mn Dy 4:41 1 21:59 4	25 06 12 9≏18 12 23 33 56 7™50 46 St Aspect Hr Mn 16:05 ♂ ♂ ♂ 2:26 4 △	29 04.9 29D 04.6 29 04.7 29 05.2) Ingress Dy Hr M (2) 5:3 (2) 4 7:1	12 08.8 11 35.7 11 00.9 10 25.1 Last A In Dy Hr I 6 2 10::	5 23.6 5 28.6 5 35.7 5 45.1 spect	29 20.8 29 57.3 0 33.6 1 09.7 D Ingress Dy Hr M 2 16:07	12 31.6 12 34.9 12 37.9 12 40.5 10 Phas 10 Dy Hr I 7 7 10:4 3 14 14:0	24 29.4 24 22.4 24 15.4 24 08.3 sees & Eclip Mn 36 0 17 04 (24	0 19.6 0 15.7 0 11.9 0 07.9 eses 1 M.20 Jul	9 45.3 9 47.5 9 49.7 Astro May 2020 lian Day #	20 57.2 20 57.0 20 56.8 Data	24 09.6 24 08.3 24 06.9
26 F 27 Sa 28 Su 29 M 30 Tu Astro D D 0 S D 1 5 R 1 1 9 R 1	18 18 18 18 22 15 18 26 12 18 30 08 18 34 05 Data Dy Hr Mn 5 1:59 0 9:01 11 4:10 13 6:46	5 48 53 6 46 07 7 43 19 8 40 31 Planet Ing Dy Q IR 5 V II 11 O II 20	18 02 22 2≏11 34 16 25 45 0™,42 24 ress La Hr Mn Dy 4:41 1 21:59 4 4:18 6 13:50 8	25 06 12 9≏18 12 23 33 56 7™50 46 St Aspect Hr Mn 16:05 ♂ ♂ ♂ 1 2:26 4 △ 1 2:32 4 □ 1 2:40 4 ★ :	29 04.9 29D 04.6 29 04.7 29 05.2) Ingress Dy Hr M P) 2 5:3 4 7:11 m, 6 7:0 2 8 7:11	12 08.8 11 35.7 11 00.9 10 25.1 10 25.1 10 27 10:4 11 4 11:5 16 6 4:6 18 18:1	5 23.6 5 28.6 5 35.7 5 45.1 spect	29 20.8 29 57.3 0 33.6 1 09.7 D Ingress Dy Hr M 2 16:07 4 17:18 3 6 19:48 9 9 0:55	12 31.6 12 34.9 12 37.9 12 40.5 10 Phas 10 Phas 17 7 10:4 13 14 14:6 15 22 17:4 15 30 3:3	24 29.4 24 22.4 24 15.4 24 08.3 ses & Eclip Mn 16 0 17 14 (24 10 • 2	0 19.6 0 15.7 0 11.9 0 07.9 0 07.9 0 sees 1 M 20 Jul 314 SV 105 GC	9 45.3 9 47.5 9 49.7 Astro May 2020 P 4\(\frac{4}{5}\) 8' 27\(\frac{2}{5}\) 27\(\frac{4}{5}\) 03.	20 57.2 20 57.0 20 56.8 Data # 43951 51" .4 \$ 0% .8 # 72	24 09.6 24 08.3 24 06.9
26 F 27 Sa 28 Su 29 M 30 Tu Astro D 0 OS Ω D 1 5 R 1 9 R 1 1 Q R 1	18 18 18 18 22 15 18 26 12 18 30 08 18 34 05 Data Dy Hr Mn 5 1:50 10 9:01 11 4:10 3 6:46 4 14:17 4 14:33	5 48 53 6 46 07 7 43 19 8 40 31 Planet Ing Dy S IR 5 ¥ II 11 ♂ H 13 ○ II 20 ¥ S 28	ress La Hr Mn 4:41 1 4:18 6 13:50 8 18:10 10	25 06 12 9≏18 12 23 33 56 7™,50 46 St Aspect Hr Mn 16:05 ♂ ♂ ♂ 2:26 4 △ □ 2:32 4 □ □ 2:40 4 ※ □ 6:12 ♂ ※ □ 10:31 4 ♂ ♂	29 04.9 29D 04.6 29 04.7 29 05.2 → Ingress Dy Hr M D 2 5:3 △ 4 7:1 T, 6 7:0 ★ 8 7:1 10 9:4 ₩ 12 15:4	12 08.8 11 35.7 11 00.9 10 25.1 10 25.1 11 Last A 10 Dy Hr I 16 4 11:: 16 6 4:: 16 8 18:: 10 10 14::	5 23.6 5 28.6 5 35.7 5 45.1 spect In 4 1	29 20.8 29 57.3 0 33.6 1 09.7 Dy Hr M 2 16:07 4 17:18 6 19:45 9 0:55 11 9:33	12 31.6 12 34.9 12 37.9 12 40.5 10 Phas 10 Phas 14 14:0 14 14:0 15 22 17:4 16 22 17:4 17 7 10:4 16 19:1	24 29.4 24 22.4 24 15.4 24 08.3 sees & Eclip Mn 16 0 17 14 (24 10 • 2 31) 9	0 19.6 0 15.7 0 11.9 0 07.9 0 07.9 0 07.9 0 07.9 1 N 0 07.9	9 45.3 9 47.5 9 49.7 Astro May 2020 lian Day # P 4)(58';	20 57.2 20 57.0 20 56.8 Data # 43951 51" .4 \$ 0% .8 * 72 .5 \$ 151	24 09.6 24 08.3 24 06.9
26 F 27 Sa 28 Su 29 M 30 Tu Astro D D 0S Ω D 1 5 R 1 9 R 1 4 R 1 4 R 1 9 N 1	18 18 18 18 22 15 18 26 12 18 30 08 18 34 05 18 34 05 18 34 05 19 11 10 12 10 10 12 10 10 12 10 10 12 10 10 12 10 10 12 10 12	5 48 53 6 46 07 7 43 19 8 40 31 Planet Ing Dy \Omega IR 5 \Omega II 11 \Omega II 20 \Omega 28 \Omega 28	18 02 22 2△11 34 16 25 45 0™,42 24 ress La Hr Mn Dy 4:41 1 21:59 4 4:18 6 13:50 8 18:10 10 12:21:45 14 1:46 17	25 06 12 9≏18 12 23 33 56 7™,50 46 st Aspect Hr Mn 2:26 4 Δ ≤ 2:32 4 □ □ 2:40 4 × ⇒ 6:12 6" × ↑ 10:31 4 0 □ 4:04 0 □ 8:00 4 × ⇒	29 04.9 29D 04.6 29 04.7 29 05.2 → Ingress Dy Hr M → 2 5:3 ← 4 7:1 → 6 7:0 √ 8 7:1 → 10 9:4 ₩ 12 15:4 ← 15 1:2 ↑ 17 13:3	12 08.8 11 35.7 11 00.9 10 25.1 Last A 10 10 10 11 11 11 11 11 11 11 11 11 11 1	5 23.6 5 28.6 5 35.7 5 45.1 spect Mn 41 4 0 m 48 4 × 3 12 4 0 m 77 4 0 m 36 0 0 0 0 0 0 0 0 0 0 0 0 0 0 0 0 0 0 0	29 20.8 29 57.3 0 733.6 1 09.7 D Ingress Dy Hr M 1 2 16:07 4 17:18 3 9 0:55 4 11 9:33 1 18 21:00	12 31.6 12 34.9 12 37.9 12 40.5 12 40.5 12 17.4 17 7 10.4 18 14 14:4 19 22 17.4 19 22 17.4 19 23 18 18 18 18 18 18 18 18 18 18 18 18 18	24 29.4 24 22.4 24 15.4 24 08.3 sees & Eclip Mn 16 0 17 14 (24 10 9 2 11) 9 14 0 15 16 4 A 16 15 (22	0 19.6 0 15.7 0 11.9 0 07.9 0 07.9 0 07.9 0 07.9 0 07.9	9 45.3 9 47.5 9 49.7 Astro Λay 2020 Ilan Day # P 4+58'5; 27,507.7 's 24,703.7 Λ24. Mean Ω	20 57.2 20 57.0 20 56.8 Data # 43951 51" .4 \$ 0% .8 # 72 .5 \$ 151	24 09.6 24 08.3 24 06.9
26 F 27 Sa 28 Su 29 M 30 Tu Astro D D D D D D D D D D D D D	18 18 18 18 22 15 18 26 15 18 26 15 18 26 10 18 30 08 18 34 05 18 34 05 19 Hr Mn 5 1:59 0 9:01 11 4:10 13 6:46 4 14:17 4 14:33 18 13:32 44 21:33 10 3:26 11 10:27	5 48 53 6 46 07 7 43 19 8 40 31 Planet Ing Dy \(\Pi \) II 11 6 \(\Pi \) I 20 \(\Pi \) 28 \(\Pi \) 28	18 02 22 22 11 34 16 25 45 0 0 42 24	25 06 12 9-18 12 33 35 66 7m,50 46 st Aspect Hr Mn 6:05 o' o' o' 2:32 4	29 04.9 29D 04.6 29 05.2 → Ingress Dy Hr M → 2 5:3 ← 4 7:1 → 6 7:0 √ 8 7:1 → 15:4 ↔ 12 15:4 ↔ 15 12:2 ↑ 17 13:3 ♥ 20 2:1: II 22 13:3	12 08.8 11 35.7 11 00.9 110 25.1 Last A In Dy Hr I 6 2 10:4 6 6 4 41:: 6 6 8 18:0 0 13 12:2 0 13 12:2 7 18 12:2 2 20 21:2 7 23 7:2	5 23.6 5 28.6 5 35.7 5 45.1 spect Win 11 4 0 m 32 2 ¥ 0 m 32 2 ¥ 0 m 33 4 4 0 m 33 4 4 0 m 33 4 4 0 m 31 4 0 m 31 4 0 m 32 2 ¥ 0 m 33 4 4 0 m 31 4 0 m 3	29 20.8 29 57.3 0 733.6 1 09.7 b Ingress Dy Hr M 1, 2 16:07 4 17:18 5 6 19:47 1 19:33 7 18 21:07 1 18 21:07 1 18 21:07 2 21 6:03 2 21 6:03	12 31.6 12 34.9 12 37.9 12 40.5 12 40.5 12 40.5 12 40.5 13 62.6 14 14.6 15 19:1 13 62.6 16 21 6:4 17 519:2 13 6:2 13 6:2 14 12 16:4 14 12 16:4	24 29.4 24 22.4 24 15.4 24 08.3 3 Ess & Eclip 16 0 17 14 (24 10 0 2 11) 9 14 0 15 15 (22 13 0 0 11:15 4 A (0 19.6 0 15.7 0 11.9 0 07.9 0 0 07.9	9 45.3 9 47.5 9 49.7 Astro	20 57.2 20 57.0 20 56.8 Data # 43951 51" 4 2 0% 8 # 72 5 \$ 151 1949.8	24 09.6 24 08.3 24 06.9 %06.1 445.5R
26 F 27 Sa 28 Su 29 M 30 Tu Astro DOS D 1 5 R 1 4 R 1 D 0S 1 20 R 3 D 0S 2 D 1 D 0S	18 18 18 18 18 26 15 18 26 15 18 26 15 18 30 08 18 34 05 Data by Hr Mn 5 1.59 10 9:01 1 4:10 3 6:46 4 14:17 44 14:33 24 21:33 10 3:26 11 10:27 6 18:05 3 6:37	5 48 53 6 46 07 7 43 19 8 40 31 Planet Ing Dy \$\text{U}\$ IR 11 \$\text{O}\$ IF 13 \$\text{U}\$ IF 28 \$\text{U}\$ S	ress La: Hr Mn Dy 4:41 1 122:59 4 4:18 6 818:10 10:122:45 14:146 17:123:50 818:10 10:122:45 14:146 17:123:50 818:10 10:122:45 14:146 17:123:50 818:10 10:123:50	25 06 12 9 18 12 23 33 56 7 10,50 46 st Aspect Hr Mn 16:05 ♂ ♂ ♂ ♂ ♂ ♂ ♂ ♂ ♂ ♂ ♂ ♂ ♂ ♂ ♂ ♂ ♂ ♂ ♂	29 04.9 29 04.6 29 05.2 29 05.2 Dy Hr M 2 5:3 △ 4 7:1 ↑ 10 9:4 ₩ 12 15:4 ₩ 12 15:4 ₩ 12 15:4 ₩ 12 13:3 ♥ 20 2:1 ₩ 22 13:3 ♥ 20 2:2 ♥ 20 2:2 ♥ 20 2:2 ♥ 20 2:3 ♥ 20 2:3	12 08.8 11 35.7 11 00.9 10 25.1 11 00.9 11 25.1 11 00.9 11 411: 16 6 2 10: 11 4 11: 16 6 6 6 4: 17 10 14: 10 10 14: 10 10 14: 10 10 14: 10 13 12: 12 12 12 12 12 12 12 12 12 12 12 12 12 1	5 23.6 5 28.6 5 5 28.6 5 5 45.1 spect Win	29 20.8 29 57.3 0 33.6 1 09.7 D Ingress Dy Hr M 2 16:07 4 17:18 6 19:44 13 21:00 13 21:00 14 23 12:34 15 27 20:18 2 27 20:18	12 31.6 12 34.9 12 37.9 12 40.5 10 Dy Hr I 7 7 10:4 3 14 14:1 5 22 17:5 3 30 3:3 3 5 19:1 7 5 19:2 7 5 19:2 8 21 6:4 8 21 6:4 8 28 8:1	24 29.4 24 22.4 24 15.4 24 08.3 3 Ess & Eclip 16 0 17 14 (24 10 0 2 11) 9 14 0 15 15 (22 13 0 0 11:15 4 A (0 19.6 0 15.7 0 11.9 0 07.9 0 07.9 0 07.9 0 07.9 0 07.9 0 07.9 0 07.9 0 07.9 0 07.9 0 07.9	9 45.3 9 47.5 9 49.7 Astro May 2020 Iian Day # P 4\+58'5 27\cdot 07.7 Mean Ω uune 2020 Iian Day # P 4\+58'4 27\cdot 07.7 24\cdot 27.7 27\cdot 07.5 24\cdot 27.5 27\cdot 07.5	20 57.2 20 57.0 20 56.8 Data # 43951 51" 4 \$ 0% 8.8 # 725 5 \$ 151 249.8 # 43982 477" 2 # 52	24 09.6 24 08.3 24 06.9 306.1 445.5R 446.1
26 F 27 Sa 28 Su 29 M U Astro D 0 1 5 P R 1 1 P P R 1 P P P P P P P P P P P P	18 18 18 18 18 22 15 18 26 15 18 26 15 18 30 08 18 34 05 Data by Hr Mn 5 1:5 1:59 0 9:01 13 6:46 4 14:17 44 14:33 8 13:32 44 21:33 10 3:26 11 10:27 6 18:05 3 6:37 4 21:17 8 5:50	5 48 53 6 46 07 7 43 09 8 40 31 Planet Ing Dy Ω IR 5 9 H 11 3 ○ H 13 3 ○ H 20 9 E 28 0 S 20 5 ↑ ↑ 28 28 P 25 6: 29 P 25 6: 20 D 25 6: 20 D 25 6: 20 D 28 8: 20 D 28 8:	18 02 22 2 1 34 16 25 45 16 25 45 16 25 45 17 20 12 21 45 14 1 1 2 20 12 21 45 14 1 1 2 20 12 21 33 24 49 27 08 28 28 27 20 22 27 20 28 28 27 20 28 28 27 20 28 28 28 27 20 28 28 28 27 20 28 28 28 28 28 28 28	25 06 12 9-18 12 23 33 56 770,50 46 st Aspect Hr Mn 6:05 of e 2 2:26 4 4 = 2 2:40 4 * 2 2:40 4 * 3 4:01 4 * 4 11:11 \$ 4 \to 6 11:11 \$ 4 \to 7 11:13 \$ 4 \to 7	29 04.9 29D 04.6 29 05.2 29 05.2 → Ingress Dy Hr M 0 2 5.3 △ 4 7:1 M, 6 7:0 √ 8 7:1 H 10 9:4 W 12 15:4 W 17 17 13:3 ∀ 20 2:1: 17 13:3 ∀ 20 2:1: 18 22 13:3 ✓ 24 23:3 ✓ 24 23:3	12 08.8 11 35.7 10.9 10 25.1 1	5 23.6 5 28.6 5 5 28.6 5 5 45.1 spect Win	29 20.8 29 57.3 0 33.6 1 09.7 D Ingress Dy Hr M 2 16:07 4 17:18 6 19:44 13 21:00 13 21:00 14 23 12:34 15 27 20:18 2 27 20:18	12 31.6 12 34.9 12 37.9 12 40.5 10 Dy Hr I 7 7 10:4 3 14 14:1 5 22 17:5 3 30 3:3 3 5 19:1 7 5 19:2 7 5 19:2 8 21 6:4 8 21 6:4 8 28 8:1	24 29.4 24 22.4 24 15.4 24 08.3 3 Ess & Eclip 16 0 17 14 (24 10 0 2 11) 9 14 0 15 15 (22 13 0 0 11:15 4 A (0 19.6 0 15.7 0 11.9 0 07.9 0 0 07.9	9 45.3 9 47.5 9 49.7 Astro May 2020 Ilian Day # P 4\\\68'' 122.7\\cdot 07.5 133.7 144.6 145.8 1	20 57.2 20 57.0 20 56.8 Data # 43951 51" 4 \$ 0% 8 # 72-5 5 \$ 151 249.8 # 43982 # 43982 # 52 1 \$ 2 0% 5 2 # 52 1 \$ 2 1 \$	24 09.6 24 08.3 24 06.9 306.1 245.5R 445.5R 413.2R 52.3

Q

1 W 18 38 01 9\$37 43 14458 41 22405 45 29\$\pi\$05.5 9\$\pi\$49.0 5\$\pi\$56.5 1\$\times\$45.7 12\times\$42.8 24\times\$01.1 0\times\$04.0 9\times\$51.8 20\times\$56.6 24\times\$05.5

ď

2 4 to ፠

18.6 17 43.2 26 03.7 05.3 17 40.7 26 00.9

10 36.4 19 53.8 22 46.7 10 35.7 19 52.2 22 45.8 Astro Data

17.4 26.2 5 5

July 2020 Day Sid.Time

0

0 hr)

Noon) True

LONGITUDE

Ā

2 Th 3 F 4 Sa	18 41 58 18 45 54 18 49 51	11 32 06	13 - 17 38		29 06.8 29 07.6 29R 08.0	9R 13.0 8 38.0 8 04.3	6 09.9 6 25.3 6 42.7	2 21.4 2 57.0 3 32.3	12 46.4	23R 53.8 23 46.5 23 39.1	291759.9 29R 55.9 29 51.8		20R 56.3 20 56.0 20 55.7	24R 04.1 24 02.7 24 01.3
5 Su 6 M 7 Tu 8 W 9 Th 10 F 11 Sa	18 57 44 19 01 41 19 05 37 19 09 34 19 13 30	13 26 28 14 23 39 15 20 49 16 18 01 17 15 12 18 12 23 19 09 38	24 23 33 7 8 33 21 20 25 18 2 3 10 03 15 19 26 5 27 26 17	14 01 32 26 44 44 9+11 31 21 24 13	29 07.7 29 06.7 29 05.0 29 02.7 29 00.1 28 57.6 28 55.5	7 32.7 7 03.8 6 37.9 6 15.6 5 57.4 5 43.5 5 34.2	7 01.9 7 22.9 7 45.6 8 10.0 8 36.1 9 03.7 9 32.9	4 07.5 4 42.4 5 17.1 5 51.6 6 25.9 7 00.0 7 33.7	12R 49.4 12 49.3 12 48.8 12 48.0	23 09.0 23 01.4 22 53.7	29 39.3 29 35.1	10 03.7 10 05.5 10 07.3 10 09.1	20 55.3 20 54.9 20 54.5 20 54.1 20 53.6 20 53.1 20 52.5	23 59.9 23 58.5 23 57.0 23 55.6 23 54.2 23 52.7 23 51.3
12 Su 13 M 14 Tu 15 W 16 Th 17 F 18 Sa	19 25 20 19 29 16 19 33 13 19 37 10 19 41 06	22 01 14 22 58 20 23 55 43 24 52 50	21 17 36 4 3 0 10 57 3 15 09 03 3 27 16 30 3 9 11 37 28	15 21 13 27 13 59 90 09 07 21 11 20 3 II 25 03 15 54 07 28 41 29	28D 54.1 28 53.6 28 54.1 28 55.3 28 56.9 28 58.5 28R 59.5	6 27.3	12 56.4	8 07.3 8 40.6 9 13.6 9 46.3 10 18.8 10 50.9 11 22.8	12 41.1 12 38.5 12 35.5	21 59.7	29 17.9 29 13.5 29 09.1 29 04.7 29 00.3 28 55.9 28 51.5	10 15.6 10 17.2 10 18.7 10 20.1	20 51.9 20 51.3 20 50.7 20 50.0 20 49.3 20 48.6 20 47.8	23 49.8 23 48.4 23 46.9 23 45.5 23 44.0 23 42.6 23 41.1
19 Su 20 M 21 Tu 22 W 23 Th 24 F 25 Sa	19 52 56 19 56 52 20 00 49 20 04 45 20 08 42	26 47 30 27 44 44 28 42 00 29 39 20 0 0 36 40 1 34 00 2 31 20	3 18 30 14 5 2 ብ 07 37 3 16 02 31 2 0 መ 11 15 0 14 29 10	7 ^m 19 23 21 40 00		7 28.5 8 07.3 8 51.5 9 41.2 10 36.2 11 36.4 12 41.8	15 35.9 16 18.3 17 01.6	11 54.4 12 25.6 12 56.5 13 27.1 13 57.3 14 27.2 14 56.7	12 04.7 11 58.8	21 44.3 21 36.6 21 29.0 21 21.3 21 13.8 21 06.3 20 58.8	28 47.1 28 42.6 28 38.2 28 33.7 28 29.3 28 24.9 28 20.4	10 25.5 10 26.7	20 42.7	23 39.7 23 38.2 23 36.8 23 35.4 23 33.9 23 32.5 23 31.1
26 Su 27 M 28 Tu 29 W 30 Th 31 F	20 20 32	3 28 3 4 25 5 5 23 2 6 20 4 7 18 0 8 15 2	9 27 30 01 0 11 M,40 08 0 25 41 26 2 9 ₹ 32 53	4 ^m ,36 06 18 41 58 2×38 26 16 24 45	28 35.5 28D 34.0 28 34.0 28 35.0 28 36.4 28R 37.4	13 52.3 15 07.8 16 28.1 17 53.2 19 22.8 20 56.7	20 51.4 21 39.7	15 25.9 15 54.7 16 23.1 16 51.2 17 18.8 17 46.1	11 32.2 11 24.7	20 44.0 20 36.8 20 29.6 20 22.4	28 07.2 28 02.8 27 58.5	10 32.1 10 33.0	20 38.8 20 37.8	23 29.6 23 28.2 23 26.8 23 25.4 23 24.0 23 22.6
Aud	gust 2	020				LONG	ITUDE	=						
	9							_						
Day	Sid.Time	0	0 hr))	Noon))	True	Å	Q	ď	2	4	ħ	Ж	Ψ	В
Day 1 Sa 2 Su 3 M 4 Tu 5 W 6 Th 7 F 8 Sa 9 Su 10 M	Sid.Time 20 40 14 20 48 08 20 52 04 20 56 01 20 59 57 21 03 54 21 07 50 21 11 47 21 15 43	9.0 12 4 10 10 1 11 07 3 12 04 5 13 02 2 13 59 5 14 57 1 15 54 4 16 52 1 17 49 5	6 6 19 44 01 0 20 02 33 4 3 8 8 5 8 16 02 12 4 28 42 15 1 11 + 09 05 9 23 23 45 8 5 \tau 27 50 8 17 24 04 0 29 15 55	13 17 24 46 26 37 16 9 18 37 10 22 23 54 4 +5 7 18 17 17 53 29 26 58 11 ↑ 26 44 23 20 19 5 1 1 38	True \(\) 28 \(\pi \) 20 \(\pi \) 27 \(\pi \) 28 \(\pi \) 27 \(\pi \) 28 \(\pi \) 27 \(\pi \) 27 \(\pi \) 27 \(\pi \) 27 \(\pi \) 27 \(\pi \) 27 \(\pi \)	22©34.8 24 16.8 26 02.4 27 51.3 29 43.2 1,037.8 3 34.6 5 33.4 7 33.8 9 35.3	Q 24 II 09.1 25 00.2 25 52.0 26 44.3 27 37.3 28 30.9 29 25.0 0 19.7 1 14.9 2 10.6	18 12.9 18 39.3 19 05.3 19 30.8 19 55.9 20 20.5 20 44.7 21 08.3 21 31.5 21 54.1	11H00.3 10R 51.5 10 42.5 10 33.1 10 23.5 10 13.6 10 03.4 9 53.0 9 42.3 9 31.3	20\(\text{r}\)08.5 20\(\text{R}\)01.6 19 54.9 19 48.2 19 41.6 19 35.2 19 28.9 19 22.7 19 16.6 19 10.6	27 16.4 27 16.4 27 27 37.1 27 32.9 27 28.7 27 24.6 27 20.5 27 16.4 27 12.4	10 36.3 10 37.0 10 37.6 10 38.2 10 38.7 10 39.2 10 39.7 10 40.1 10 40.4 10 40.4	20+34.5 20R 33.3 20 32.2 20 31.0 20 29.8 20 28.5 20 27.3 20 26.0 20 24.7 20 23.4	23 f) 21.2 23R 19.8 23 18.5 23 17.1 23 15.8 23 14.4 23 13.1 23 11.8 23 10.5 23 09.2
Day 1 Sa 2 Su 3 M 4 Tu 5 W 6 Th 7 F 8 Sa 9 Su 10 M 11 Tu 12 W 13 Th 14 F 15 Sa 16 Su 17 M	Sid.Time 20 40 14 20 40 14 20 48 08 20 52 04 20 56 01 20 59 57 21 03 54 21 07 50 21 15 43 21 19 40 21 27 37 12 12 37 12 13 30 21 31 30 21 31 30 21 31 30 21 31 32 21 43 19 21 43 19	9\(\sigma\) 12 4 11 07 3 12 04 5 13 02 2 13 59 5 14 57 1 15 54 4 16 47 2 17 49 5 18 47 2 18 47 2 20 42 37 4 21 40 1 22 37 4 24 33 3 3 3 3 24 33 3	6 6 6 6 4 4 0 1 0 2 0 0 2 3 3 4 3 5 0 8 5 6 8 1 1 1 1 1 1 1 4 0 9 0 2 9 1 5 5 6 3 1 1 5 0 7 5 2 3 0 4 2 5 1 0 3 1 5 0 0 5 1 2 9 0 5 1 2 3 0 4 2 5 1 0 4 0 1 7 3 1 5 4 9 0 5 1 2 3 1 1 6 2 5 1 1 3 1 6 2 5 1 1 2 6 4 5 2 1 1 2 6 4 5 2 1 1 2 6 4 5 2 1 1 2 6 4 5 2 1 1 2 6 4 5 2 1	13 ⅓24 46 26 37 16 9‰37 10 22 23 54 4 ⊬57 18 17 17 53 29 26 58 11 ↑ 26 44 23 20 19 5 11 38 17 05 12 29 06 00 11 Ⅱ 19 09 23 49 31 19 57 42 3 € 3 € 3 9 37	True S 28 II 37.2 28 R 35.3 28 31.4 28 25.6 28 10.2 27 54.8 27 49.0 27 45.0 27 42.7 27 43.7 27 44.9 27 44.9 27 44.9 27 44.9 27 44.9 27 44.9	22534.8 24 16.8 26 02.4 27 51.3 29 43.2 1,937.8 3 34.6 5 33.4 7 33.8 9 35.3 11 37.7 13 40.6 15 43.7 17 46.7 19 49.5 21 51.8 23 53.3	Q 24 109.1 25 00.2 25 52.0 26 44.3 27 37.3 28 30.9 29 25.0 0 11.4 2 10.6 3 06.9 4 03.5 5 00.7 5 58.3 6 56.3 7 54.8 8 53.6	78 18 12.9 18 12.9 18 39.3 19 30.8 19 55.9 20 20.5 20 44.7 21 08.3 21 31.5 22 37.8 22 37.8 23 19.2 23 39.0 24 16.2	11\(\mathcal{H}\)00.3 10\(\mathcal{H}\)51.5 10 42.5 10 33.1 10 23.5 10 13.6 10 03.4 9 53.0 9 42.3 9 31.3 9 20.8 8 57.1 8 45.3 8 33.3 8 21.1 8 08.7	20)708.5 20R 01.6 19 54.9 19 48.2 19 48.2 19 28.9 19 22.7 19 10.6 19 10.6 19 04.8 18 59.1 18 48.1 18 42.8 18 32.7 18 32.7	271349.8 27R 45.6 27 41.3 27 37.1 27 32.9 27 28.7 27 24.6 27 20.5 27 16.4 27 12.4 27 08.4 27 04.5 27 06.5 26 56.8 26 53.0 26 45.6	10 36.3 10 37.0 10 37.6 10 38.2 10 38.7 10 39.7 10 40.1 10 40.4 10 40.7 10 41.3 10 41.5 10R 41.5 10 41.5	20+34.5 20R 33.3 20 32.2 20 31.0 20 29.8 20 27.3 20 26.0 20 24.7 20 23.4 20 22.1 20 20.7 20 19.4 20 18.0 20 16.6 20 15.1 20 13.7	23)721.2 23R 19.8 23 18.5 23 17.1 23 15.8 23 14.4 23 13.1 23 11.8 23 10.5 23 09.2 23 07.9 23 06.4 23 04.1 23 02.9 23 00.5
Day 1 Sa 2 Su 3 M 4 Tu 5 W 6 Th 7 F 8 Sa 9 Su 10 M 11 Tu 12 W 13 Th 14 F 15 Sa 16 Su 17 M	Sid.Time 20 40 14 20 44 11 20 48 88 20 52 04 20 56 01 20 59 60 21 11 47 21 15 43 21 19 40 21 23 37 21 21 33 21 31 30 21 31 30 21 31 30 21 35 25 21 47 16 21 55 12 21 55 90 22 10 55 22 10 55 22 10 55	95 12 4 10 10 1 11 07 3 12 04 5 13 02 2 13 59 5 14 57 1 15 54 4 16 52 1 17 49 5 18 47 2 20 42 3 21 40 1 22 37 4 23 35 3 25 26 28 3 27 26 28 24 1 25 30 5 26 28 24 1 27 29 22 0 0 1 17 4 2 15 3	6 6)744 00 20 02 338 81 16 02 17 11 11 11 11 11 11 11 11 11 11 11 11	13 \(724 \) 46 26 37 16 99\(837 10 \) 10 22 23 54 4 \(457 18 \) 17 17 53 29 26 58 11 \(726 44 \) 23 20 19 5 \(501 13 \) 11 \(726 44 \) 23 20 19 23 49 31 6 \(65 47 23 \) 19 57 42 31 17 45 54 17 45 54 11 14 19 99 11 14 17 45 54 11 14 19 11 16 53 27 1 1 \(40 33 \) 18 16 25 49 11 10 21 6 15 24 51 24 51 29 30 50 11 \(65 34 23 \) 19 57 42 25 16 53 27 1 \(65 34 23 \) 19 57 42 34 34 39 37 11 24 34 34 34 34 34 34 34 34 34 34 34 34 34	True O 28 I 37.2 28 R 35.3 28 31.4 28 25.6 28 18.4 28 10.2 28 02.1 27 54.8 27 49.0 27 45.0 27 45.0 27 44.9 27 42.7 27 42.7 27 42.7 27 42.7 27 40.6 27 84.8 27 84.9 27 84.9 27 84.9 27 84.9 27 84.9 28 6 53.9 26 49.6 26 53.9 26 49.6	22 3 34.8 24 16.8 26 02.4 27 51.3 29 43.2 1.0 37.8 3 34.6 5 33.4 7 33.8 9 9 35.3 11 37.7 19 49.5 21 51.8 22 55.4 1.0 50.6 5 41.6 7 35.4 9 27.9 27.9 27.9 27.9	Q 24 II 09.1 25 00.2 25 52.0 26 44.3 27 37.3 28 30.9 29 25.0 0 □ 19.7 1 14.9 2 10.6 3 06.9 4 03.5 5 00.7 5 58.3 6 56.3 7 54.8	18Y12.9 18 39.3 19 05.3 19 05.3 19 55.9 20 20.5 20 44.7 21 31.5 22 16.2 22 37.8 23 39.0 23 58.3 24 16.8 24 45.8 24 52.3 25 09.0 25 55.0 26 09.0 26 26 22.3	11+00.3 10R 51.5 10 42.5 10 33.1 10 23.5 10 03.4 9 53.0 9 42.3 9 31.3 9 20.2 9 31.3 9 20.2 9 31.3 8 21.1 8 08.7 7 56.2 7 43.5 7 7 07.6 6 51.7 6 51.7 6 6 51.7 6 6 51.7	20)708.5 20R 01.6 19 54.9 19 48.2 19 41.6 19 28.9 19 22.7 19 10.6 19 10.6 19 10.6 19 10.6 18 59.1 18 48.1 18 42.8 18 37.7 18 27.9 18 18.4 18 18.4 18 18.4 18 18.4 18 18.4 18 18.4 18 18.4 18 18.4 18 18.5 18 18 18 18 18 18 18 18 18 18 18 18 18 1	271349.8 27R 45.6 27 41.3 27 37.1 27 32.9 27 28.7 27 24.6 27 24.6 27 20.5 27 16.4 27 10.4 27 08.4 27 08.4 27 08.6 26 55.8 26 45.6 26 45.6 26 45.6 26 31.5 26 26.8 26 26.8 26 26.8 26 26.8 26 26.8 26 26.8 26 27.8 27.8 28.8 28.8 28.8 28.8 28.8 28.8	10 836.3 10 37.0 10 38.7 10 38.7 10 38.7 10 39.7 10 40.1 10 40.4 10 40.7 10 41.0 10 41.2 10 41.3 10 41.5 10 41.5 10 41.6 10 41.9 10 41	20\day 34.5 20\day 34.5 20\day 33.3 20\day 32.2 20\day 31.0 20\day 29.8 20\day 26.0 20\day 26.0 20\day 23.4 20\day 22.1 20\day 20.1 20\day 20.1 20\day 16.6 20\day 16.6 20\day 16.6 20\day 16.6 20\day 20.7	23\(\frac{7}{2}\)1.2 23\(\frac{7}{2}\)1.2 23\(\frac{1}{8}\)1.8 23\(\frac{1}{8}\)1.5 23\(\frac{1}{8}\)1.5 23\(\frac{1}{8}\)1.6 23\(\frac{1}{8}\)1.6 23\(\frac{1}{8}\)1.6 23\(\frac{1}{8}\)1.6 23\(\frac{1}{8}\)1.6 23\(\frac{1}{8}\)1.6 23\(\frac{1}{8}\)1.6 23\(\frac{1}{8}\)1.7 23\(\frac{1}{8}\)1.7 23\(\frac{1}{8}\)1.7 22\(\frac{1}{8}\)1.7 23\(\frac{1}{8}\)1.7 23\(\frac

Astro Data	Planet Ingress	Last Aspect	Ingress	Last Aspect	Ingress	Phases & Eclipses	Astro Data
Dy Hr Mn	Dy Hr Mn	Dy Hr Mn	Dy Hr Mn	Dy Hr Mn	Dy Hr Mn	Dy Hr Mn	1 July 2020
ΩR 4 3:25	ち nR 123:39	2 1:22 5 * x			₩ 218:12	5 4:46 0 131338	Julian Day # 44012
2 R 7 4:02	⊙ ଣ 22 8:38	3 13:07 ¥ □ Y	ß 4 4:49	4 21:47 Q A	₩ 5 2:29	5 4:31 & A 0.354	SVP 4\(\text{58}\)'41"
♂0N 11 12:19		6 9:36 5 0 N	₩ 610:09	7 12:55 9 🗆	↑ 7 13:06	12 23:30	GC 27.707.5 \$ 241927.3R
DON 12 5:03	¥ N 5 3:33	7 4:39 % 🗆 🕽	H 8 18:14	9 19:51 5 🗆	o 10 1:29	20 17:34 • 28527	Eris 24 ↑ 31.5 * 8 ← 48.9
¥ D 12 8:28	9 5 7 15:22	11 3:50 5 × 1	↑ 11 5:07	12 7:56 ₺ △	II 12 13:47	27 12:34) 4M,56	8 9 ° 23.2 \$ 11 ° 549.3
ΩD 12 23:38	¥ m 20 1:31			14 11:20 d*	S 14 23:37		Mean Ω 28 □ 36.0
ΩR 18 12:37	⊙ [™] 22 15:46	16 3:22 5 △ I	II 16 5:20	17 0:00 5 o	ญ 17 5:40	3 16:00 0 118346	
DOS 25 21:35		17 21:16 ¥ □ S			m 19 8:21	11 16:46 (19\()28	1 August 2020
ΩD 27 12:22		20 17:56 58 8	ຄ 20 20:17	21 3:38 ₺ △	≏ 21 9:17	19 2:43 • 26໓35	Julian Day # 44043
4×¥ 27 16:08		22 0:28 Q × n	D 22 23:41	23 4:21 5 0	m, 23 10:17	25 17:59) 2259	SVP 4\(\frac{4}{58}\)'36"
ΩR 31 9:35		24 23:09 5 4 4	△ 25 1:55	25 6:28 5 ×	× 25 12:50		GC 27.207.6 \$ 161318.8R
DON 8 12:17		27 1:10 5 0 1	n 27 4:13	27 12:01 ♂ △	19 27 17:38		Eris 24 \ 32.9R * 15 \ 17.6
ΩD 11 16:53	DOS22 3:50	29 4:02 5 × x	£ 29 7:26	29 19:32 ♂ □	₩ 30 0:38		క 9Υ15.9R \$ 25©25.1
ΩR 14 19:26	Ω D25 17:46	31 0:09 Q o Y	rg 31 11:59) Mean Ω 26 II 57.5
ኞ R 15 14:28	Ω R27 11:55						

30 Su 22 34 35 7 05 12 29 39 32 6 8 03 55 26 42 0 18 30.7 22 10.4 27 31 M 22 38 31 8 03 12 12 8 25 3 18 44 33 26 35 2 20 15 3 23 13 9 27

						LONG	ITUDE		1117141	LICO	9	Septe	mber	2020
Day	Sid.Time	0	0 hr)	Noon)	True	¥	Q	ď	2	4	5	ж	Ψ	P
1 Tu 2 W 3 Th 4 F 5 Sa		9 ^m 01 13 9 59 16 10 57 20 11 55 26 12 53 34	25\0058 7\007426 20 19 42 06 1\00748 58 13 48 03	1 + 14 52 13 35 23 25 46 35 7 ↑ 49 23 19 45 13	26 II 25.7 26 R 14.1 26 01.1 25 48.0 25 35.9	21 ¹ 58.7 23 40.8 25 21.7 27 01.3 28 39.7	24©17.6 25 21.5 26 25.8 27 30.3 28 35.0	27	4)+52.0 4R 38.8 4 25.7 4 12.6 3 59.6	17f) 38.3 17R 36.1 17 34.1 17 32.2 17 30.6	25 f 58.3 25 R 55.7 25 53.3 25 50.9 25 48.5	10 34.9 10R 34.1 10 33.2 10 32.3 10 31.3	19\(\frac{1}{5}\)0.6 19R 49.0 19 47.3 19 45.7 19 44.1	22 \(\frac{44.9}{22 R 44.0} \) 22 \(43.1 \) 22 \(42.3 \) 22 \(41.5 \)
6 Su 7 M 8 Tu 9 W 10 Th 11 F 12 Sa	23 06 07 23 10 04 23 14 00 23 17 57 23 21 53	13 51 44 14 49 56 15 48 09 16 46 25 17 44 43 18 43 03 19 41 25	25 41 12 7 31 01 19 21 01 1 1 15 25 13 19 05 25 37 18 8 5 15 19	1 0 36 19 13 25 45 25 17 22 7 11 15 46 19 26 03 1 5 5 3 3 1 14 43 17	25 25.7 25 17.9 25 12.9 25 10.3 25 09.5 25 09.5 25 09.1	0≏17.0 1 53.0 3 27.9 5 01.6 6 34.1 8 05.5 9 35.8	29 40.0 0.0 45.2 1 50.7 2 56.3 4 02.3 5 08.4 6 14.7	28 01.7 28 04.7 28 06.9 28R 08.1 28 08.5 28 08.0 28 06.6	3 46.8 3 34.0 3 21.4 3 08.9 2 56.6 2 44.4 2 32.5	17 29.2 17 27.9 17 26.8 17 26.0 17 25.3 17 24.8 17 24.5	25 46.3 25 44.1 25 42.1 25 40.1 25 38.2 25 36.4 25 34.7	10 30.3 10 29.3 10 28.2 10 27.0 10 25.8 10 24.6 10 23.3	19 42.4 19 40.8 19 39.1 19 37.5 19 35.8 19 34.2 19 32.5	22 40.7 22 39.9 22 39.2 22 38.4 22 37.8 22 37.1 22 36.4
13 Su 14 M 15 Tu 16 W 17 Th 18 F 19 Sa	23 29 46 23 33 43 23 37 39 23 41 36 23 45 33 23 49 29	20 39 49 21 38 15 22 36 43 23 35 13 24 33 45 25 32 20 26 30 55	21 17 52 4 0 48 25 18 48 19 3 10 15 56 18 06 17 3 10 10 10 18 20 19	27 59 30 11 € 44 43 25 58 53 10 ⊕ 38 43 25 37 30 10 ≏ 45 51 25 53 14	25 07.3 25 03.1 24 56.3 24 47.0 24 36.1 24 24.7 24 14.1	11 04.8 12 32.8 13 59.5 15 25.1 16 49.4 18 12.6 19 34.4	7 21.3 8 28.0 9 35.0 10 42.1 11 49.5 12 57.0 14 04.7	28 04.3 28 01.2 27 57.1 27 52.2 27 46.3 27 39.7 27 32.1	2 20.7 2 09.1 1 57.8 1 46.6 1 35.8 1 25.1 1 14.8	17D 24.4 17 24.5 17 24.8 17 25.2 17 25.9 17 26.8	25 33.1 25 31.6 25 30.1 25 28.8 25 27.6 25 26.4 25 25.4	10 22.0 10 20.7 10 19.3 10 17.8 10 16.4 10 14.8 10 13.3	19 30.9 19 29.2 19 27.6 19 25.9 19 24.3 19 22.6 19 21.0	22 35.8 22 35.2 22 34.7 22 34.1 22 33.6 22 33.1 22 32.7
20 Su 21 M 22 Tu 23 W 24 Th 25 F 26 Sa	0 01 19 0 05 15 0 09 12 0 13 08 0 17 05 0 21 01		3M,23 25 18 11 42 2,2 39 17 16 43 23 0 17 23 58 13 42 49 26 42 45	10M,49 51 25 28 19 9x 44 19 23 36 32 7m 05 57 20 14 57 3 806 35	23 55.1 23 53.4	27 16.6 28 28.2	15 12.5 16 20.6 17 28.8 18 37.1 19 45.7 20 54.4 22 03.2	27 23.7 27 14.5 27 04.6 26 53.8 26 42.3 26 30.0 26 17.1	1 04.7 0 54.8 0 45.3 0 36.1 0 27.2 0 18.6 0 10.3	17 30.5 17 32.2 17 34.0 17 36.0 17 38.2	25 24.4 25 23.5 25 22.8 25 22.1 25 21.6 25 21.1 25 20.7	10 11.7 10 10.1 10 08.4 10 06.7 10 04.9 10 03.2 10 01.3	19 19.3 19 17.7 19 16.1 19 14.5 19 12.9 19 11.2 19 09.7	22 32.3 22 31.9 22 31.5 22 31.1 22 30.8 22 30.5 22 30.3
27 Su 28 M 29 Tu 30 W	0 24 58 0 28 55 0 32 51 0 36 48	6 18 31	9826 51 21 58 02 4 + 18 43 16 30 47	15 43 54 28 09 33 10 + 25 44 22 34 04	23 49.2 23 42.2 23 32.4 23 20.4	0M,45.9 1 51.8	23 12.2 24 21.3 25 30.6 26 40.1	26 03.4 25 49.2 25 34.3 25 18.8	0 02.3 29%54.7 29 47.4 29 40.4	17 46.0 17 49.0	25 20.5 25 20.3 25D 20.2 25 20.3	9 59.5 9 57.6 9 55.7 9 53.8	19 08.1 19 06.5 19 04.9 19 03.4	22 30.0 22 29.8 22 29.7 22 29.5
						LONG	ITUDE					Oct	ober	2020
_	0 40 44	0	0 hr)	Noon)	True	ğ	φ	ď	3	4	ħ	Ж	Ψ	В
1 Th 2 F 3 Sa	0 44 41 0 48 37	9 15 22 10 14 23	28 \(\pm\) 35 42 10 \(\pm\) 34 38 22 28 47	16 32 14 28 24 29	23 II 07.0 22 R 53.5 22 40.8	4 55.7 5 51.8	28 59.4 0町09.3		29\33.8 29R 27.5 29 21.6	17 58.9 18 02.6	25 20.4 25 20.6 25 20.9	9051.8 9R 49.8 9 47.8	19R 00.3 18 58.8	22 19.4 22 R 29.3 22 29.2
4 Su 5 M 6 Tu 7 W 8 Th 9 F 10 Sa	0 56 30 1 00 27 1 04 24 1 08 20 1 12 17	13 11 39 14 10 49 15 10 01 16 09 16	4 © 19 34 16 08 54 27 59 23 9 II 54 17 21 57 39 4 © 14 06 16 48 35	22 03 49 3 11 56 03 15 54 38 28 03 56 10 28 47	22 30.1 22 21.9 22 16.5 22 13.7 22D 13.0 22 13.4 22R 13.7	6 44.9 7 34.8 8 21.2 9 03.8 9 42.1 10 15.9 10 44.6	2 29.4 3 39.7 4 50.2 6 00.7 7 11.4	22 58.9 22 40.0	29 01.4 28 57.3 28 53.5	18 10.5 18 14.8 18 19.2 18 23.7 18 28.5	25 21.4 25 21.9 25 22.5 25 23.2 25 24.1 25 25.0 25 26.0	9 45.7 9 43.6 9 41.5 9 39.3 9 37.2 9 35.0 9 32.8	18 51.4 18 50.0	22D 29.2 22 29.2 22 29.3 22 29.3 22 29.4 22 29.5 22 29.6
11 Su 12 M 13 Tu 14 W 15 Th 16 F 17 Sa	1 24 06 1 28 03 1 31 59 1 35 56 1 39 53	19 07 13 20 06 36 21 06 02 22 05 30 23 05 01	29 45 58 13 0 10 22 27 04 19 11 □ 27 47 26 17 26 11 ≏ 26 17 26 44 24	20 03 34 4™12 29 18 49 42 3≏50 02 19 04 53	22 05.8 21 58.7 21 50.1 21 40.8	11 36.2 11R 40.2 11 36.7 11 25.4	10 44.2 11 55.3 13 06.6 14 18.0 15 29.5	21 23.4 21 04.2 20 45.2 20 26.3	28 42.1 28 40.2 28 38.6 28 37.4	18 43.8 18 49.2 18 54.8 19 00.6 19 06.5	25 27.1 25 28.4 25 29.7 25 31.1 25 32.6 25 34.2 25 35.9	9 19.1	18 45.8 18 44.4 18 43.1 18 41.7 18 40.4	22 29.8 22 30.0 22 30.3 22 30.5 22 30.8 22 31.1 22 31.5
18 Su 19 M 20 Tu 21 W 22 Th 23 F 24 Sa	1 51 42 1 55 39 1 59 35	26 03 44 27 03 22 28 03 02 29 02 44	12型00 32 27 04 05 11 × 46 51 26 03 59 9 ½ 53 53 23 17 31 6 ※ 17 40	4 × 28 27 18 58 48 3 17 02 20 16 38 50 29 50 19		10 00.7 9 15.4 8 21.8 7 20.9 6 13.6	19 04.6 20 16.5 21 28.4 22 40.5 23 52.7	19 31.0 19 13.3 18 55.9 18 39.0 18 22.6	28 36.1 28 36.4 28 37.0 28 38.0 28 39.4	19 25.3 19 31.9 19 38.6 19 45.5 19 52.5	25 37.7 25 39.6 25 41.7 25 43.8 25 46.0 25 48.3 25 50.6	9 07.2 9 04.8 9 02.3	18 36.7 18 35.4 18 34.3 18 33.1 18 31.9	22 31.9 22 32.3 22 32.7 22 33.2 22 33.7 22 34.3 22 34.8
25 Su 26 M 27 Tu 28 W 29 Th 30 F 31 Sa	2 15 22 2 19 18 2 23 15 2 27 11 2 31 08 2 35 04 2 39 01	3 01 48 4 01 38 5 01 30 6 01 24	18 57 57 1 + 22 18 13 34 25 25 37 36 7 ↑ 34 38 19 27 47 1 ♂ 18 56	7 + 29 40 19 36 56 1 ↑ 36 44 13 31 34 25 23 30	20 43.6	2 30.2 1 15.5	28 42.2 29 54.8 1-07.5 2 20.3	17 36.6 17 22.5 17 09.0 16 56.2 16 44.1	28 45.7 28 48.5 28 51.7 28 55.2 28 59.0	20 14.6 20 22.2 20 30.0 20 37.9 20 46.0	25 53.1 25 55.7 25 58.4 26 01.1 26 04.0 26 06.9 26 09.9	8 50.1 8 47.6 8 45.1	18 28.7 18 27.6 18 26.6 18 25.6 18 24.6	22 35.4 22 36.0 22 36.7 22 37.3 22 38.1 22 38.8 22 39.5
● ON ¥ OS 4 D 1 ● OS 2 0 D 2 0 C R 2 5 D 2	y Hr Mn 4 18:51 6 6:27 9 22:24 3 0:42 8 12:37 2 13:32 3 12:29 4 1:52 9 5:13 2 1:01 4 13:34 8 0:30 8 0:30 2 7:07	¥ ≏ 51 ♀ 0 6 ○ ≏ 221 ♀ ₩R 27 ▼ Ⅲ 27 ♀ Ⅲ 22 ♀ Ⅲ 22 2 ▼ □ 22 2 ▼ □ 22 2	Fr Mn Dy F 9:47 1 7:23 3 1 7:23 3 1 7:42 11 13 1 0:49 15 1 3:01 17 1 1:35 19 1 1:42 21 1 23 1 26	4:46 o o o o o o o o o o o o o o o o o o o	2 17 18:57 19 18:34 2 21 19:33 3 23 23:17 8 26 6:09	In Dy Hr I 5 30 17:3 3 3 5:4 5 5 18:4 9 8 1:5 4 10 16:0 4 12 14:3 8 14 22:4 7 16 22:1 4 18 21:4 1 3:3 7 23 4:3 9 24 21:5	Win ちちちがらなるロースに 1812 であるない 2 m 2 m 2 m 2 m 2 m 2 m 2 m 2 m 2 m 2	Dy Hr M 1 2:48 3 15:14 6 4:04 8 15:47 11 0:26 13 4:57 15 5:55 17 5:07 19 4:44 21 6:45 23 12:18	In Dy Hr M 3 2 5:2 4 10 9:2 4 17 11:0 7 24 1:5 6 10 0:4 7 1 21:0 7 16 19:3 4 23 13:2 5 31 14:5	3 0 10: 7 (18: 1 • 25: 6) 1: 6 0 9: 1 (17: 2 • 23: 4) 0:	H12 Ju II08 SV P01 GC H229 Eri T08 ≥ I T08	IS 24 ↑ 24. 8 ↑ 23. Mean Ω 25. Dctober 26. Ilian Day # P 4 + 58.2 27 ₹ 07.	r 2020 ‡ 44074 32" 7	254.7 154.4 156.5

November 2020

LONGITUDE

Day	Sid.Time	0	0) hr)	D	Noon)	Tru	β	Ž	٤	Q		C	3"		2	2	Į.	t	2)	Ķ	4	2	Е	2
1 Su 2 M 3 Tu 4 W 5 Th 6 F 7 Sa	2 50 50 2 54 47 2 58 44 3 02 40		17 25 20 6 25 18 32 13	5 1 5 7 3 1 5 0 8 0 3 2 9 0	00 31 36 36 02 07	19 ♥ 05 37 0 II 59 13 12 57 12 25 02 05 7 \$ 16 54 19 45 10 2 € 30 40	20R 20D 20D 20	23.5 20.5 19.5	26R 25D 25 26 26	37.2 11.3 57.0 54.2 02.6 21.5 50.1	7 1 8 2 9 3 10 5	59.1 12.1	16R 16 15 15	12.0 02.9 54.4 46.8 40.0	29 29 29 29 29	12.6 17.7 23.2 29.0 35.2	21 21	11.0 19.6 28.4 37.2 46.3	26 26 26 26 26	13.1 16.3 19.6 22.9 26.4 30.0 33.6		340.2 37.7 35.3 32.8 30.3 27.9 25.4	18R 18 18	19.4 18.6 17.9	22 22 22 22 22 22 22	40.3 41.2 42.0 42.9 43.8 44.7 45.7
8 Su 9 M 10 Tu 11 W 12 Th 13 F 14 Sa	3 10 33 3 14 30 3 18 26 3 22 23 3 26 20 3 30 16 3 34 13	18 02 19 02 20 03 21 03	21 2: 38 6 58 2: 19 4 42 1:	9 \$\ 01 (2 19 : 6 \$\pi 03 (0 12 : 4 \$\sigma 47 (9 42 : 4 \$\pi 51 (22 00 56 43 52	15 37 12 29 07 54 13™04 42 27 27 26 12≏13 08 27 15 53 12™,27 06	20R 20 20 20 20 20 20 20	24.3 24.4 23.1 20.4 16.5 12.2 08.1	29	09.9	14 3 15 4 16 5 18 19	32.1 45.7 59.3 13.0 26.8	15 15	28.7 24.2 20.5 17.7 15.7 14.4 14.0		48.4 55.5 (02.9 10.5 18.5 26.8 35.4	22 22 22 22 22 22 22 23	04.7 14.0 23.6 33.2 42.9 52.8 02.8	26 26 26 26 26 26 27	37.3 41.1 45.0 49.0 53.1 57.2 01.4	888888	23.0 20.5 18.1 15.7 13.3 10.9 08.5	18 18 18 18 18 18 18	17.2 16.5 15.9 15.3 14.7 14.1 13.6	22 22 22 22 22 22 22 22	46.6 47.7 48.7 49.7 50.8 51.9 53.1
15 Su 16 M 17 Tu 18 W 19 Th 20 F 21 Sa	3 42 06 3 46 02 3 49 59 3 53 55 3 57 52	24 05	02 32 11 04 37 11	0 02 5 × 08 9 57 4 ½ 24 8 25 1 % 59 5 06	02 39 50 42 12	27 36 50 12 x 35 17 27 14 21 11 17 28 41 25 15 50 8 36 01 21 31 27	20 20 20 20 20 20 20 20	04.8 02.7 02.1 02.6 03.9 05.5 06.8	4 6 7 8 10 11 13	49.7 09.7 32.2 56.7 23.1 50.9 19.9	23 24 25 26 28	36.3 50.4	15 15 15 15 15 15	14.4 15.6 17.6 20.3 23.9 28.2 33.3	0 0 1 1 1 1	44.2 53.4 02.8 12.5 22.5 32.7 43.3	23 23 23 23 23 24 24	12.9 23.1 33.4 43.9 54.4 05.1 15.9	27 27 27 27 27 27 27 27	05.7 10.1 14.5 19.0 23.7 28.3 33.1	8 8 8 7 7 7	06.1 03.8 01.4 59.1 56.8 54.5 52.3	18 18 18 18 18 18 18	13.1 12.6 12.2 11.8 11.5 11.2 10.9	22 22 22 22 22 23 23	54.3 55.4 56.7 57.9 59.2 00.5 01.8
22 Su 23 M 24 Tu 25 W 26 Th 27 F 28 Sa	4 09 42 4 13 38 4 17 35 4 21 31 4 25 28	3 10	00 1 39 2 19 00 1 42 2	0 ± 16 2 26 4 ↑ 26 6 19	05 19 00 10 26	4 + 05 39 16 22 47 28 27 13 10 ↑ 23 09 22 14 27 4 ∀ 04 29 15 56 04	20 20 20 20 19	07.4 07.1 05.9 03.9 01.6 59.0 56.7	14 16 17 19 20 22 24	49.9 20.8 52.3 24.3 56.7 29.5 02.5	1 3 4 5 6	47.1 01.3 15.6	15 15 15 16 16 16	39.1 45.7 53.0 01.0 09.7 19.1 29.2	1 2 2 2 2 2 3	54.0 05.1 16.4 27.9 39.7 51.7 04.0	24 24 24 24 25 25 25	26.7 37.7 48.7 59.9 11.2 22.5 33.9	27 27 27 27 27 27 28 28	37.9 42.8 47.7 52.8 57.9 03.0 08.2	777777	50.0 47.8 45.6 43.4 41.3 39.2 37.1	18 18 18 18 18 18 18	10.6 10.4 10.2 10.0 09.9 09.8 09.8	23 23 23 23 23 23 23 23	03.1 04.5 05.8 07.2 08.7 10.1 11.6
29 Su 30 M	4 33 21 4 37 18	7 13 8 13	10 56	1 53 3 II 51		27 51 37 9 II 53 05	19 19	54.9 53.8	25 27	35.7 09.1		13.2 27.7	16 16	39.9 51.2	3	16.5 29.2	25 25	45.5 57.1	28 28	13.5 18.9	7	35.0 33.0		09.8	23 23	13.0 14.6
										110			_													
Dec	cembe	er 20	20						LU	NG	Hι	JDE	=													
Day	Sid.Time	_		0 hr)	Noon)	Tru	ıeΩ	}	ğ.	Ç)	-	o [*]		2	_	4	-	⁵	_	y	_	¥	Η.	2
	Sid.Time 4 41 14 4 45 11 1 4 49 07 4 53 04	9×14 10 15 11 16 12 17	43 1 31 2 21 1 11 2	0 hr 5 II 56 8 10 0 \$33 3 08 5 Ø 57	35 06 37 47	Noon) 22 II 02 11 4 5 20 30 16 49 38 29 31 16 12 0 27 10	191 190 19	_	2811	-	11 ^m , 12 14 15)	-	03.2 15.8 29.0 42.7 57.1	3) 3 4 4 4	2 (42.2 55.3 08.7 22.4 36.2	_	908.8 20.6 32.5 44.4 56.5	-	24.3 29.8 35.3 40.9 46.6	71	731.0 R 29.0 27.1 25.2 23.3	_	(09.8 09.9 10.0 10.2 10.4	Η.	2 016.1 17.6 19.2 20.8 22.4
Day 1 Tu 2 W 3 Th 4 F	Sid.Time 4 41 14 4 45 11 4 49 07 4 53 04 4 57 00 5 04 53 5 08 50 5 12 47 1 5 16 43 5 20 40	9x 14 10 15 11 16 12 17 13 18 14 18 15 19 16 20 17 21 18 22 19 23	43 1 31 2 21 1 11 2 03 57 1 51 47 1 44 2 42 1	5 II 56 8 10 0 S 33 3 08	35 06 37 47 19 02 41 39 32 43 54	22 II 02 11 4 5 20 30 16 49 38 29 31 16	191 191 19 19 19 19 19 19 19 19	153.3 53.9 54.6 55.4 56.0 56.4 756.5 56.4 56.3 556.2	28 ^{II} 0× 1 3 4 6 8 9	1,42.5 216.1 49.7 23.4	11 ^m , 12 14 15 16 17 19 20 21 22 24	42.2 56.8 11.4 26.0	177 17 17 17 17 17	15.8 29.0 42.7	3 4 4	42.2 55.3 08.7 22.4	261 26 26 26 26 27 27 27	308.8 20.6 32.5 44.4	287 28 28 28 28 28 28 29 29	24.3 29.8 35.3 40.9	71 71 7	31.0 29.0 27.1 25.2	18) 18 18 18	09.8 09.9 10.0 10.2	23) 23 23 23	716.1 17.6 19.2 20.8
Day 1 Tu 2 W 3 Th 4 F 5 Sa 6 Su 7 M 8 Tu 9 W	Sid.Time 4 41 44 4 45 11 4 49 07 4 53 04 5 04 53 5 12 47 5 16 43 5 22 94 5 32 29 5 44 19 5 48 16	9x 14 10 15 11 16 12 17 13 18 14 18 15 19 16 20 17 21 18 22 19 23 20 24 21 25 22 26 23 27 24 28 25 30 26 31	43 1 2 21 11 2 2 1 11 2 2 1 1 1 2 2 1 1 1 2 2 1 1 1 2 2 1 1 1 2 2 1 1 1 2 2 1 1 1 2 1 2 1 1 1 2 1 2 1 1 1 1 2 1	5 II 56 8 10 0 S 33 3 08 5 0 57 9 01 2 P 21 6 00 9 58 4 4 14 28 46 13 M 30	35 06 37 47 19 02 41 39 32 43 54 55 50 28 17 27 45 01	22 II 02 11 4 5 20 30 16 49 38 29 31 16 12 9 27 10 25 39 09 9 10 8 49 22 57 14 7 10 4 26 21 29 01 6 10 7 46	197 190 191 19 19 19 19 19 19 19 19 19 19 19 19	153.3 53.9 54.6 55.4 56.0 56.4 3 56.5 56.4 56.3 56.3	28 ⁿ 0× 1 3 4 6 8 9 11 12 14 15 17 19 20 22 23 25	0.42.5 16.1 49.7 23.4 57.1 30.8 04.5 38.3 12.1 45.9 19.8	11m, 12 14 15 16 17 19 20 21 22 24 25 26 27 29	42.2 56.8 11.4 26.0 40.7 55.4 10.1 24.9 39.7 54.5 09.3	177 17 17 17 17 18 18 18 19 19	703.2 15.8 29.0 42.7 57.1 12.0 27.5 43.4 00.0 17.0 34.5	3 4 4 4 4 5 5 5 5 6 6 6 6 6 7 7 7 7 7	55.3 08.7 22.4 36.2 50.2 04.5 18.9 33.6 48.4 03.5	261 266 266 266 267 277 277 277 278 288 288 299 299 299 299	308.8 20.6 32.5 44.4 56.5 08.6 20.8 33.1 45.4 57.9	287 28 28 28 28 28 29 29 29 29 29 29 29 29 29 29 29 29 29	524.3 29.8 35.3 40.9 46.6 52.3 58.1 03.9 09.8 15.7 21.7	77 7 7 7 7 7 7 7 7 7 7 7 7 7 7 7 7 7 7 7	231.0 27.1 25.2 23.3 21.5 19.7 17.9 16.1 14.4 12.8	18) 18 18 18 18 18 18 18 18 18 18 18 18 18	10.8 09.9 10.0 10.2 10.4 10.6 10.9 11.2 11.5 11.8	231 23 23 23 23 23 23 23 23 23 23 23	616.1 17.6 19.2 20.8 22.4 24.0 25.7 27.3 29.0 30.7 32.4
Day 1 Tu 2 W 3 Th 4 F 5 Sa 6 Su 7 M 8 Tu 11 F 12 Sa 13 Su 15 Tu 16 W 17 Tu 18 F	Sid.Time 4 41 14 4 45 11 1 4 49 77 1 4 53 04 1 5 00 57 1 5 16 43 2 5 20 40 2 5 24 36 2 6 15 5 5 21 24 5 6 15 5 5 21 2 6 6 00 05 6 6 15 5 6 6 15 5 6 6 15 5 6 6 15 5 6 6 15 5 6 6 15 5 6 6 15 5 6 6 15 5 6 15 5 6 15 5	9×14 10 15 11 16 12 17 13 18 14 18 15 19 16 20 17 21 18 22 21 25 22 26 23 27 24 28 25 30 29 34 20 17 35 20 27 32 20 37 3 3 38	43 1 1 2 2 1 1 2 1 1 1 1 1 1 1 1 1 1 1 1	5 1 56 8 10 0 2 33 3 08 5 0 57 9 00 1 6 00 9 9 58 4 4 14 1 6 00 1 8 20 1 8	35 06 37 47 19 02 41 39 32 43 54 55 50 28 17 27 45 60 60 60 60 60 60 60 60 60 60 60 60 60	22 π 02 11 4	193 196 199 199 199 199 199 199 199 199 199	153.3 153.3 153.3 153.3 153.9 154.6 155.4 156.5 156.4 156.5 156.4 156.5 156.4 156.5 156.4 156.5	28 ^m 0x 1 3 4 6 8 9 11 12 14 15 17 19 20 22 23 25 26 28 0) 1 3 4 6	\$\frac{\pmu}{42.5}\$\frac{\pmu}{16.1}\$ 49.7 23.4 57.1 30.8 04.5 38.3 12.1 45.9 19.8 53.7 27.7 01.7 35.9 144.5 19.0	11m, 12 14 15 16 17 19 20 21 22 24 25 26 27 29 0 3 1 2 4 5 6 7 9	42.2 56.8 40.7 55.4 10.1 24.9 39.0 53.9 24.2 39.0 23.8 38.8 53.7	177 17 17 17 17 17 18 18 18 19 19 19 20 20 21 21 21 22 22 22 22 23 24	15.8 29.0 42.7 57.1 12.0 27.5 43.4 00.0 17.0 34.5 52.6 11.1 30.1 49.6 09.5 29.9 50.7	3 4 4 4 4 5 5 5 5 5 6 6 6 6 6 7 7 7 7 7 8 8 8 9 9 9 9	55.3 08.7 22.4 36.2 50.2 04.5 18.9 33.6 48.4 03.5 18.7 34.2 49.8 05.6 21.6 37.8 54.1	26) 26 26 26 26 27 27 27 27 27 28 28 28 29 29 29 29 29 0 0 0 0 0 1	308.8 20.6 32.5 44.4 56.5 08.6 20.8 33.1 45.4 57.9 10.4 22.9 35.6 48.3 01.1 13.9 26.8 39.8	287 28 28 28 28 28 29 29 29 29 29 29 29 0 0 0 0	524.3 29.8 35.3 40.9 46.6 52.3 58.1 03.9 09.8 15.7 21.7 27.7 33.8 40.0 46.1 52.4 58.7 805.0	777777777777777777777777777777777777777	531.0 227.1 25.2 225.2 223.3 21.5 19.7 17.9 16.1 12.8 11.2 09.6 08.1 05.1 03.7 02.3 01.0 59.7 59.7 55.7 55.8	18) 18 18 18 18 18 18 18 18 18 18 18 18 18	10.9 10.0 10.2 10.4 10.6 10.9 11.2 11.5 11.8 12.2 12.7 13.1 13.6 14.2 14.7 15.4	231 23 23 23 23 23 23 23 23 23 23 23 23 23	316.1 17.6 19.2 20.8 22.4 24.0 25.7 27.3 29.0 30.7 32.4 34.1 35.8 37.6 39.4 41.2 43.0 44.8

I ¥ D 3 17:51	12 H 914:49	1 2 2:31 5 △ H 2 10:01	1 1 4:23 ¥ □ 5 2 3:34	8 13:47 (160/37	Julian Day # 44135
ΩD 4 2:40	¥ m, 10 21:57	4 13:50 ¥ A \$ 4 21:47	4 10:30 5 ያ ብ 4 12:54	15 5:08 ● 23M,18	SVP 4\(\frac{4}{58}\)'26"
	Q M, 21 13:23	7 1:28 🗸 🗆 🔊 7 7:19	5 22:29 d A TD 6 19:47	22 4:46) 0)(20	GC 27×07.8 \$ 191350.9
DOS 12 10:34	0 2 21 20:41	9 11:06 ¥ * ID 9 13:31	8 22:36 5 A = 9 0:02	30 9:31 O 8II38	Eris 23 ↑ 51.2R * 13 ™ 53.3
4 d P 12 21:40	,	11 11:00 5 4 4 11 16:11		30 9:44 • A 0.828	
d D 14 0:37	¥ x 1 19:52	13 11:34 5 D M 13 16:20	13 1:59 5 * \$ 13 2:40		Mean Ω 22 ■ 05.2
ΩD 17 0:05	♀ ₹ 15 16:22	15 11:14 5 × × 15 15:48	14 16:18 O o 19 15 3:36		100
ΩR 22 4:40	5 W 17 5:05	17 7:56 9 × 13 17 16:36	17 5:36 4 o 8 17 6:28	14 16:18 • 23,708	1 December 2020
DON 25 14:04	4 88 19 13:08	19 16:31 O × Ø 19 20:26	19 8:46 O × H 19 12:40	14 16:14:39 T 02'10"	Julian Day # 44165
¥ D 29 0:37	¥ 19 20 23:08	21 0:50 d × + 22 4:07		21 23:42) 0 35	SVP 4\(\text{58}'21"\)
ΩD 1 7:42	O 19 21 10:03	24 10:46 5 × Y 24 15:06	23 22:52 0 0 24 10:57	30 3:29 0 8553	GC 27.707.9 ♀ 281901.3
ΩR 8 0:53	40021 18:22	26 23:47 5 0 0 27 3:44			Eris 23 ↑ 35.9R * 24 \ 06.6
	Ω D21 23:31	29 12:50 5 A II 29 16:17	29 3:02 8 5 29 10:29	I	§ 5℃02.6R § 13™29.1
	DON22 21:25		31 13:46 ♂□ 幻 31 18:59	1	Mean Ω 20 II 29.9
ΩR 14 11:30	Ω R28 15:07			1	18591
*	0 1	(1 1	1 1110	' 1 1 / T"	(O OO I I'T')

Last Aspect

4:23 ¥ □ 50

Dy Hr Mn

*Giving the positions of planets daily at midnight, Greenwich Mean Time (0:00 UT) Each planet's retrograde period is shaded gray.

Astro Data

1 November 2020 Julian Day # 44135 SVP 4\text{\tiliex{\text{\texi\text{\texi}\text{\text{\text{\texi{\text{\texi{\te\text{\text{\text{\texi{\texi\texi{\text{\terice{\texi\texi{\tex{\texi{\texi{\texi{\texi{\texi{\terichter{\terint{\tert{\texi{\te

1 November 2020

16ญ37

) Phases & Eclipses

Dy Hr Mn

8 13:47

Ingress Dy Hr Mn 2 3:34

Astro Data

¥ D 3 17:51 Ω D 4 2:40 Ω R 8 14:00) 0S 12 10:34 4 σ P 12 21:40

Dy Hr Mn

Planet Ingress

9 14:49 10 21:57

Dy Hr Mn

Last Aspect

Dy Hr Mn

2 2:31 5 4 13:50 ¥ 7 1:28 ¥

Ingress Dy Hr Mn

2 10:01

2020 ASTEROID EPHEMERIS

2020		Ceres 2	Pallas 💠	Juno *	Vesta →	2020	Psyche *	Eros 💭	Lilith (Toro g
JAN	1 11 21 31 10			179 21.8 93 1.1 1.1 1.1 1.1 1.1 1.1 1.1 1.1 1.1 1.	56569334933895528679748197968546834434661 10348807447544281991644469284343434681 1288570976937112848193540888719444581844688871111288	JAN 1 11 21 31	2 HO 3 - 6 - 6 - 6 - 6 - 6 - 6 - 6 - 6 - 6 -	27 135 3 . 6 3 164 7 . 0 9 42 . 3	9.45.2 13 05.9 16 20.0 19 26 0	-
FEB MAR	10 20 1	3#48.2 7 41.2 11 30.1	8 44.4 12 22.0 15 48.1	17 a 21.8 19 12.9 20 35.3 21 25.1 21R39.0 21 15.1 20 13.1 18 36.5 16 32.8	12006.5 12036.6 13 45.5 15 28.6 17 40.9 20 17.3 23 14.2 26 27.9 29 55.3	FEB 10 20 MAR 1	19 09.4 23 40.3 28 14.8	15 39.7 21 39.5 27 41.9 3 X 47.5	13 05.9 16 20.0 19 26.0 22 21.9 25 06.0 27 35.8 29 48.8	26 10.1 1909.5 6 08.8
APR	21 31 10 20	2.0.60.2.2.17.0.67.31.0.82.78.9.9.5.8.1.9.4.1.9.	22.559.14040.1559.659.659.659.659.659.659.659.659.659.	1212.23.31.01.52.63.63.63.63.63.63.63.63.63.63.63.63.63.	120 4 2 4 1 4 4 5 1 2 4 1 2 4	APR 10 20 30	2 HO 3 6 6 6 1 1 4 2 2 2 9 4 1 2 3 4 1 4 8 8 2 2 1 5 1 6 0 3 8 1 9 5 1 2 1 2 1 2 2 1 2 1 2 1 2 2 1 2 1 2 1	2 7 が5 3 7 0 3 7 1 9 1 6 3 4 4 1 7 1 6 4 4 4 1 7 1 7 2 7 3 9 6 1 3 7 3 7 3 9 5 3 7 3 7 3 4 4 1 7 6 4 4 4 1 7 6 4 4 1 7 6 4 4 1 7 6 4 4 1 7 6 4 4 1 7 6 4 6 7 6 7 6 7 6 7 6 7 6 7 6 7 6 7 6	93 445.20090000000000000000000000000000000000	61 00 8 8 3 1 9 3 8 8 3 1 9 3 8 8 3 1 9 3 8 8 3 1 9 3 8 8 3 1 9 3 8 8 3 1 9 3 8 8 3 2 1 7 5 1 8 1 8 1 8 1 8 1 8 1 8 1 8 1 8 1 8 1
MAY	21 31 10 20 30 10 20 30	1 * 47.1 4 29.0 6 53.8 8 58.2	29 59.9 0846.6 0R55.8 0 24.5	7 54.7 6 38.8 5 57.1 5 D49.8	11 18.9 15 21.5 19 29.2 23 41.2 27 56.6	MAY 10 20 30	26 04.1 0838.9 5 11.0 9 39.5	11 53.5 18 36.0 25 26.9 2827.1	4R56.0 4 25.6 3 21.7 1 47.4	1830.8 6 52.3 12 27.8 18 25.3 24 56.0 2¥19.1 11 05.4 22 02.2
JUN	10 20 30 19 29 19 29 19 29 8	4 29.0 6 53.8 8 58.2 10 39.3 11 53.8 12 37.9 12 R48.9 12 24.5 11 24.8 9 53.1	29 1 312.0 27 21.0 24 58.7 22 17.5	6 15.0 7 09.5 8 30.0	25614.7 6 34.9 10 56.7 15 19.4	JUN 9 19 29 JUL 9 19 29	14 03.4 18 22.1 22 34.4 26 39.1	9 37.3 16 58.6 24 31.8 2117.4	1 47.4 29.49.7 27 38.6 25 26.5 23 26.5	2 ¥ 19.1 11 05.4 22 02.2 6 T 18.3
AUG	19 29 8	12 24.5 11 24.8 9 53.1 7 56.3	19 32.6 17 00.1 14 53.5 13 21.3	12 14.9 14 33.3 17 05.4 19 49.2 22 42.8 25 44.6 28 53.1	10 56.7 15 19.4 19 42.8 24 06.1 28 28.9 2850.7	AUG 8	26 39.1 0 x 35.1 4 20.4 7 53.3	10 16.2 18 28.3 26 53.6 5%31.9	21 48.9 20 41.5 20 08.4 20D10.1	6 7 18.3 24 54.2 17 6 01.3 9 x 00.6
SEP	28 7 17 27	4 29 . 0 6 8 . 82 3 8 . 9 10 1 3 3 7 8 . 9 11 2 R 4 2 4 . 8 1 2 2 2 4 3 . 3 11 2 2 2 4 3 . 3 11 2 2 3 3 3 5 . 3 12 3 3 5 . 9 11 2 2 3 3 3 5 . 9 11 2 3 3 5 . 9 11 5	0 46 6 6 0 24 5 5 27 21 0 24 58 7 22 17 21 0 24 58 7 7 22 17 32 6 6 17 0 3 5 6 6 6 6 6 6 6 6 6	22 42.8 25 44.6 28 53.1 2m07.2	7 10.9 11 28.6 15 43.2 19 53.5 23 58.4 27 56.6	SEP 7 17 27	14 12.3 16 52.5 19 08.4 20 55.7	14 22.0 23 22.7 2 8 32.6 11 49.2	29.49.7 27.38.6 25.26.5 21.48.9 20.48.4 20.010.1 20.45.6 21.52.3 23.27.0 25.26.7	27 32.8 12 5 16.0 24 21.3 4 0 56.9
OCT	18 28 7 17 27 17 27 16 16 26 16 12 55	3 34.1 1 35.9 0 02.4 29\$01.5 28 36.6 29 35.2 0\(\frac{4}{5}\) 5.2 7 21.6 10 10.7 13\(\frac{4}{1}\) 4.7	0 0 4 6 5 6 8 0 24 5 5 8 9 0 24 5 5 8 7 21 0 0 27 21 0 0 24 5 8 7 22 17 5 6 17 0 0 0 1 1 4 5 8 7 12 27 7 1 20 1 2 3 4 2 7 7 1 6 3 2 5 6 1 3 2 7 6 1 3 2 7 7 1 2 6 3 2 5 6 1 3 2 3 2 2 2 3 2 2 1 2 3 3 2 2 1 2 3 3 2 2 1 2 3 3 2 2 1 2 3 3 2 2 1 2 3 3 2 2 1 2 3 3 2 2 1 2 2 3 3 2 2 1 2 2 3 3 2 2 1 2 2 3 3 2 2 1 2 2 3 3 2 2 1 2 2 3 3 2 2 1 2 2 3 3 2 2 1 3 2 3 2	6 38 8 8 8 5 5 149 18 18 18 18 18 18 18 18 18 18 18 18 18	23 58.4 27 56.6 1m46.2 5 25.3	17 27 0CT 7 17 27 NOV 6	0 8 38 9 6 1 1 9 0 1 9 1 9 1 9 1 9 1 9 1 9 1 9 1 9	11 49.2 21 10.2 0mp33.3 9 55.6 19 14.3	6 37.4	24 54 2 9 10 0 1 3 9 10 0 1 6 27 28 16 0 0 24 21 3 3 40 5 6 7 20 4 21 3 10 5 8 1 10 5 8 1 11 8 43 5 25 5 6 3 8 4 12 7 19 06 0
DEC	16 26 6 16	0¥53.4 2 39.7 4 50.2 7 21.6	16 34.5 18 41.0 21 04.7 23 42.7 26 32.6 29 32.1 2839.4 5 52.8 9 \$\$10.7	12 10 8 15 35 8 19 00 9 22 25 1 25 47 3 29 06 4 2 20 9 5 29 6	8 51.4 12 01.3 14 51.4 17 17.6 19 14.6 20m37.1	NOV 6 16 26 DEC 6 16 26 JAN 5	20 38.4 18 45.4 16 35.1 14 23.4	19 14.3 28 27.1 7 31.0 16 23.6 25 02.8	6 37.4 10 01.4 13 36.2 17 20.2 21 12.3 25 11.1 29 13 15.6	25 56.7 2036.3 8 42.0 14 12.7 19 06.0 23019.0
JAN	1				_					
FEB MAR	21 10 1	25 20.2 24 06.1 22 37.0 21 01.4	04 27.2 05 56.2 08 02.9 10 40.9	05 S 15 . 3 05 25 . 3 04 34 . 9 02 41 . 1 00 00 . 1 02 N 45 . 9 04 47 . 4 05 39 . 7 04 20 . 3 02 42 . 3 00 43 . 5 01 S 25 . 7 03 37 . 7	09 N12 . 2 10 54 . 4 13 02 . 7 15 20 . 4 17 34 . 0 19 33 . 0 21 09 . 1 22 16 . 1 22 50 . 1	JAN 1 FEB 10 MAR 1 APR 10 30 MAY 20 JUN 9 JUN 9 JUL 19 AUG 8	11 S 3 2 . 7 9	20\$11.9 1635.4 07 20.8 01849.4 09 47.2 15 44.8 21 24.9 26 21.0 29 55.3	23 S 26 . 4 24 06 . 3 24 25 . 7 24 13 . 0 23 53 . 0 23 30 . 8 23 08 . 1 22 41 . 4 22 07 . 9 21 33 . 7	26S04.5 27 17.7 27 42.9 27 16.6 25 55.6 23 34.7 20 02.3 14 503.7 06N18.4 27 29.2 43 43.5
MAY JUN	10 30 20 9	19 28.9 18 10.5 17 18.1 17 04.6	13 40.3 16 45.6 19 33.8 21 32.1	02 41.1 00 00.1 02N45.9 04 47.4 05 39.0 05 24.7	19 33.0 21 09.1 22 16.1 22 50.1	APR 10 30 MAY 20 JUN 9	08 27.6 11 28.1 14 04.7	09 47.2 15 44.8 21 24.9	23 30.8 23 08.1 22 41.4	20 02.3 14 50.7 06 53.7
JUL AUG	29 19 8 28 17	17 41.3 19 12.7 21 25.2 23 38.4	22 04.3 20 48.2 17 54.9 14 05.0	04 47.4 05 39.0 05 24.7 04 20.3 02 42.3 00 43.5 01\$25.7 03 37.1	22 49.3 22 14.3 21 07.8 19 34.5 17 41.2	JUL 19 AUG 8 28	16 12.7 17 48.9 18 52.4 19 25.0	29 55.1 31 20.3 29 55.4	21 33.6 21 09.7 21 00.6	06N18.4 27 29.2 43 43.5 39 14.2 28 16.8
SEP OCT NOV	7 27 16	265 \$12.7 224 066.11 222 37.221 011.49 128.55 117.7 041.37 223 301.225 301.225 224 000.62 119 333.41 16 \$3	03N40.0 04 27.2 05 56.2 910 40.9 110 40.9 113 40.3 119 32.1 121 32.1 122 0448.2 117 54.9 110 05.0 03 33.0 00 05.7 00 S29.0	05 43.7 07 39.0 09 17.4	09N12.2 1054.4 11302.7 11520.4 11734.0 12103.1 12216.1 122216.1 122214.3 2107.8 1741.2	SEP 17 OCT 7 NOV 16 DEC 6	11 S 32 G 7 9 08 32 G 7 9 08 21 1 1 1 0 1 1 1 1 1 1 1 1 1 1 1 1 1 1	20 \$\ 11 \ 9 \ 16 \ 35 \ 7 \ 12 \ 16 \ 4 \ 4 \ 9 \ 16 \ 36 \ 37 \ 20 \ 31 \ 25 \ 26 \ 21 \ 51 \ 31 \ 25 \ 35 \ 31 \ 35 \ 35 \ 31 \ 35 \ 35 \ 3	23 \$26. 4 25. 17 24 25. 17 24 13. 00 6. 3 30. 8 23 23 30. 8 23 30. 8 23 30. 8 23 30. 8 23 30. 8 23 30. 8 21 30. 6 21 30. 6 21 30. 6 21 30. 6 21 30. 6 21 30. 6 21 30. 6 21 30. 6 21 30. 6 21 30. 6 21 30. 6 21 30. 6 21 30. 6 21 30. 6 21 30. 6 21 30. 6 21 30. 6 21 30. 6 21 30. 6 20. 5 56. 5 56. 5	26 S O 4 . 5 . 7 . 7 . 7 . 7 . 7 . 7 . 7 . 7 . 7
DEC	26	16020 1	00529.0	10 33.7	10 10.4	26	17N52 3	10 13.6 18559.1	18520 6	15050 0
2020							I.e.: \		I	
2020 JAN	1	Saffo 🍄	Amor ①	Pandora 🗇	Icarus 😽	2020	Diàna)	Hidalgo 2	Ürania ≀ ∤	Chiron &
	1 11 21 31 10 20	Saffo 🍄	Amor ①	Pandora 🗇	Icarus 😽	2020 JAN 1 11 21 31 FEB 10 MAR 1 11	Diàna)	Hidalgo 2	Ürania ≀ ∤	Chiron &
JAN FEB MAR APR	1 11 21 31 10 20	Saffo 🍄	Amor ①	Pandora 🗇	Icarus 😽	2020 JAN 1 21 FEB 10 MAR 1 121 APR 10 20 30	Diàna)	Hidalgo 2	Ürania ≀ ∤	Chiron &
JAN FEB MAR	1 11 21 31 10 20	Saffo 🍄	Amor ①	Pandora 🗇	Icarus	2020 JAN 1 21 FEB 10 MAR 1 121 APR 10 20 30	Diàna)	Hidalgo C 4 9 8 8 2 5 6 2 4 7 7 2 2 6 2 3 3 1 0 0 4 4 2 2 6 2 2 4 3 3 1 0 0 4 4 2 2 1 2 1 2 1 2 1 2 2 1 2 2 1 2	Ürania ≀ ∤	Chiron &
JAN FEB MAR APR MAY JUN JUL	1 11 21 31 10 20	Saffo 🍄	Amor ①	Pandora 🗇	Icarus	2020 JAN 11 121 FEB 10 MAR 11 APR 10 MAY 120 MAY 120 JUN 19 JUL 19 JUL 19	Diàna)	Hidalgo C 4 9 8 8 2 5 6 2 4 7 7 2 2 6 2 3 3 1 0 0 4 4 2 2 6 2 2 4 3 3 1 0 0 4 4 2 2 1 2 1 2 1 2 1 2 2 1 2 2 1 2	Ürania ≀ ∤	Chiron &
JAN FEB MAR APR MAY JUN	1 11 21 31 10 20	Saffo 🍄	Amor ①	Pandora 🗇	Icarus	2020 JAN 11 211 211 FEB 100 MAR 11 APR 100 MAY 100 MAY 100 JUN 19 JUL 19 JUL 19 AUG 28	Diàna)	Hidalgo C 4 9 8 8 2 5 6 2 4 7 7 2 2 6 2 3 3 1 0 0 4 4 2 2 6 2 2 4 3 3 1 0 0 4 4 2 2 1 2 1 2 1 2 1 2 2 1 2 2 1 2	Ürania ≀ ∤	Chiron &
JAN FEB MAR APR MAY JUN JUL AUG	1 11 21 31 10 20	Saffo 🍄	Amor ①	Pandora	Icarus	2020 JAN 11 211 211 FEB 100 MAR 11 APR 100 MAY 100 MAY 100 JUN 19 JUL 19 JUL 19 AUG 28	Diàna)	Hidalgo C 4 9 8 8 2 5 6 2 4 7 7 2 2 6 2 3 3 1 0 0 4 4 2 2 6 2 2 4 3 3 1 0 0 4 4 2 2 1 2 1 2 1 2 1 2 2 1 2 2 1 2	Ürania ≀ ∤	Chiron &
JAN FEB MAR APR MAY JUN JUL AUG SEP OCT	1 1123100 11211000 123123123123 123123123 123123 123123 123123 12312 1231 12312 12312 12312 12312 12312 12312 12312 12312 12312 12312 1231	Saffo 🍄	Amor ①	Pandora	Icarus	2020 JAN 1 1 1 1 1 1 1 1 1 1 1 1 1 1 1 1 1 1 1	Diàna)	Hidalgo C 4 9 8 8 2 5 6 2 4 7 7 2 2 6 2 3 3 1 0 0 4 4 2 2 6 2 2 4 3 3 1 0 0 4 4 2 2 1 2 1 2 1 2 1 2 2 1 2 2 1 2	Ürania ≀ ∤	Chiron &
JAN FEB MAR APR MAY JUN JUL AUG SEP OCT NOV DEC JAN	1 1123100 11211000 12312312300 1299999999999999999999999999999999999	Saffo 11.4.44 6.4 4.4 1.4 1.4 1.4 1.4 1.4 1.4 1.4 1.4 1	Amor	Pandora	Carus V 4 0 80 7 7 4 9 6 9 8 6 1 2 8 9 7 5 7 8 9 6 9 9 8 6 1 2 8 9 7 5 7 8 9 6 9 9 8 6 1 2 8 9 7 5 7 8 9 6 9 9 8 6 1 2 8 9 9 7 5 7 8 9 8 9 9 8 9 8 9 8 9 8 9 8 9 8 9 8 9	2020 JAN 11 21 21 21 21 21 21 21 21 21 21 21 21	Diana 2 8m 33 3 2 6 6 9 7 6 0 8 9 8 9 8 9 8 9 8 9 8 9 8 9 8 9 8 9 8	Hidalgo o de	Urania	Chiron 8 8 7.59,167,516,267,27,20,20,20,20,20,20,20,20,20,20,20,20,20,
JAN FEB MAR APR MAY JUN JUL AUG SEP OCT NOV	11111000111111000000099999998887777777666666665 112111111111111111111111111111	Saffo	Amor	Pandora	Carus \$\frac{1}{4} \\ 4 \\ 0 \\ 8 \\ 0 \\ 8 \\ 1 \\ 1 \\ 1 \\ 1	2020 JAN 11 121 121 121 121 121 121 121 121 121	Diana 2 8m 33 3 2 5 3 3 3 6 6 6 6 7 7 6 6 6 6 7 7 6 7 6 7 6	Hidalgo O O O O O O O O O O O O O O O O O O O	Urania W	Chiron 6 8 7.59.149.307.79.09.26.249.26.26.26.26.26.26.26.26.26.26.26.26.26.
JAN FEB MAR APR JUN JUL AUG SEP OCT NOV DEC JAN JAN FEB MAR APR	11111000111111000000099999998887777777666666665 112111111111111111111111111111	Saffo	Amor	Pandora	Carus \$\frac{1}{4} \\ 4 \\ 0 \\ 8 \\ 0 \\ 8 \\ 1 \\ 1 \\ 1 \\ 1	2020 JAN 11 121 121 121 121 121 121 121 121 121	Diana 2 8m 33 3 2 5 3 3 3 6 6 6 6 7 7 6 6 6 6 7 7 6 7 6 7 6	Hidalgo O O O O O O O O O O O O O O O O O O O	Urania W	Chiron 6 8 7.59.149.307.79.09.26.249.26.26.26.26.26.26.26.26.26.26.26.26.26.
JAN FEB MAR APR MAY JUN JUL AUG SEP OCT NOV DEC JAN JAN FAB APR MAY JUN	11111000111111000000099999998887777777666666665 112111111111111111111111111111	Saffo	Amor	Pandora	Carus \$\frac{1}{4} \\ 4 \\ 0 \\ 8 \\ 0 \\ 8 \\ 1 \\ 1 \\ 1 \\ 1	2020 JAN 11 121 121 121 121 121 121 121 121 121	Diana 2 8m 33 3 2 5 3 3 3 6 6 6 6 7 7 6 6 6 6 7 7 6 7 6 7 6	Hidalgo O O O O O O O O O O O O O O O O O O O	Urania W	Chiron 6 8 7.59.149.307.79.09.26.249.26.26.26.26.26.26.26.26.26.26.26.26.26.
JAN FEB MAR APR JUN JUL AUG SEP OCT NOV DEC JAN JAN FEB MAR APR MAY	111110011111100000009999999888777777666666	Saffo 11.4.44 6.4 4.4 1.4 1.4 1.4 1.4 1.4 1.4 1.4 1.4 1	Amor	Pandora	Carus V 4 0 80 7 7 4 9 6 9 8 6 1 2 8 9 7 5 7 8 9 6 9 9 8 6 1 2 8 9 7 5 7 8 9 6 9 9 8 6 1 2 8 9 7 5 7 8 9 6 9 9 8 6 1 2 8 9 9 7 5 7 8 9 8 9 9 8 9 8 9 8 9 8 9 8 9 8 9 8 9	2020 JAN 11 FEB 310 MAR 111 APR 1200 MAY 1200 JUN 199 JUL 199 JUL 199 AUG 288 SEP 177 OCT 177 NOV 166 DEC 1266 DEC 1266 DEC 1266 JAN 11 FEB 100 JAN 21 FEB 200 JAN 21 FEB 100 JAN 21 FEB 200 JAN 21 FEB 100 JAN 21 FEB 300 JAN 21 FEB 300 JAN 21 JAN 300 MAY 300 MAY 300	Diana 2 8m 33 3 2 6 6 9 7 6 0 8 9 8 9 8 9 8 9 8 9 8 9 8 9 8 9 8 9 8	Hidalgo o de	Urania W 20 20 20 20 20 20 20	Chiron 8 8 7.59,167,516,267,27,20,20,20,20,20,20,20,20,20,20,20,20,20,

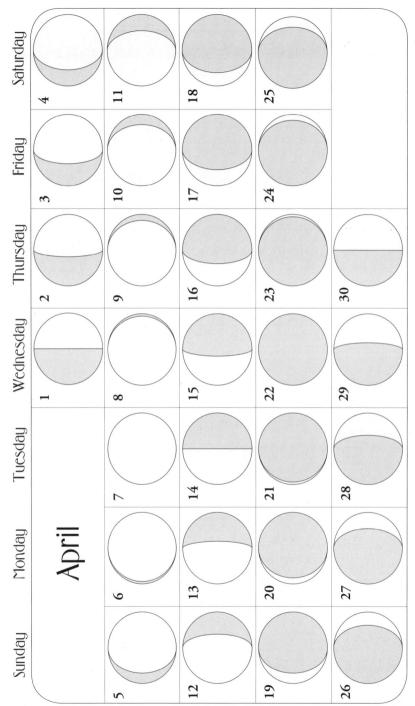

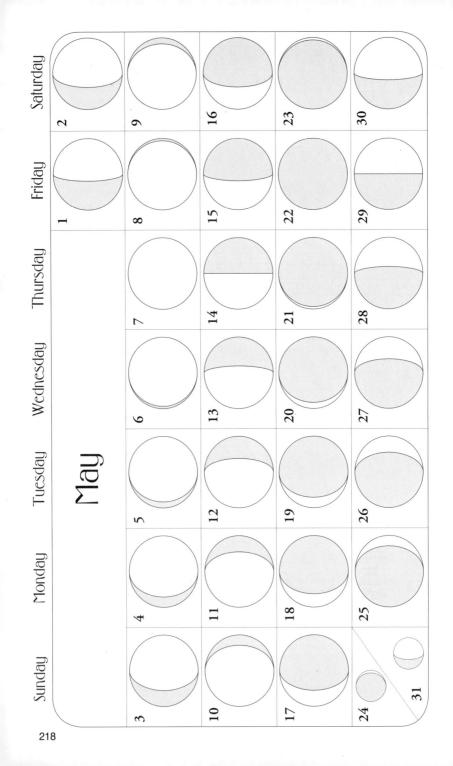

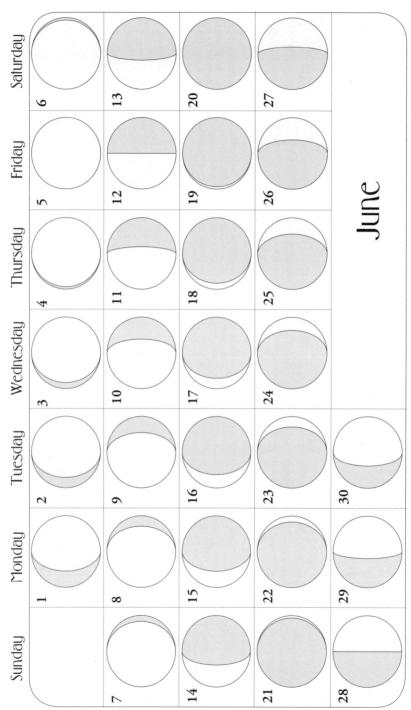

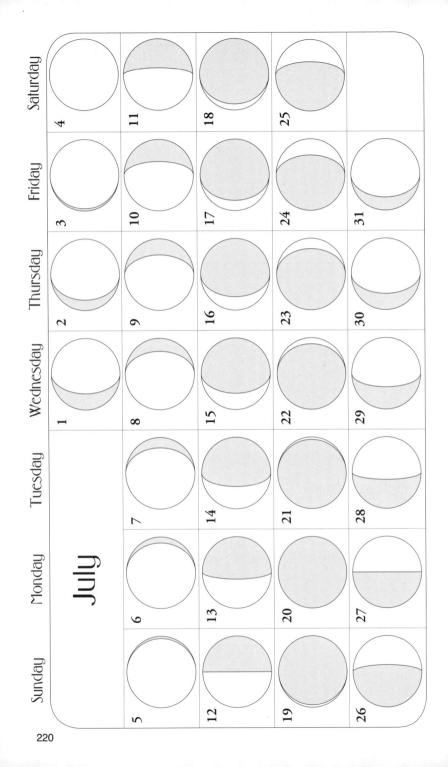

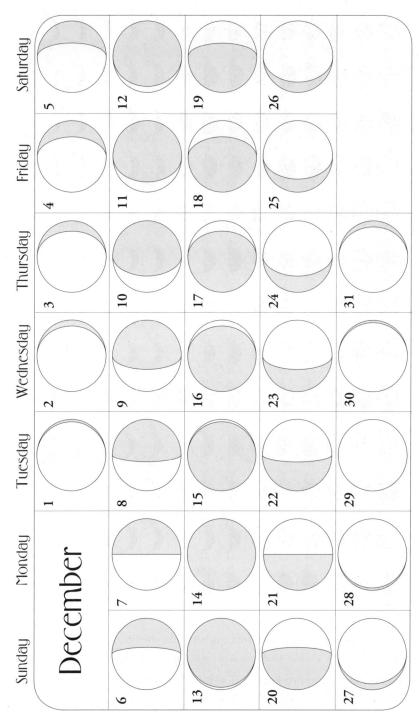

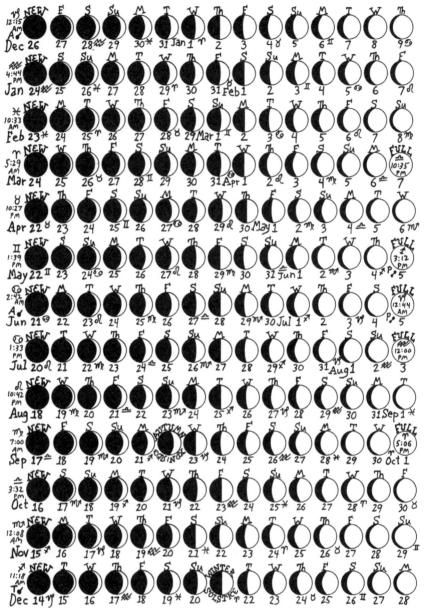

Eclipse Key:

✓= Solar ✓= Lunar T=Total A=Annular n=Penumbral P=Partial Lunar Eclipses are visible wherever it is night and cloud free during full moon time.

Times on this page are in EST (Eastern Standard Time -5 from GMT) or DST, Daylight Saving Time (Mar 8 - Nov 1, 2020)

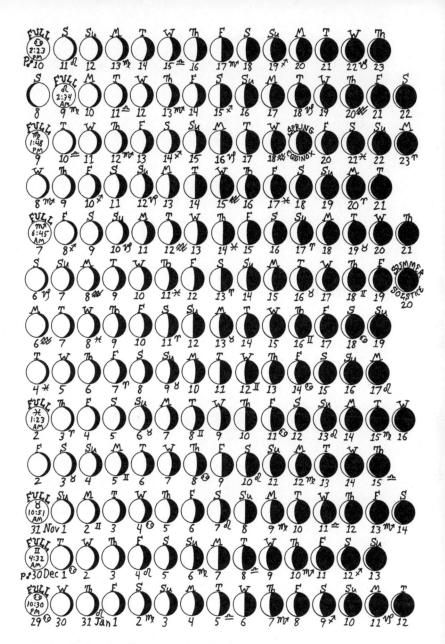

2020 Lunar Phases

© Susan Baylies, reproduced with permission

This format available on cards from: http://snakeandsnake.com

Snake and Snake Productions 3037 Dixon Rd Durham, NC 27707

		JAN	NUA	RY		
S	M	T	W	T	F	S
					1	2
3	4	5	6	7	8	9
10	11	1	13	14	15	16
17	18	19	20	21	22	23
24	25	26	27	28	29	30
31						
		M	ARC	H		
S	M	T	W	T	F	S

30 31

		N	IAI	7		
S	M	T	W	T	F	S
						1
		4				
9	10	0	12	13	14	15
16	17	18	19	20	21	22
23	24	25	26	27	28	29
30	31					
		T	111 3	J		

S	M	T	W	T	F	S
				1	2	3
4	5	6	7	8	9	10
				15		
18	19	20	21	22	23	24
25	26	27	28	29	30	31

S

NOVEMBER 25 26 29 30

		FEE	RU.	ARY		
S	M	T	W	T	F	S
				4		
7	8	9	10	0	12	13
14	15	16	17	18	19	20
21	22	23	24	25	26	27
28						
				4		

		A	PR	IL.		
S	M	T	W	T	F	S
				1	2	3
4	5	6	7	8	9	10
0	12	13	14	15	16	17
18	19	20	21	22	23	24
25	26	27	28	29	30	

		J	UN	E		
S	M	T	W	T	F	S
				3		200000000000000000000000000000000000000
6	7	8	9	0	11	12
13	14	15	16	17	18	19
20	21	22	23	24	25	26
27	28	29	30			

		AL	GU	51		
S	M	T	W	T	F	S
	2					
8	9	10	11	12	13	14
15	16	17	18	19	20	21
22	23	24	25	26	27	28
29	30	31				

29	30	31				
		OC	тоі	BER		
S	M	T	W	T	F	S
					1	2
3	4	5	6	7	8.	9
10	11	12	13	14	15	16
17	18	19	20	21	22	23
24	25	26	27	28	29	30
31						
	10 10 10 10 10 10 10 10 10 10 10 10 10 1	TIC	A ALCE	TOTAL		

3	N	1			F	
			1	2	3	4
5	6	7	8	9	10	11
12	13	14	15	16	17	18
19	20	21	22	23	24	25
26	27	28	29	30	31	

= FULL MOON, PST/PDT

PreacherWoman for the Goddess:

Poems, Invocations, Plays and Other Holy Writ

A spirit-filled word feast puzzling on life and death mysteries—rich with metaphor, surprise, earth-passion: a harvest of decades among women who build their own houses, bury their own dead, invent their own ceremonies.

By Bethroot Gwynn—poet, theaterwoman, temple keeper on women's land, and a longtime editor for the We'Moon Datebook.

Softbound, 6x9, 120 pages with 7 full color art features, \$16

In the Spirit of We'Moon Celebrating 30 Years:

AN ANTHOLOGY OF WE'MOON ART AND WRITING

This unique Anthology showcases three decades of We'Moon art, writing and herstory from 1981–2011. The anthology includes new insights from founding editor Musawa and other writers who share stories about We'Moon's colorful 30-year evolution. Now in its third printing!

256 full color pages, paperback, 8x10, \$26.95

by Starhawk, illustrated by Lindy Kehoe In the very heart of the last magic forest lived the last wild Witch...

In this story, the children of a perfect town found their joy and courage, and saved the last wild Witch and the forest from destruction. A Silver Nautilus Award winner, this book is recognized internationally for helping readers imagine a world as it could be with abundant possibilities.

34 full color pages, 8x10, Softbound, \$9.95

An Eco-Fable for Kids and Other Free Spirits.

WE'MOON 2020: WAKE UD CALL

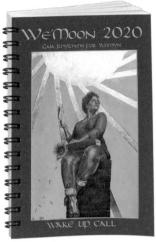

• **Datebook** The best-selling astrological moon calendar, earth-spirited handbook in natural rhythms, and visionary collection of women's creative work. Week-at-a-glance format. Choice of 3 bindings: Spiral, Sturdy Paperback Binding or Unbound. 8x51/4, 240 pages, \$21.95

• We'Moon en Español!

We are proud to offer a full translation of the classic datebook. in Spanish! Spiral Bound, 240 pages, 8x5¹/₄, \$21.95

Cover Poster featuring art by Saba Taj: "Lioness," radiating confidence and awakened wisdom. 11x17, \$10

• We'Moon on the Wall

A beautiful full color wall calendar featuring inspired art and writing from We'Moon 2020, with key astrological information, interpretive articles, lunar phases and signs. 12x12, \$16.95

• We'Moon 2020 Tote Bag 100% Organic Cotton tote, proudly displaying the cover of We'Moon 2020. Perfect for stowing all of your goodies in style. 13x14, \$13

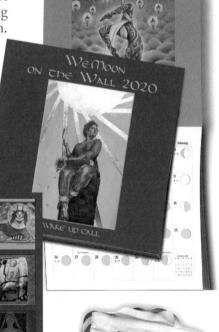

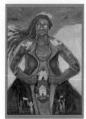

• Greeting Cards An assortment of six gorgeous note cards featuring art from *We'Moon 2020*, with writings from each artist on the back. Wonderful to send for any occasion: Holy Day, Birthday, Anniversary, Sympathy, or just to say hello. Each pack is wrapped in biodegradable cellophane. Blank inside. 5x7, \$11.95

More Offerings! Check out page 229 for details on these books:

- The Last Wild Witch by Starhawk, illustrated by Lindy Kehoe.
- In the Spirit of We'Moon ~ Celebrating 30 Years: An Anthology of We'Moon Art and Writing
- Preacher Woman for the Goddess: Poems, Invocations, Plays and Other Holy Writ by We'Moon Special Editor Bethroot Gwynn.

Order Now—While They Last! Take advantage of our Special Discounts:

- We'll ship orders of \$50 or more for **FREE** within the US!
 - Use promo code: **20Awake** to get 10% off orders of \$100 or more!

We often have great package deals and discounts. Look for details, and sign up to receive regular email updates at

www.wemoon.ws

Email weorder@wemoon.ws Toll free in US 877-693-6666 Local & International 541-956-6052 Wholesale 503-288-3588 Shipping and Handling

Prices vary depending on what you order and where you live.

See website or call for specifics.

To pay with check or money-order.

To pay with check or money-order, please call us first for address and shipping costs.

All products printed in full color on recycled paper with low VOC soy-based ink.

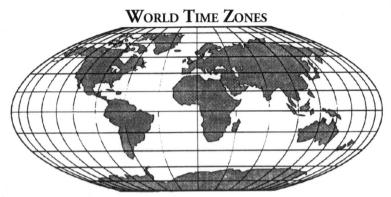

ID LW		CA HT		PST	MST	CST	EST	AST	BST	ΑT	WAT	GMT	CET	EET	ВТ		USSR Z4	USSR Z5	SST	CCT	JST	GST	USSR Z10	
-12	-11	-10	9	-8	-7	-6	-5	4	-3	-2	-1	0	+1	+2	+3	+4	+5	+6	+7	+8	+9	+10	+11	+12
4	-3	-2	-1	0	+1	+2	+3	+4	+5	+6	+7	+8	+9	+10	+11	+12	+13	+14	+15	+16	+17	+18	+19	+20

STANDARD TIME ZONES FROM WEST TO EAST CALCULATED FROM PST AS ZERO POINT:

IDLW:	International Date Line West	-4	BT:	Bagdhad Time	+11
NT/BT:	Nome Time/Bering Time	-3	IT:	Iran Time	+11 1/2
CA/HT:	Central Alaska & Hawaiian Time	-2	USSR	Zone 3	+12
YST:	Yukon Standard Time	-1	USSR	Zone 4	+13
PST:	Pacific Standard Time	0	IST:	Indian Standard Time	+13 1/2
MST:	Mountain Standard Time	+1	USSR	Zone 5	+14
CST:	Central Standard Time	+2	NST:	North Sumatra Time	+14 1/2
EST:	Eastern Standard Time	+3	SST:	South Sumatra Time & USSR Zone 6	+15
AST:	Atlantic Standard Time	+4	JT:	Java Time	+15 1/2
NFT:	Newfoundland Time	+4 1/2	CCT:	China Coast Time	+16
BST:	Brazil Standard Time	+5	MT:	Moluccas Time	+16 1/2
AT:	Azores Time	+6	JST:	Japanese Standard Time	+17
WAT:	West African Time	+7	SAST:	South Australian Standard Time	+17 1/2
GMT:	Greenwich Mean Time	+8	GST:	Guarn Standard Time	+18
WET:	Western European Time (England)	+8	USSR	Zone 10	+19
CET:	Central European Time	+9	IDLE:	International Date Line East	+20
EET:	Eastern European Time	+10			

How to Calculate Time Zone Corrections in Your Area:

ADD if you are **east** of PST (Pacific Standard Time); **SUBTRACT** if you are **west** of PST on this map (see right-hand column of chart above).

All times in this calendar are calculated from the West Coast of North America where We'Moon is made. Pacific Standard Time (PST Zone 8) is zero point for this calendar, except during Daylight Saving Time (March 8–November 1, 2020, during which times are given for PDT Zone 7). If your time zone does not use Daylight Saving Time, add one hour to the standard correction during this time. At the bottom of each page, EST/EDT (Eastern Standard or Daylight Time) and GMT (Greenwich Mean Time) times are also given. For all other time zones, calculate your time zone correction(s) from this map and write it on the inside cover for easy reference.

Conventional Holidays 2020

January 1	New Years Day*
January 20	Martin Luther King Jr. Day
January 25	Chinese/Lunar New Year
February 14	Valentines Day*
February 17	Presidents Day
February 26	Ash Wednesday
March 8	International Women's Day*
March 8	Daylight Saving Time Begins
March 12	Mexika New Year
March 17	St. Patrick's Day*
April 5	Palm Sunday
April 10	Good Friday
April 9–April 16	Passover
April 12	Easter
April 22	Earth Day*
April 24–May 23	Ramadan
May 5	Cinco De Mayo*
May 10	Mother's Day
May 25	Memorial Day
June 21	Father's Day
July 4	Independence Day*
September 7	Labor Day
Sept. 19-Sept. 20	Rosh Hashanah
September 28	Yom Kippur
October 12	Indigenous Peoples' Day
October 31	Halloween*
November 1	All Saints' Day*
November 1	Daylight Saving Time Ends
November 2	Day of the Dead*
November 11	Veteran's Day*
November 26	Thanksgiving Day
December 11–18	Chanukah/Hanukkah
December 25	Christmas Day*
December 26	Boxing Day*
Dec. 26–Jan. 1	Kwanzaa*
December 31	New Years Eve*
*Samo	e date every year

Become a We'Moon Contributor!

Send submissions for WE'MOON 2022 The 41st edition!

Call for Contributions: Available in the spring of 2020 Postmark-by Date for all art and writing: August 1, 2020 Note: It is too late to contribute to

We'Moon 2021: The World

We'Moon is made up by writers and artists like you! We welcome creative work by women from around the world, and aim to amplify diverse perspectives. We especially encourage those of us who are women of color or who are marginalized by the mainstream, to participate in helping We'Moon reflect our unique visions and experiences. We are eager to publish more words and images depicting people of color created by WOC. By nurturing space for all women to share their gifts, we unleash insight and wisdom upon the world—a blessing to us all.

We invite you to send in your art and writing for the next edition of We'Moon!

Here's how:

Step 1: Visit wemoon.ws to download a Call for Contributions or send your request for one with a SASE (legal size) to **We'Moon Submissions, PO Box 187, Wolf Creek, OR 97497.** (If you are not within the US, you do not need to include postage.) The Call contains current information about the theme, specifications about how to submit your art and writing, and terms of compensation. There are no jury fees. The Call comes out in the early Spring every year.

Step 2: Fill in the accompanying Contributor's License, giving all the requested information, and return it with your art/writing and a self addressed envelope by the due date. *No work will be accepted without a signed license!* **New!** We now accept email submissions. See our website for details.

Step 3: Plan ahead! To assure your work is considered for **We'Moon 2022**, get your submissions postmarked by August 1, 2020.

Notes

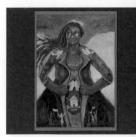

Sanctuary © Kate Langlois 2018

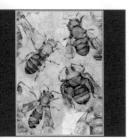

Local Heroes
© Nancy Watterson 2016

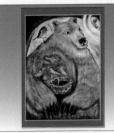

Love Awakens
© Denise Kester 2017

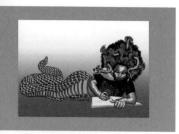

Nagakanya Artist at Work © KT InfiniteArt 2018

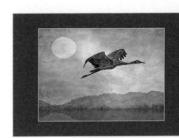

Morning Crane © Lyndia Radice 2018

Cauldron
© Sophia Rosenberg 2008